CHAPTER 1

···

Getting Started with Flash Video

Flash Video offers unparalleled reach while offering the most options for interactivity from any Internet video format. This chapter introduces you to the number one streaming video format.

Video and the Web

File formats, such as HTML, GIF, and JPEG, have made distributing text and images over the World Wide Web common. The MP3 audio file format expanded the Web to become a vehicle for audio distribution. It wasn't until the introduction of Flash Video (FLV) in Adobe Flash Player that video became viewable by the majority of the general Internet audience.

In Web 1.0 (1994 – 2003), Web video was difficult to distribute because authoring support for integrating video with other Web content was nonexistent, few formats were guaranteed to be ubiquitous across platforms, and few people had broadband connectivity. These factors made for poor viewing experiences as video plug-ins were not available or too bothersome to install and update.

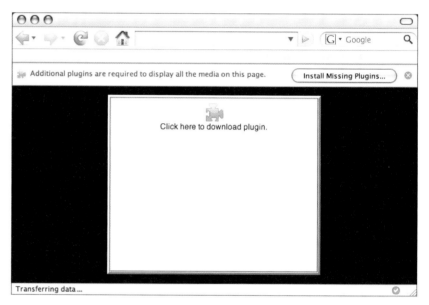

Figure 1.1: *A missing plug-in message frequently seen with other video formats.*

Flash Video and Web 2.0

With Web 2.0 (2004 to present day), video is everywhere on the web thanks to Flash Video: You Tube, Google Video, CNet reviews, The New York Times, and on countless marketing and movie trailer sites. Designers, developers, and producers choose Flash Video because it has the reach, performance, tooling options, and potential for rich experiences that no other video format can match:

- 99% of Internet-connected PCs can play Flash Player 7 content and 80% of PCs will be capable of playing Flash Player 9 content within one year of release.

- The Flash Platform and Flash Video are truly cross-platform. Players exist for various versions of Windows, Mac OS X, and Linux.

- There are many tooling options for Flash Video: one can create sophisticated Flash applications with Flash Professional or Flex. With about five clicks, one can insert

encoded Flash Video into a web page with Dreamweaver. There are several ways to create Flash Video with third-party solutions from On2, Sorenson, Autodesk, and the open-source community.

 This is all I'll say about the strengths of Flash Video. If you need more information, go to Adobe's Developer Center website and view the Flash Video technology center: http://www.adobe.com/devnet/flash/video.html.

Before You Begin

This book is not a book meant to replace the documentation that comes with Adobe Flash Professional CS3. If it did, it would have to be a thousand pages or more! It won't cover how to do shape tweens, teach you how to develop components, or use Flash to skin an Adobe Flex application.

This book is for video and design professionals who are not skilled at using Flash Professional but want to learn how to develop Flash Video content. This book can also help the Flash developer who is not aware of most video terms and best practices and wants to improve the production quality of her video. I'm going to cover how to create decent video for Flash Video distribution and teach you how to create Flash applications with video. We'll walk through code and you should feel quite comfortable in working with ActionScript and how it pertains to video by the end of the book.

How This Book Is Organized

This book has eight chapters. This chapter, Chapter 1, discusses the book's organization and then presents two simple tutorials for working with Flash Video. Here are the rest of the chapters:

- **Chapter 2:** This chapter reviews basic video production skills for Flash Video. It's a short crash course for the interactive developer with little to no video experience.

- Chapter 3: Interactive video concepts

- Chapter 4:

- **Chapter 5:** This covers video compression and includes background material on video formats and compression technology. It includes tutorials for encoding a single file, a batch of files, and embedding cue point in video.

- **Chapter 6:** Here we build two Flash Video players from scratch.

- **Chapter 7:** Here we get creative with Flash Video, alpha channels, and the Flash Player's bitmap and color effects.

- **Chapter 8:** This is a primer on embedding Flash Video in HTML pages. It discusses several methods for embedding Flash Video.

- **Chapter 9:** In this chapter, we work with XML, closed-caption text, and integration between the Flash Player and JavaScript.

- **Chapter 10:** This last chapter discusses preparing video for streaming servers and mobile devices.

Icon Glossary

Throughout the book are short relevant notes. To better distinguish between tips, cautionary notes, DVD-ROM content, and useful resources on the Internet, the book has the following icons:

Production tip	Keyboard shortcuts and time-saving methods.	**Cautionary note**	Production gotchas to avoid.
On the DVD-ROM	Material on the book's DVD-ROM.	**Web reference**	Links to Internet resources.

How to Use the Book and DVD

The DVD has three main folders: Additional Content, Completed Tutorials, and Tutorials. When beginning any of the tutorials, you'll be asked to copy folders from the Tutorials folder to your local hard drive. The files in this folder are places to start. In most cases they won't compile to anything useful until you've completed the tutorial. If you'd like to see how something was done, look inside the Completed Tutorials folder. The Additional Content folder has a few things you might find useful such as cheat sheets, additional code examples, and sample content.

 When I buy a book, I make a backup of the DVD-ROM content. I also file the book's CD or DVD in a disc storage case. It's often too easy to lose a disc or have it become damaged.

Required Software

- You should have **Adobe Flash Professional CS3** to complete the book's tutorials.

- **Adobe Dreamweaver CS3** is required for the short tutorial at the end of this chapter. It or another HTML or text editor can be used for the XML and HTML tutorials that are later in the book.

- **Adobe After Effects Professional 7** is required for the tutorials in Chapter 5.

 To get a free trial version of these products, go to: http://www.adobe.com/downloads/ and look for the trial links for Flash Professional, Dreamweaver, and After Effects.

Tutorial: Inserting Flash Video in Flash Professional

The **Import Video wizard** in Flash Professional provides several easy steps for creating Flash Video from an encoded FLV or nonencoded source video. In this tutorial we'll import a video that is encoded as Flash Video and add it to an existing Flash document.

Figure 1.2: *The finished example.*

1. Navigate to the **Tutorials > Chapter 1** folder. Copy the **Insert in Flash** folder to your computer.

2. Open Flash Professional and choose **File > Open**. Navigate to the **Insert in Flash** folder and open the file, **feet_traffic.fla**.

3. Select **File > Import > Import Video**. The first step in the wizard appears.

Figure 1.3: *Selecting a source video in the Import Video wizard.*

4. Select **On your computer** and click **Choose**. Select **feet_traffic.flv** in the **Insert in Flash** folder and click **Select** (Windows) or **Open** (Mac OS X). Click **Continue**.

5. In the next step, select **Progressive download from a web server** (it should already be selected). Click **Continue**.

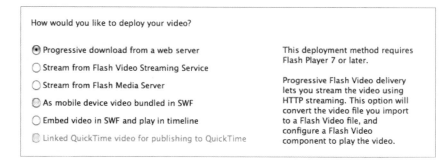

How would you like to deploy your video?

⦿ Progressive download from a web server

◯ Stream from Flash Video Streaming Service

◯ Stream from Flash Media Server

◯ As mobile device video bundled in SWF

◯ Embed video in SWF and play in timeline

◯ Linked QuickTime video for publishing to QuickTime

This deployment method requires Flash Player 7 or later.

Progressive Flash Video delivery lets you stream the video using HTTP streaming. This option will convert the video file you import to a Flash Video file, and configure a Flash Video component to play the video.

Figure 1.4: *Selecting a source video in the Import Video wizard.*

6. The **Skinning** step appears. Select **SkinOverPlaySeekFullvcreen.swf** from the **Skin** dropdown. This skin offers play, pause, seek, and full-screen video controls.

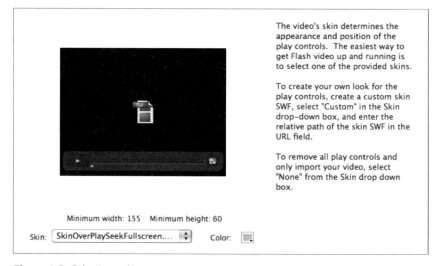

The video's skin determines the appearance and position of the play controls. The easiest way to get Flash video up and running is to select one of the provided skins.

To create your own look for the play controls, create a custom skin SWF, select "Custom" in the Skin drop–down box, and enter the relative path of the skin SWF in the URL field.

To remove all play controls and only import your video, select "None" from the Skin drop down box.

Minimum width: 155 Minimum height: 60

Skin: SkinOverPlaySeekFullscreen.... ⇕ Color: ⊞

Figure 1.5: *Selecting a skin.*

7. Click the **Color** control, and at the top of the pop-up panel, set the **Color** to **#666677** and the **Alpha** to **50%**.

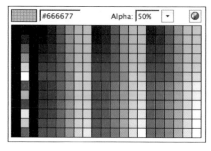

Figure 1.6: *Specifying the skin color and alpha (opacity).*

8. You should see an instance of the FLVPlayback component on the stage. For best practice purposes, we should give the instance a name. Select the component and

in the **Properties** panel, name it **myFlvPlayback**. Naming the instance is important if the component will be used with ActionScript. Now would be a good time to set both the **X** and **Y** properties to **0** using the **Properties** panel too.

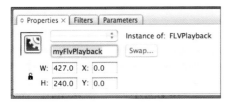

Figure 1.7: *Name the instance of the playback.*

9. Preview the movie by choosing **Control > Test Movie**.

10. It looks good, but now let's set the controls to fade away when the pointer is not over the video portion of the Flash movie. Close the preview by pressing **Control+W** (Windows) or **Command+W** (Mac OS).

11. Select **Window > Component Inspector**. Click the **Parameters** tab.

12. Select the **myFlvPlayback** instance on the Stage. In the **Component Inspector** panel, set the **skinAutoHide** property to **true**.

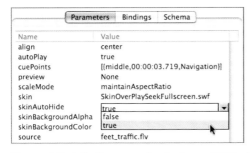

Figure 1.8: *Adjusting properties for the myFLVPlayback instance.*

13. Select **Control > Test Movie** to preview the movie.

Tutorial: Inserting Flash Video in Dreamweaver

Dreamweaver includes the **Insert Flash Video** command, which is the easiest way to get video onto an existing web page. Here's how it works: after picking an encoded FLV file, Dreamweaver inserts a playback SWF referencing the video and includes the required HTML and JavaScript in the web page.

 Dreamweaver does not convert raw video to Flash Video. If your video is not encoded as Flash Video, you will need to process it with Flash Professional, Premiere Pro CS3, the QuickTime export module for Flash Video, the stand-alone Flash Video Encoder, or a third-party encoder.

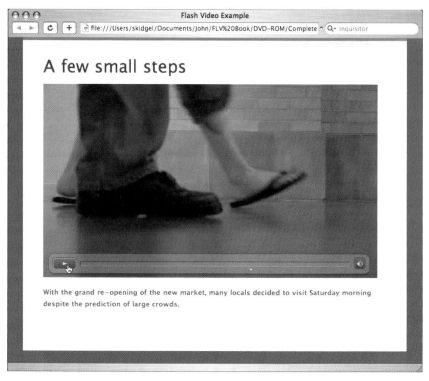

Figure 1.9: *Previewing the page in a browser.*

1. Navigate to the **Tutorials > Chapter 1** folder. Copy the **Insert in Dreamweaver** folder to your computer.

2. Open Dreamweaver and choose **File > Open**. Navigate to the **Insert in Dreamweaver** folder and open the file, **index.html**.

3. Select the text, "remove this text and place video here" and delete it.

4. Select **Insert > Media > Flash Video** or select **Flash Video** from the **Insert Flash** button in the Common toolbar.

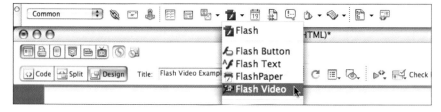

Figure 1.10: *Adding Flash Video from the Insert bar.*

5. The **Insert Flash Video** dialog appears. Select **Progressive Download Video** as the **Video type**.

6. Set the movie to display. Enter **feet_traffic.flv** in the **URL** field.

7. Choose the **Corona Skin 2**.

8. Click **Detect Size** to properly size the SWF file. The dialog updates to show the width as 640 pixels and the height as 360 pixels.

Note the remaining options that can be set, such as auto play, auto rewind, and a customized message that appears when Flash is not installed.

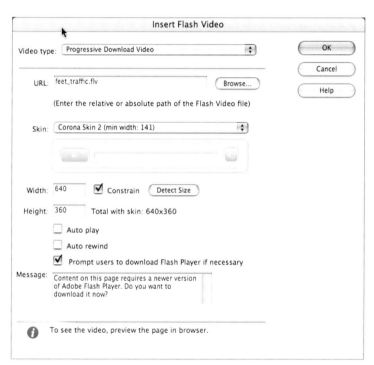

Figure 1.11: *The Insert Flash Video dialog.*

9. Click **OK** when finished. Choose **File > Preview in Browser** and select a web browser to preview the page.

 If you need to change the settings, select the video object in the **Design** view and change the settings in the **Property Inspector (Window > Properties)**.

Figure 1.12: *The Property Inspector palette showing the settings for a Flash Video element.*

Wrapping Up

While they are undoubtedly the easiest ways to get video into a Flash movie or a web page, these two tutorials are barely scratching the surface of what's possible with Flash Video and the creative arsenal provided by Adobe. Luckily, there are seven more chapters in the book.

CHAPTER 2

Video Production Tips for Flash Video

A short primer on how to shoot video for integration with Flash.

 If you are new to video production, this chapter is for you. It covers best practices for shoot-ing video for streaming media and blue and green screen compositing, as well as providing small tips, like not forgetting to record sound effects.

If your only intention is to post a video clip on the Internet, it's strongly recom-mended that you tailor your production and editing methodology to optimize for this delivery format. You want small, continuously playing media that loads quickly and looks its best given the preceding constraints. While broadband is reaching mainstream levels, there will always be the need for quickly loading video with a small footprint, such as video for cell phones, or small talking-head instructional videos that are part of rich Internet applications (RIAs). Following is a list of optimi-zation tips to produce video that looks good and loads quickly.

Shoot with the Best Possible Format

If your camera supports progressive recording, always shoot in this mode when you're targeting Flash Video. Shooting in 24p or 30p preserves frame detail and progressive footage is easier to compress than interlaced footage. Whenever possible shoot in HDV, HD, or a higher quality standard definition format such as DVC-Pro 50. These formats retain more picture information and afford more flex-ibility in postproduction.

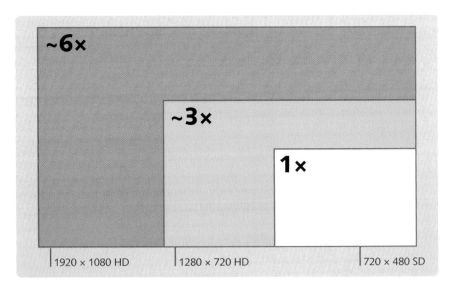

Figure 2.1: *With an HD-sized frame, you have more creative cropping options.*

Shooting in 24p mode or 24 fps means the footage has six fewer frames a second to compress. Using 24p cameras is an excellent choice for shooting process pho-tography because they shoot in progressive mode, which makes compositing much easier than interlaced footage. Since progressive footage keeps all the information in a single frame intact, it's easier to pull a decent key. When motion is split within a frame across two fields of video, it's much more difficult to pull a clean key since the motion is slightly stuttered.

An animated explanation of Panasonic's variant of 24p for the DVX-100 can be found at: http://www.skidgel.com/blog/2005/12/10/animation-explaining-24p-advanced/ and http://www.skidgel.com/blog/2005/12/09/animation-explaining-24p-standard/.

Controlling Camera Motion

The job of the cinematographer is not just to make the audience say, "what amazing cinematography." If the audience only talks about the cinematography, the filmmakers have failed. The cinematography shold help tell the story, it should not distract from it. Success is achieved when the cinematographer has developed her skills, her workflow is smooth and facilitates rather than hinders her craft, and she follows—but occasionally breaks for dramatic effect—the formal rules that are grounded in narrative and cinematic guidelines.

Avoid Quick Zooms and Whiplash Panning

Fast, unmotivated zooms and indiscriminate whiplash pans are a clear sign of an amateur filmmaker. First of all, this is never seen in professional video and cinematography. Filmmakers almost always shoot with a fixed-length lens. If they want the camera to move more closely to the subject, they move the camera and not the lens because it looks more natural, as if the audience is moving closer to the subject. Quick zooms and pans often look blurry, and they can strobe. At 24 fps, a quick pan looks even worse.

Not all zooms are bad, they just need to be motivated by the narrative needs of the story. Instead of zooming in on a subject, cut from a medium shot to a close-up. While this sounds counterintuitive, it is what filmmakers and editors have been doing for over a century, because the viewers' eyes along with their imaginations, will connect the dots and create the rest of the zoom in their minds. This is the real power of the language of film, and you should employ it wherever possible.

Controlling Movement

Excluding the movement of actors, movement that changes the view within a shot is caused either by camera movement or by changing the focal length of the lens (zooming in or out). Instead of whipping a camera around, controlled pans and tilts make your video look more professional.

Pan and Tilt

Panning involves rotating the camera to the left or right on the y axis. This is best done by rotating the camera using a pan and tilt head attached to a tripod. While panning can be done while holding the camera, it's not smooth and is best done for short pans.

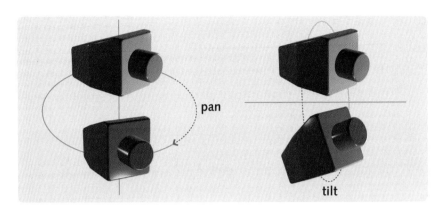

Figure 2.2: *Pan and tilt.*

Two readily available styles of tripod heads are fluid and fluid-effect. Fluid head gives the smoothest pans because the resistance created by pushing oil through the internal mechanisms dampens jerky movements and softens horizontal and vertical pans. A fluid-effect tripod softens movement with two internal greased plates arranged so that they work against each other to dampen vertical and horizontal rotations. A fluid-effect head is not as smooth as a pure fluid head, but it can do the job and is a lot less expensive.

PAN AND TILT GUIDELINES

There are several guidelines to remember when panning. A pan that is done too quickly causes judder, noticeably long movements for elements within a frame. To avoid judder, you simply need to:

- Slow down your pans.
- Turn off Optical Image Stabilization (OIS) when panning with a tripod. It will fight you the entire length of the pan and create more judder.
- If you want a fast pan, consider cutting between the two shots as it can often give you the same visual effect, but remember to follow the 30-degree rule.

Use a Tripod or a Stabilizer Wherever Possible

Although handheld shots are great, they are not meant for all shots. If you video-tape scenery, interviews, or other B roll (extra footage), a level tripod gives you steady footage, smoother pans and tilts, and video that compresses better.

Motion in a shot is easily controlled by shooting on a sturdy tripod. Time your pans correctly. Tighten the tilt head, or you could be in a for an unpleasant surprise if you apply any pressure up or down during a pan.

Don't Sweat Title and Action Safe Zones

If your only distribution medium is the Internet, there is no need to frame shots to fall within the action-safe or title-safe areas because it does not get cropped like video on a television. Likewise, titles or text do not need reside within the title safe area when designing motion graphics for Flash Video delivery since the entire frame will be seen on the web page.

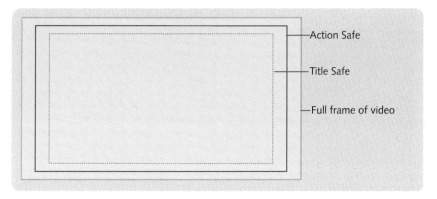

Figure 2.3: *The guidelines for action and title safe do not apply to Flash Video.*

Simplify Backgrounds

File size increases as there is more detail or motion in each frame. It goes without saying that a frame with a subject in front of a solid color compresses more than a frame with the same subject in front of moving machinery. However, a subject in front of a static field of color is boring to watch. One possible solution would include an establishing shot of the subject in front of the machinery followed by the subject in front of a simple background. Conversely, the edit could start with the subject against the simple background with a few meaningful cutaways to the complex scenery with the subject.

Figure 2.4: *Two shots with simple backgrounds.*

Use Depth of Field to Your Advantage

Another method for limiting detail is to use a shallow depth of field. Bring the subject into focus and have the background in soft focus. This will instruct the

compression software to preserve detail in the foreground. Having the background appear soft and out of focus reduces the chance of motion artifacts.

Depth of field (DOF) is the area in front of the camera where elements look sharp and in focus. Let's assume you're shooting a scene and the subject is 9 feet in front of you. When you focus on the subject, the depth of field could range from 8 to 11 feet. Anything within this area will be in focus, and anything outside of it will be soft and out of focus. Realistically, only one infinitely thin plane is truly in sharp focus at any one time, but depth of field is much deeper than this. The thin plane in focus is about one third of the way into the entire depth of field.

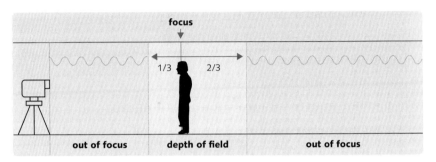

Figure 2.5: *Depth of field is the area in front of the camera that is in focus.*

> *When shooting extreme closeups in macro mode, the focus plane is closer to the middle of the entire depth of field.*

To take full advantage of the relationships between focal length, aperture, and the depth of field with your camera, learn the following rules:

DOF Decreases as Focal Length Increases

Depth of field is inversely proportional to focal length; that is, depth of field decreases as focal length increases. This means that a telephoto lens has less depth of field than a normal lens. You can use this property of a telephoto lens to your advantage when shooting with a zoom lens. First zoom all the way into a small area on the subject, like the eyes. Focus the lens so that the eyes are sharp and then zoom out to the desired framing. Since a zoom lens maintains the same focal plane regardless of zoom, you are guaranteed sharp focus.

Conversely, depth of field increases as focal lengths decrease. This means a wide-angle lens has more depth of field than either a telephoto or normal lens. In run-and-gun situations, it is best to set focus quickly and then go wide, since depth of field is deeper at short (wide) focal lengths.

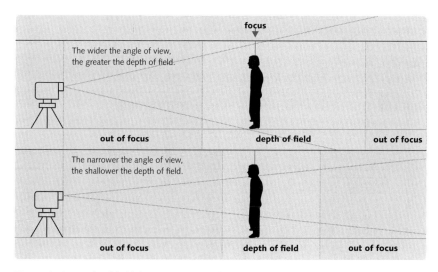

Figure 2.6: *Depth of field decreases as focal length increases.*

DOF Increases as Aperture Decreases

Depth of field is also inversely proportional to aperture, so depth of field increases as the aperture closes. This means at f/8 there is more depth of field than at f/2. When you squint (close) your eyes to focus on an eye chart, you are essentially doing the same thing.

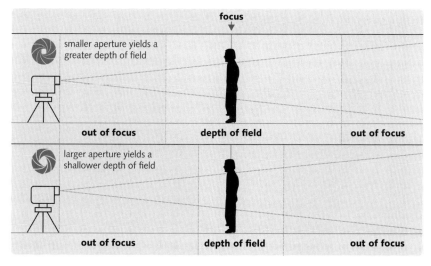

Figure 2.7: *Depth of field increases as the aperture becomes smaller and decreases as it becomes larger.*

DOF and the Camera-to-Subject Distance

Depth of field increases as the subject moves farther away from the camera and decreases the closer he is to the camera. To get more depth of field, move the camera farther from the subject or move the subject farther from the camera. To

get less depth of field, move the camera closer to the subject or bring the subject closer to the camera.

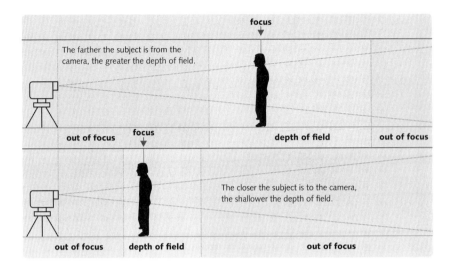

Figure 2.8: *Depth of field increases as subject moves farther from the camera.*

Racking Focus

Racking focus is a narrative film technique where the focus is shifted from one subject to another within the same frame. This is seen a lot in over-the-camera dialog shots. For example, while one man in the foreground smiles to himself, the camera shifts focus from him to another man plotting against him.

Figure 2.9: *An example of racking focus between two characters.*

Get Good Exposure and Light Softly

Footage with soft, even light compresses better than footage with hard edges created by shadows or overbright light values. Soft light can be achieved by applying diffusion material to the lights or by applying a soft box to the key light. Important information can be lost in dark exposures because compression will most likely throw out any detail in dark areas.

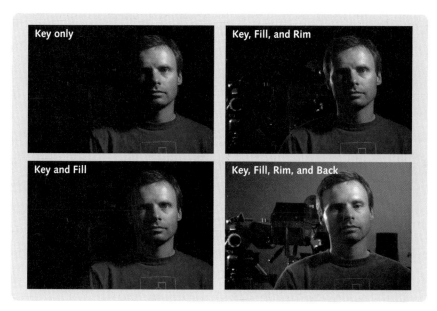

Figure 2.10: *Four point lighting can dramatically improve the quality of video.*

Reduce or Turn Off Detail or Sharpening

A camera's detail or sharpening setting is often used to boost sharpness. While this may be fine for footage that will not undergo any postprocessing, it is not recommended if you plan to use a product, such as Red Giant's Magic Bullet or Nattress Film Effects, to deartifact and retime the video. When most codecs encounter sharpening, they creates additional compression artifacts known as ringing, and overly sharp images are a telltale sign of bad video. It's hard to make bad video look good.

 To learn more about Magic Bullet, visit: http://www.redgiantsoftware.com.
To learn more about Nattress Film Effects, go to: http://www.nattress.com.

Exposure Is Everything

Unless you're shooting 4:4:4 uncompressed, most camera codecs are not kind to blown-out whites. While this may be the look you're going for, you are far better off doing this in postproduction, where you have more control over the entire image. Keep your brightness values below 100 IRE or at least turn the zebras on your camera. Shoot a stop or two down when the highlights begin to clip. In general, it is better to shoot the image slightly underexposed (and I stress *slightly*) and crank the brightness up later in postproduction.

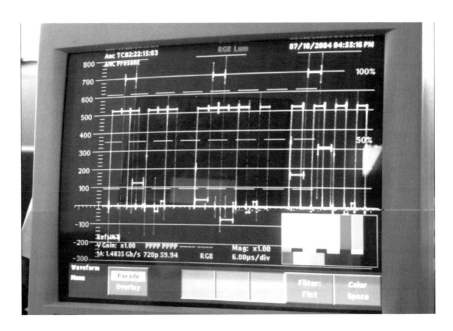

Figure 2.11: *Monitor video levels with a waveform monitor.*

You should use a graduated neutral-density (ND) filter when shooting outdoors in bright sunlight. Shooting without one will blow out the sky and make the subject appear to be backlit. Stopping the entire image down with the iris or the camera's ND filters will dull the image indiscriminately. A graduated ND filter contains a translucent gradient in the glass that cuts the brightness progressively less from top to bottom. This brings the sky under 100 IRE while not under exposing the subject. If the subject still appears backlit, a bounce card or reflective disc can serve as a fill light.

Camera codecs are equally unforgiving when it comes to dark, severely under-exposed images. When a dark image is recorded, the codec crushes the shadow detail and creates dark artifacts that are both muddy and blotchy. When you try to adjust the levels, these artifacts are impossible to repair. Again, look on the waveform monitor and be prepared to throw another light on the set, or shoot at a different time of day when more light is available.

It should go without saying that you want to get the best unadulterated exposure you can and avoid having the camera's codec, poor light, or a Gaussian filter screwed onto the camera's lens make the artistic decisions for you. If you shoot an image that is balanced and properly exposed, you will have far more creative options available to you in postproduction and your footage will look better when compressed.

Shooting Blue and Green Screen

Process photography is shooting a foreground element such as an object or talent against a color, normally blue or green, for creating a composite with a background plate. For example, you cannot afford to shoot your talent in front of the Eiffel Tower, so you shoot them in front of a green wall. In postproduction you key out (remove) the green color, and you are left with only the talent, who you can superimpose on top of a picture of the Eiffel Tower.

Backdrop Options

You can shoot talent against paper or fabric backdrops, against painted walls, or you can use a combination of portable backdrops and walls. Backdrops are smaller and transportable. They offer larger spaces but require more care to keep clean and require dedicated space. Paper is cheaper than fabric, and paint is even cheaper than paper if you are painting on an existing wall and are not building a platform. Framed flexible fabric backdrops will run from $150 – $400. Rolled fabric will run $20 per yard for a roll that is 5 feet wide. A 9-foot by 3-foot roll of green paper is about $50 dollars, but the stand for holding the paper costs about $150.

 You can find resellers of blue and green screen paint, backdrops, and kits online, by searching the Internet for "blue screen material."

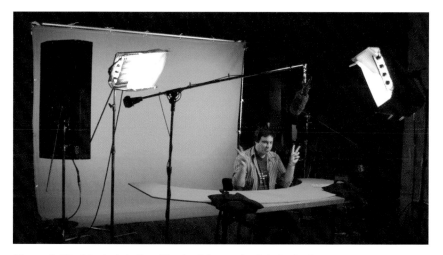

Figure 2.12: *A typical studio with a backdrop and painted sets pieces.*

Lighting Issues

All lights should be the same color temperature. Lighting a green screen with varying color temperature will create subtle uneven color shifts on the screen that can confuse the keying software. For example, if you mix tungsten and daylight balanced lights, the screen will cast an orange-yellow tint. If you use tungsten lighting on a shoot in broad daylight, it will cast a blue tint. In either case, you don't want the lights to add color to the screen. That will make things difficult to key, since the

keying software is looking for blue or green, and not for some new color created by mixing lights of different color temperatures.

The screens should also be lit as evenly as possible. An evenly lit screen is easier to key because the screen appears as one solid color. When you don't light the screen evenly, you have to create garbage mattes and adjust the white and black points before keying, which means more work and an overall decrease in the quality of the matte. In short, do your best when shooting green and blue screen footage and don't assume it can be easily fixed in postproduction.

Recording Room Tone and Effects

Room tone is 30 and preferably 60 seconds of audio recorded on set before sets and equipment are broken down. It is used by the sound editor when doing automatic dialog replacement (ADR) work or when patching over pops and clicks in the sound track. It's an important step in audio production and should not be overlooked.

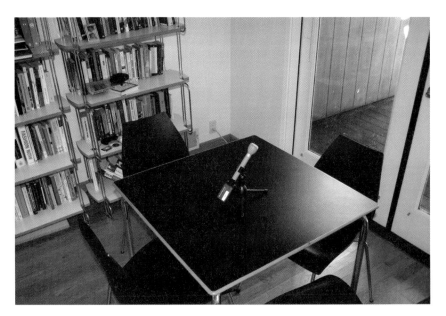

Figure 2.13: *A single microphone recording room tone.*

 Any usable sound effects should also be recorded on set. This may be a door closing or opening, footsteps, slaps, spills, car engines, horns, opening a jar, or anything else the interface might need for a button click, slider drag, or screen transition.

Wrapping Up

This chapter covered just a few basic guidelines for producing video. If you can follow these guidelines, your video will be greatly improved. To learn more specific techniques for video, film, and audio production, visit Focal Press's web site at: http://www.focalpress.com.

CHAPTER 3

An Introduction to Flash Professional and ActionScript 3

A short primer on how to design compelling user experiences for your Flash Video projects.

Getting Acquainted with Flash Professional CS3

This chapter is not a replacement for the official documentation. It is an overview illustrating what features are most used in creating Flash Video content. To learn more about a topic that is covered here, select **Help > Flash Help**.

 The primary way to author Flash Video content is with Flash Professional. While you can use Flex Builder, the Flex SDK, or Flash Develop, this book and chapter focuses on Flash Professional CS3.

Creating Flash Documents

You can create a new document from either the **Start Page** window or the **New Document** dialog. The Start Page window is shown when Flash Professional launches. It has several shortcuts for creating different Flash document types or for accessing recently open documents. It also has shortcuts to help as well as online resources.

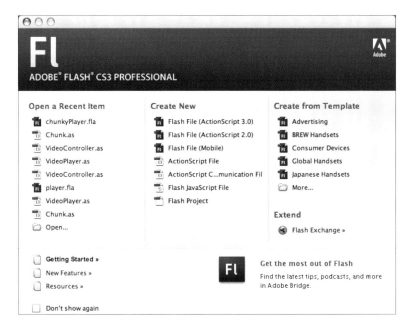

Figure 3.1: *The Start Page for Flash Professional CS3.*

New Document Dialog

Within the New Document dialog are the General or Templates tabs. Both of these tabs offer several starting points for creating a Flash document. The General tab contains blank documents with a few settings and the Templates tab has documents that are significantly tailored for web advertising banners, mobile phones and devices, quizzes, and presentations. We'll create documents mostly from the New Document dialog, but following this section is a short tutorial on creating a document template.

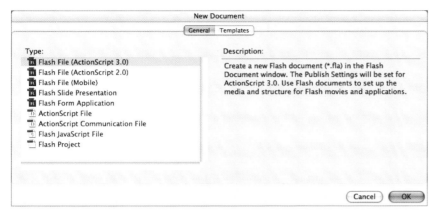

Figure 3.2: *In Flash Professional CS3, you can target either ActionScript 2 or 3 when you create documents in the New Document dialog.*

When you choose a new type in the New Document dialog, that type will be selected the next time you invoke the dialog.

ActionScript is the scripting language in Flash that has many similarities to JavaScript. At the time of this writing, Flash Player 9, which introduced ActionScript 3, is at 90% penetration and rising. That said, all the tutorials, except the Flash Lite tutorial, will target ActionScript 3. So in most cases, when we create a new file for this book, we'll pick **Flash File (ActionScript 3)**.

An editable Flash document has **fla** as the the file extension and this book will refer to one as an FLA file. A Flash document that has been compiled for deployment has the **swf** file extension and this book will refer to one as an SWF file. While a Flash document can contain most, if not all, the ActionScript code on a frame, code can reside in seperate ActionScript files. An ActionScript file has an **as** file extension and this book will refer to one as an ActionScript file. A Flash Video file has an **flv** file extension and this book will refer to one as an FLV file.

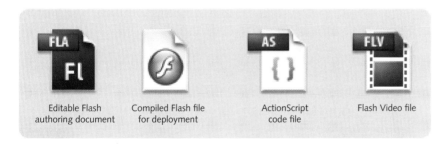

| Editable Flash authoring document | Compiled Flash file for deployment | ActionScript code file | Flash Video file |

Figure 3.3: *The icons used to represent FLA, SWF, ActionScript, and FLV files.*

Note that when you deploy your project on a web server, you will deploy the SWF and FLV files alongside any HTML and JavaScript files that are needed to properly display the Flash Video content in a Web browser such as Internet Explorer, Firefox,

or Safari. The FLA and ActionScript files do not need to be deployed, as they are combined when the SWF file is generated.

 You will often hear these file types pronounced as a "flah file," a "swif file," or a "f-l-v file." Some people will say "a-s code" but most developers say "ActionScript code," when it's internal to the FLA file or "ActionScript class files," when the code is external to the FLA file.

Tutorial: Creating a Reusable Flash Template

If you plan to create a lot of Flash Video documents that will make use of the full screen functionality added in a revision to the Flash Player 9, a document template with this publishing option set can save you a lot of repeat steps. Let's create a template now.

1. Launch Flash Professional CS3. Choose **File > New**.

2. In the **New Document** dialog select **Flash File (ActionScript 3)**.

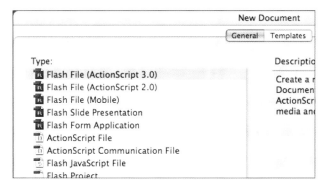

Figure 3.4: *An ActionScript 3-based Flash file is the first in the list.*

3. A new Flash document is created. Choose **File > Publish Settings**. Click the **HTML tab** at the top of the window.

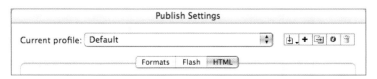

Figure 3.5: *Click the HTML tab to see the HTML publish options.*

4. From the **Template** menu, select **Flash Only - Allow Full Screen**. Click OK at the bottom of the window.

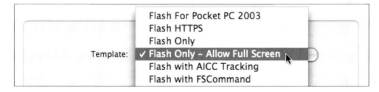

Figure 3.6: *Click the Template menu to select Flash Only - Allow Full Screen.*

5. Choose **File > Save as Template**. The Save as Template dialog appears. In this dialog enter information according to the following screen shot. By entering **Video Templates** for the **Category**, the application will create a new template category for the template and place it in the new category. Click **Save**.

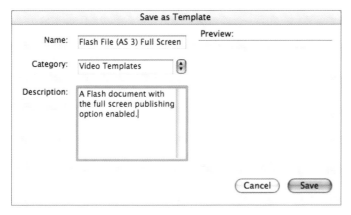

Figure 3.7: *Entering information for the new template.*

6. Close the document used to create this template. Do not save it. To test this work, select **File > New** and click the **Templates** tab. Select the **Video Templates** category and the dialog should resemble the following screen shot.

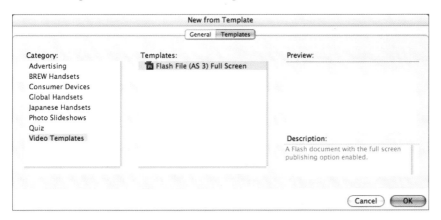

Figure 3.8: *The template just created in the New Document dialog.*

Interface Overview

Flash Professional CS3 has many user interface elements that you may have used in graphic and video software. At a high level, the interface elements we'll cover in this section are the:

○ **Stage**: It is like the monitor window in Premiere, the canvas window in Photoshop, or the artboard in Illustrator. It's where you draw, place, and animate elements.

○ **Timeline:** It is optimal for cell-based animation but not as flexible as the Timeline in After Effects. It has layers that work like traditional layers in Adobe Illustrator.

- **Tool palette:** This has tools for drawing, coloring, and transforming elements as well as creating text.

- **Properties panel:** It resembles the one in Dreamweaver the most, but there are parallels to the Control palette in Illustrator or InDesign. It's where you name elements and inspect and set properties such as scale, position, and opacity.

- **Library panel:** It is most like the Browser window in Final Cut Pro or the project window in Premiere and After Effects. This is where you keep and organize assets you create within Flash, such as movie clips and graphic symbols as well as external assets, such as images.

 Where Flash differs from traditional design and video applications is that it supports the creation of interactive content. The following interface elements are crucial to creating interactivity:

- **Actions panel:** You write code in this panel. Best practice has most code on the first frame of a locked layer named "Actions." Standalone ActionScript files do not use the Actions panel, but have their own document window.

- **Components panel:** This lists the installed components in the application's configuration folder. In Flash Professional CS3, Adobe changed the behavior of the panel to show only the Components for the currently open document's version of ActionScript.

- **Components Inspector panel:** For any component, this panel shows all the parameters for the coponent. If you don't set component parameters in code, this panel is a more comfortable alternative to the Parameters tab that is docked with the Properties and Filters tabs.

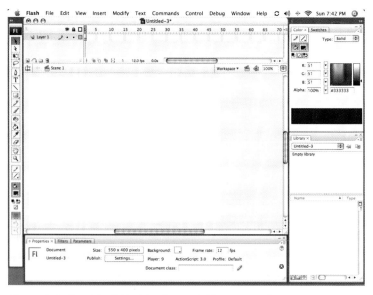

Figure 3.9: The default Flash Professional CS3 user interface.

Timeline

Layers are shown on the left side of the Timeline window. To the right are the frames for the movie. Layers run from top to bottom where bottom layers are in the background and top layers are in the foreground. Time or duration runs from left to right where the left most frame is the first frame in the Flash document.

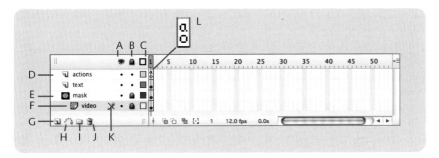

Figure 3.10: *Layer visibility toggle (A), Lock toggle (B), Layer Outline Color (C), a normal layer (D), a mask layer (E), a masked layer (F), New Layer button (G), Create Motion Guide Layer button (H), New Folder button (I), Delete button (J), Non-editable layer icon (K), and a Frame Script is marked with a lower case a and o (L).*

Each layer has a name, an indication that the layer is editable, visibility and lock toggles, and a selection outline color. A layer is editable when the layer is visible and not locked. Double-click layer text to name a layer. Double-click layer icon to display Layer Properties dialog. The types of layers are:

- **Normal layer:** It is the standard layer that is rendered when the movie is compiled as a SWF.

- **Guide layer:** It is used to help with placing elements. Like horizontal and vertical guides a guide layer is visible during authoring time, but is not visible during run-time when the compiled SWF file plays. Anything can exist on a guide layer to help with placement, but remember that it won't be rendered in the final movie.

- **Mask layer: It** is used to reveal portions of layers below it. Artwork on this layer defines the area that is shown in the final movie. This type of layer is useful for creating video shapes that are non-rectangular and Chapter 6 features a tutorial on masking video.

- **Motion guide layer:** This layer is like a null layer in After Effects or a 3-D program. It is not shown but is used as the animation settings for another layer. This book won't cover how to use them, so look them up in Flash's online help if you'd like to learn more about them.

Below the list of layers are buttons for creating a new layer, a motion guide layer, and a layer folder, and deleting a layer. At the end of this button strip is a resize handle to increase the width of the Layer pane.

The Layer Properties dialog is accessed by selecting **Modify > Timeline > Layer Properties**, double-clicking a layer icon, or context-clicking on a layer and choos-

ing Layer Properties. It is for changing any of the properties that can be set in the Layer pane.

CREATING FRAME SCRIPTS

ActionScript can be placed on just about anything; a button, a movie clip, or a frame. While that is fine for informal interactive development, it is not considered best practice because placing code throughout a FLA file makes managing the code difficult.

What most developers use are frame scripts. This is accomplished by creating a layer at the top of the layer list named Actions or ActionScript, selecting a frame in this layer (usually the first), and entering code in the Actions panel. Any code entered when this frame is selected is attached to the frame.

With the introduction of Flash Professional CS3, a FLA can have a document class file associated with it. This is a seperate ActionScript document that contains all the code for the movie. This is nice for seperating code from the design and for portability and reuse. Document classes are covered in Chapters 5 and 9.

The Stage, Shapes, and Symbols

The stage is where elements are drawn, placed, and animated. It is adjacent to the Timeline and the two panes form one window. Like most modern graphic applications it sports rulers, guides, and the ability to zoom in and out. The Edit, View, Insert, and Modify application menus help in placing and editing elements on the stage.

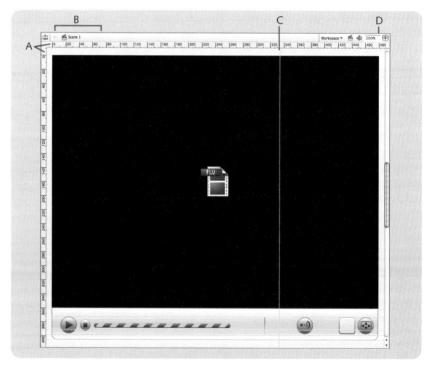

Figure 3.11: A stage with rulers (A) and guides (C). Also notice the Edit bar (B) which is used to navigate between the stage and nested movie clips and symbols. Setting the zoom level (D) is at the left side of the Edit bar.

Shapes and Symbols

Understanding the relationship between shapes and symbols will help you make the most of Flash Professional. Let's review the differences between shapes, graphic symbols, button symbols, movie clip symbols, and instances.

A shape is a graphic element that is used once. While a shape can be copied and pasted, the copy is not linked in any way to the original shape. A symbol, by contrast, is stored in the Library and instances of the symbol are placed on the stage. When a symbol is edited, all instances of it are updated to reflect the new appearance. While an instance inherits its appearance from the original symbol, effects can be applied directly to it to differentiate it from the original symbol. That said, you will use three types of symbols in this book.

1. A **graphic symbol** is artwork or text that is stored in the Library for reuse. An example of a graphic symbol is an icon used multiple times in a button symbol. Symbols do not exist on the stage, but instances of the graphic symbol do. A graphic symbol does not have its own timeline and can only be animated inside the main timeline or in a movie clip symbol. Sounds and interactivity are also not possible inside a graphic symbol.

2. A **button symbol** has a timeline with four frames: an Up frame for the normal state, an Over frame for the hover state, a Down frame for the depressed state, and a Hit frame used to define the clickable area for the button. A button symbol can generate events and integrate with ActionScript code.

3. A **movie clip symbol** is like a graphic symbol but also has its own timeline, can include sound, and can be accessed from ActionScript code. For this reason, a movie clip can contain animation. Components, which we will use to play video and create user interfaces, are movie clips with editable properties.

Creating Symbols

To create a symbol, select an element or elements on the stage you wish to make a symbol and choose **Modify > Convert to Symbol**. In the **Symbol Properties** dialog, you can set the symbol type as well as other properties.

Tool Palette

Like most graphic applications, Flash Professional has a tool palette with selection, shape creation, color, transformation, and view tools. Let's go over what's unique to Flash and what you will encounter when customizing video player skins.

Object Drawing Mode

To make shape creation more like Illustrator where the stroke and fill for a shape are connected, turn on **Object Drawing** mode. You do this by clicking the **Object Drawing** toggle button when the Pen or any of the shape tools are active.

Figure 3.12: *Object Drawing mode on (A) and off (B).*

The Gradient Transformation Tool

The Gradient Transformation tool facilates directly scaling and rotating gradients. It's located underneath the Transformation tool. In Chapter 5, we'll use the Gradient Transformation tool to scale and rotate the gradient fills of several buttons and other user interface controls.

Figure 3.13: *The Gradient Transformation tool.*

Properties Panel

The Properties panel displays settings for the selected item on the stage. Since there are many types of objects to select at any given time: a shape, a symbol, a text object, or a component to name just a few, the Properties panel displays the appropriate settings for the selected object. Settings that you will often set are x and y position and the name of an instance. There are lots of other properties such as symbol type, bitmap effects, color and gradient, or blend mode.

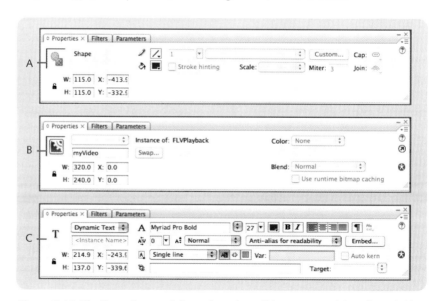

Figure 3.14: *The Properties panel shown for a shape (A), component (B), and text field (C).*

Chapter 3: An Introduction to Flash Professional and ActionScript 3

 Instances have names so they can be referenced by ActionScript code. For instance when playing a video, you need the instance name of the object that will play it.

By default, two other tabbed panels are docked with the Properties panel. They are the Filters and the Parameters panels. The Filters panel is used to apply Flash Player filters to a movie clip. Filters include drop shadow, glows, bevels, and blurs. In Chapter 6 we'll go into more detail about the filters and apply them using this panel or ActionScript. The Parameters panel is used for setting component properties.

I personally prefer the Component Inspector panel to the Parameters panel since it is much larger by default. I think this makes it easier to see and set component properties.

A component is a movie clip that has parameters that can be set using the Parameters tab, the Component Inspector panel, or via ActionScript. For example, the FLVPlayback component which plays Flash Video has a skinBackgroundColor property for setting the skin's fill color. This property and all other component properties appear in the Parameters panel. Components can often eliminate the need to write code since their properties are exposed to the user through a user interface. Some components can also be highly customized. The components that are included when targeting ActionScript 3 are a big improvement over the V2 Components that shipped with Flash MX2004 and 8.

Adjusting Movie Properties and Publish Settings

When there is no selection the Properties panel shows the properties for the FLA file. From here you can click the Size button to display the Document Properties dialog or the Settings button to display the Publishing Options dialog. The Document Properties dialog presents controls for setting metadata, the size of the FLA and SWF, or the background color.

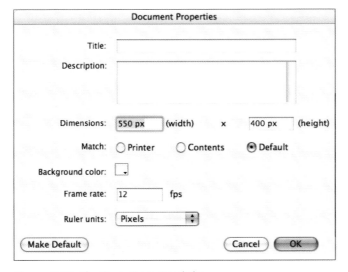

Figure 3.15: *The Movie Properties dialog.*

The Publish Settings dialog helps with generating the SWF, changing the target player or ActionScript version, and setting HTML publishing options. The Publishing Options dialog, like we learned in the template creation tutorial, is crucial for setting web page parameters to correctly enter full-screen mode.

Library Panel

The Library panel stores symbols and assets imported into a FLA file. Elements in the panel can be grouped into folders and in many ways, it is like a Mac OS X Finder window or Windows Desktop Explorer window in table view. You are free to drag and drop items from one folder to another and when you need to use an item on the stage, you drag it from the Library panel directly to the stage. Like most other Adobe products, it has a Panel options menu and a set of command buttons along the bottom of the panel for creating symbols and folders, viewing properties or deleting items from the Library.

Figure 3.16: *The Library panel's Panel Options button (A), Panel Options menu (B), and Command buttons (C).*

Creating a video object is a task you'll have to do often. A video object is a box for displaying video. It can be used to store embedded video that is synchronized with a timeline or you can insert a blank video object, give it an instance name, and write ActionScript code to display and control video.

While you can import video into the Library panel, you should do this only when the clips are small or when working with embedded device video for Flash Lite. Embedded video clips dramatically increase a SWF's size and they are not as network efficient as external video that uses a component or a video object that is ActionScript-controlled.

To create a video object using the Library panel, do the following:

1. Click the **Panel Options** button. Choose **New Video** from the menu.

2. In the **Video Properties** dialog, select the video type and click **OK**. The video object is now stored in the Library panel and you can use it like any other imported graphic or symbol.

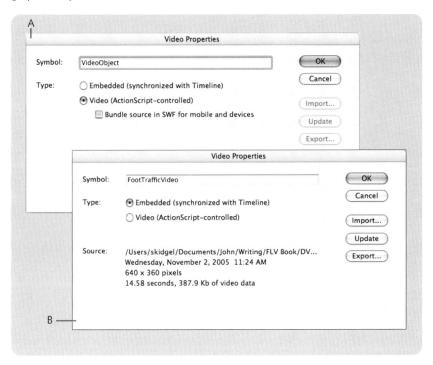

Figure 2.17: *Two versions of the Video Properties dialog showing embedded video (A) and ActionScript-controlled video (B).*

Components Panel

Components are movie clips with editable properties that you can set using the Parameters panel or the Components Inspector panel. While component properties can be set with ActionScript, they also be set through the Parameters panel or the Component Inspector panel without writing any code. To access components choose **Window > Components**. To use a component, you drag it from the Components panel to the stage.

When you create a FLA file for ActionScript 3, the Components panel will only show you components that are written for ActionScript 3, such as the ActionScript 3 User Interface components and the FLVPlayback components for ActionScript 3.

Figure 2.18: *The Components and Components Inspector panels in Flash Professional CS3.*

Several chapters in the book will use the ActionScript 3 User Interface components as well as the FLVPlayback components. We'll set properties using both the panel interfaces and ActionScript. We'll also create Flash Video applications without using components since that is a question Flash developers often have.

The Actions Panel

The Actions panel, not surprisingly, is where you enter ActionScript code. It is shown by choosing **Window > Actions**. A few Actions panel features that I use regularly are at the top of the panel.

- I click the **Check Syntax** button before testing a movie. It reports coding errors in the **Compiler Errors** panel.

- To the left of the **Check Syntax** button is the **Auto Format** button. It reformats code according to the settings in the **Auto Format** preferences. This is helpful when I enter code quickly and want to have consistent indenting and spacing.

Be sure to check the Auto Format preferences first though, so you can adjust them to your coding style. Choose File > Preferences (Windows) or Flash > Preferences (Mac OS X) and select the Auto Format category.

- The **Code Collapse** buttons collapse an arbitrary selection of code down to a button. This feature is great when working on a section of code because you can collapse the code blocks you're not currently working on. Note that you can also collapse code by clicking the collapse/expand controls to the right of the line numbers in the gutter. To expand code that has been collapsed, click the collapse/expand controls in the gutter or click the **Expand All** button.

To collapse code that exists outside of the current selection (inverse code collapse) press the Option key (Mac OS X) or the Alt key (Windows) and click the Collapse Code button.

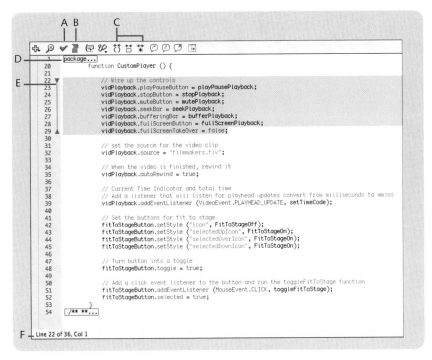

Figure 2.19: *Check Syntax (A), Auto Format (B), and Code Collapse command buttons (C), and Collapsed Code button (D), Collapse/Expand controls (E), and Line and Column Numbers (F).*

Compiler Errors and Output Panels

The **Compiler Errors** and **Output** panels are used extensively when debugging code. The **Compiler Errors** panel is automatically shown when errors occur in code. There are times when the error description isn't clear. What I usually do in this case is right-click (Windows) or Control-click (Mac OS X) on the error listing in the **Compiler Errors** panel and choose **Copy Description**. I will then paste the error description into Google and search for it. The returned search results will often list several blog or forum posts where someone has encountered the same error and community members have responded with solutions.

Figure 2.20: *The Compiler Errors dialog.*

The Output panel comes in handy when trying to test a portion of code. When I want to see if a method is being called properly, I will add a trace statement to the

method and test the FLA file. If the method is called properly, I will see the text I traced in the Output panel.

The Help Panel

I use the Help panel a lot. It's displayed by choosing **Help > Flash Help**. I spend most of my time reading not about features, but about ActionScript. When I'm using a class for the first time, I will look the class up in Help and learn what its methods and properties are and I will also read the sample code listings if they exist for the class.

Testing with the Preview Window

To preview your work, you choose **Control > Test Movie**. By default, the Preview window appears in a separate window. If you'd like to test movies in a new tab in the Flash interface, follow these steps:

1. Choose **File > Preferences** (Windows) or **Flash > Preferences** (Mac OS X).

2. Select the **General** category.

3. Check **Open test movies in tabs** and click **OK**.

Wrapping Up

This chapter presented highlights of the Flash Professional interface and how to make best use of it when authoring Flash Video content. It certainly won't be the only introduction to user interface features. As we progress through each tutorial, I will discuss the user interface or ActionScript concepts where appropriate. With that said, let's move on to the next chapter and learn about encoding Flash Video.

CHAPTER 4

Encoding Flash Video

Understanding how video is encoded on your camcorder, decoded on your computer, and encoded for delivery helps you get the best quality possible. It also reinforces why best practices should be followed when shooting video.

This chapter covers converting video from its original format to one of the Flash Video codecs: Sorenson Spark or On2 VP6. It starts, however, with a brief introduction to analog and digital theory. It's meant to help you understand how digital processing influences the quality of your video. It also discusses the factors outside digital processing such as Internet access speed, site quota limits, and targeting a specific version of the Flash Player.

Analog and Digital Theory

For something to be analog means that it is analogous, or similar to the original. Let's take an example of cymbals clapping. When they collide, sound vibrations are produced. An analog microphone and recorder record the cymbals as an analog waveform. The waveform reproduces sound vibrations that are analogous to the vibrations of the original.

So one might ask, "When a digital recording of the cymbals plays back, the sound it produces appears to be analogous to the original sound. What is the difference?" The difference is in how each method represents the recording of the original sound. An analog recording represents the sound as a smooth physical waveform. A digital recording, by contrast, is a sampled, discreet, and often compressed approximation.

The Analog-to-Digital Process

Another misconception is that digital video cameras are completely digital. This is not true, because the charged coupled device (CCD) outputs an analog signal measured in volts that the camera's digital signal processor (DSP) converts into a digital signal. This conversion involves two steps: color sampling and quantization. These steps yield a data rate that then can be further compressed before the video is stored or transmitted.

Color Spaces

Before we talk about color sampling, it is important to have a brief discussion about color spaces. Digital pictures originate in the RGB (red, green, and blue) color space. Computer-generated motion graphics and renderings also originate in RGB. This color space has three discreet channels of color where color is distributed across red, green, and blue. When the three channels are combined, they form a full-color image.

Broadcast video, however, is broadcast in a different color space known as Y'CbCr. You will also hear Y'CbCr referred to as YUV or possibly YIQ. This is incorrect. Video software developers (or let's blame their marketing departments) have constantly referred to Y'CbCr as YUV. YUV actually refers to the way Y'CbCr is represented in PAL, and YIQ is the actual way Y'CbCr is referred to in NTSC.

Y'CbCr represents luma (Y) and chrominance (Cb and Cr). The Y channel contains all green information as well as parts of the red and blue information. The Cb and Cr channels contain the remaining red and blue information. Broadcast television uses the Y'CbCr color space because it is easier to compress with little noticeable difference (more on that in the next section) and because the luma channel, or Y, offers compatibility with black-and-white televisions.

Color spaces may affect your material if you convert between color spaces in postproduction. If your nonlinear editor (NLE) works in YUV, but your motion graphics package works in RGB, there will be slight color shifts. If color consistency is important, you should take the time to learn more about these issues. One way is to search the Internet with the query string, "converting YUV to RGB."

Color Sampling

The human eye is better at discerning between shades of gray than it is at discerning between different colors. Video standards exploit this weakness by preserving the luminance channel while taking fewer samples of the color information. Most commonly, color sampling refers to the stored ratio of luminance to chrominance across four lines of video.

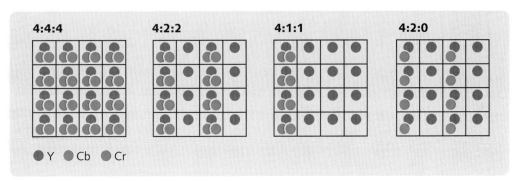

Figure 4.1: *Color sampling.*

- 4:4:4:(4) samples every pixel for color and luminance in the 4 × 4 array of pixels. It is used when quality is of the utmost concern and storage space is not an issue. Given a proper conversion, 4:4:4 Y'CbCr is nearly identical to the original RGB source in picture and size and so it is the highest-quality sampling rate. It is nearly identical because rounding errors can occur when converting between the two color spaces. As a result, 4:4:4 is limited to high-end applications in production and postproduction and is not used in broadcast or other means of distribution. The fourth 4 represents the alpha channel or key when it is present.

- 4:2:2 samples every pixel in the first and third columns for luminance and color but samples only luminance for the second and fourth columns. Think of it as all of the flavor with half of the calories. 4:2:2 is used in DVCpro50 and 100 HD cameras.

- 4:1:1 samples every pixel for luminance but samples only the first column for color. It's all the flavor with a quarter of the calories. 4:1:1 is used in NTSC Mini DV.

- 4:2:0 samples every pixel for luminance but alternates between sampling Cr and Cb color information. Like 4:1:1, it's all the flavor with a quarter of the calories, but some bites have pepper and some have salt and you chew to experience the flavor. 4:2:0 is used for broadcast, PAL DV, and DVD, but it is also part of the prosumer high-definition video (HDV) standard.

When working with video and computer-generated imagery, or even working between different video software packages, a noticeable color shift can result when converting between RGB and YUV color space.

Quantization

The difference between a frame of digital video and a frame of film is that the digital video frame is described in discreet color values, whereas the color values for a frame of film are continuously variable and infinite. For example, a pixel in an 8-bit video frame has a tonal value between 0 and 255 for each of its three channels Y'CbCr.

Quantizing each frame is the next step in analog-to-digital conversion. It involves assigning a precise value to each image pixel based on the image's bit depth. In most cases, this is 8 bits per channel or 24 bits for all three. For this level of quantization, a pixel is one of 16.7 million colors. The actual number can actually be lower when shooting NTSC since its 8-bit gamut ranges from 16 to 235.

Data Rate

The data rate for a digital video format is calculated by multiplying the number of horizontal pixels sampled for Y'CbCr by the number of vertical pixels and multiplying this sum by the quantizing level (bit depth) and the frame rate. This calculation is the raw or effective data rate. Applying a compression algorithm can get the data rate even lower.

Compression

Compression decreases a video segment's storage and bandwidth requirements by removing or reducing redundant or less-important information. Compression is not always a given with digital video. Depending upon the stage in production, postproduction, or distribution, different compression schemes, or **compression-decompression algorithms (codecs)**, come into play. Codecs are written to solve particular needs. For instance, the codec used for real-time teleconferencing is not sufficient for displaying a feature film in a theater, and vice versa. In the first case, the result is akin to blowing up a one-inch postage stamp to 12 feet across. In the reverse case, the teleconference never gets by the first frame as the video signal is hundreds of times larger than the recommended size.

The following list classifies codecs by their place in the spectrum between production and distribution:

1. **Production codecs** are used by the camera to store video onto media (in most cases tape, but disc and solid-state memory are being used). A camera normally only supports one codec, but higher-end cameras geared at film and news production are now capable of supporting a few codecs (some even employ little to no compression). A production codec has to preserve as much information as it can in the audio and video signals while still being economically stored on the camera media.

2. **Postproduction codecs** are present, but most video producers simply use the production codec they shot with in the postproduction process. Postproduction or intermediate codecs are used when the video producer needs to incorporate motion graphics, special effects, or is required to transcode material into a specific format for television or film distribution. These codecs are used because they are better at preserving more audio and video quality than production codecs and because more storage and specialized processing power is available during postproduction.

3. **Distribution codecs** are used for delivering audio and video content quickly and efficiently. They squeeze the material to the smallest size possible and ensure that the media doesn't clog a network connection. While audio and video quality decreases significantly, newer codecs and Internet speeds are improving to the point that Internet video can be as good as DVD video. The Flash Player includes two distribution codecs: **Sorenson Spark** and **On2 VP6** and the VP6 codec can certainly produce video that rivals DVD quality.

Lossy and Lossless Codecs

While some codecs are lossless or near lossless, most production, postproduction, and distribution codes are "lossy" codecs. That is to say, some information is lost in the encoding process. In general, you will use lossy codecs throughout your project, but try to minimize their use.

By contrast, lossless codecs preserve most if not all of the information, but require significantly more processing power and available storage. There are also lossless codecs that preserve most if not all of the original image information. They are great for preserving high levels of quality, but they do not offer real-time decompression with normal computing hardware, which is important when you are editing material. To make up for this, video producers working in this format often purchase a video board that greatly accelerates the decompression and compression. Production and postproduction codecs can be either lossy or lossless. Distribution codecs are always lossy and probably will continue to be until processing power, access speeds, and storage become irrelevant.

Intraframe and Interframe Compression

Intraframe compression looks for patterns within the same frame, and interframe compression looks for patterns across frames. Intraframe compression offers better quality than interframe compression because the integrity of each frame is maintained with intraframe compression. Since interfame compression attempts to remove redundant information across different frames, some unique information is lost. Normally, codecs either are just intraframe or employ both intraframe and interframe compression methods.

DV and HDV are two lossy codecs widely used in production. DV and its larger-capacity siblings, DVCPro 50 and DVCPro 100, are intraframe codecs whereas HDV is both an intraframe codec and an interframe codec. Both Flash Player codecs (Spark and VP6) are lossy codecs that employ both interframe and intraframe compression. The keyframe interval setting in the Flash Video encoder specifies the amount of interframe compression.

Compression Ratios

Compression ratios represent how efficient a codec is by relating the original size to the compressed size. A compression ratio of 2:1 is considered lossless, and higher compression ratios most likely involve sacrificing some image quality for size. Hardware-based codecs tend to be high quality or lossless but require hardware such as a board to work. Software-based codecs vary according to their purpose. Streaming and real-time playback codecs tend to have high compression ratios, and there are now almost completely lossless software codecs available for production archiving and exchange. Many DV codecs are not hardware-based and have a compression ratio of 5:1. Sorenson Spark and VP6 both have high compression ratios (in the ballpark of 30:1).

The Takeaway

Compression is used from the moment you press record on the camera to the moment your audience presses play on your Flash movie. When producing video, you will want to start with the best codec possible. This will be limited by your camera. When going into postproduction, remain at this codec, but also consider keeping material in a higher quality production codec if you are going to be combining your source material with text, graphics, or effects. How you deliver your material to your audience often dictates what distribution codec to use. In short, you maintain quality by not compressing the video to a distribution codec until it is ready to go on your web site.

Important Factors Regarding Compression

How you encode your video is influenced by these two factors: your audience's Internet access speed and the Flash Player version you wish to target. The first factor

is important because not everyone has access to a high speed Internet connection. The second is important because there are some people who have not updated their version of the Flash Player.

Internet Access Speed

The speed at which your audience accesses the Internet will often dictate the speeds at which you offer your material. If a significant portion of your audience accesses the Internet using low-bandwidth dial-up modems, you will certainly want to publish a video with a total bit rate around 40k a second. Conversely, users accessing the Internet over DSL or cable modems can handle a total bit rate between 200k and 500k per second.

Flash Player Versions and Video Codecs

With Flash Video, there are two codecs to choose from: the Sorenson Spark codec and the On2 VP6 codec. The former was introduced in Flash Player 6 and the latter was introduced in Flash Player 8.

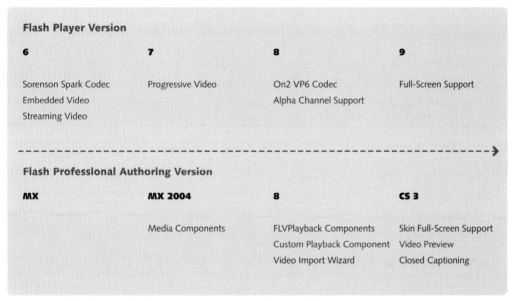

Flash Player Version

6	7	8	9
Sorenson Spark Codec	Progressive Video	On2 VP6 Codec	Full-Screen Support
Embedded Video		Alpha Channel Support	
Streaming Video			

Flash Professional Authoring Version

MX	MX 2004	8	CS 3
	Media Components	FLVPlayback Components	Skin Full-Screen Support
		Custom Playback Component	Video Preview
		Video Import Wizard	Closed Captioning

Figure 4.2: *Video features introduced across Flash Player and Flash Professional releases.*

Sorenson Spark

When the Sorenson Spark codec was initially introduced in Flash Player 6, the player only supported embedded video (which was usually small in size) or streaming video. Embedded video has to be added to the SWF, which makes the SWF inefficiently big and prone to sync issues since the frame rate for the SWF and the FLV need to be the same or a multiple of the other. Having the FLV reside on a server and streamed into a SWF is a much better option, but it requires the content

producer to have a Flash Streaming Server (it was originally called Flash Communication Server but its name has since changed to Flash Media Server).

With the introduction of Flash Player 7, an FLV file could reside alongside a SWF on a regular web site and be progressively downloaded into the SWF without a streaming server. While this doesn't always work as well as playback from a streaming server, it allows anyone with a web site to easily host and deploy video with their Flash content. Player 7 also improved playback performance, and as a result of these two developments, the use of Flash Video increased dramatically.

The Spark codec is a paired-down version of H.263, a codec originally intended for real-time video conferencing. It excludes some of H.263's compression and decompression features in order to keep its footprint small. While this seems unfortunate, it was necessary, since Macromedia (now Adobe) has always strived for keeping the Flash Player's footprint as small as possible.

 To learn more about the differences between the Spark and H.263 codecs, read Fabio Sonnati's blog at: www.progettosinergia.com/flashvideo/flashvideoblog.htm.

On2 VP6 Codec

The VP6 codec developed by On2 Technologies was licensed by Macromedia for Flash Player 8. It was added to keep the Flash platform's video offerings competitive. The primary advantage VP6 has over Spark is that it offers the same quality at a much lower bit rate (or significantly increased quality at the same bit rate). This difference can really be seen in scenes with motion, blur, or gradations. For example, footage compressed with Spark will look choppy, pixelated, and have bands of color, while the same footage compressed with On2 will appear much smoother and preserve more detail.

 A great tool for comparing codec and encoding software quality is the Flash Video FAQ site put together by Roguish. It's located at: http://www.flashvideofaq.com/.

The VP6 codec also introduced support for alpha channels. This allows the Flash Video producer to seamlessly composite video on top of other elements inside a Flash movie or on top of elements in a web page. An alpha channel is a separate, grayscale layer of video that creates transparency in the video. Where there are white or light pixels, the video will appear transparent, and where there are dark or black pixels, the video will appear opaque.

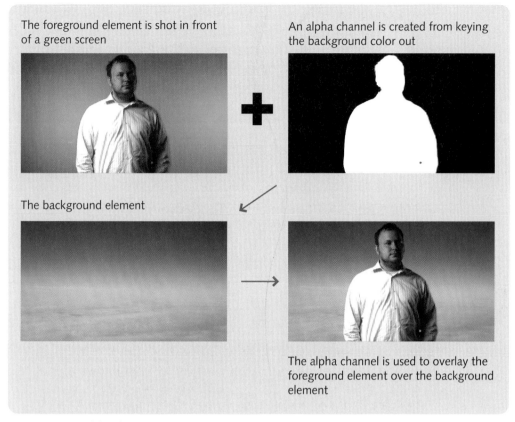

The foreground element is shot in front of a green screen

An alpha channel is created from keying the background color out

The background element

The alpha channel is used to overlay the foreground element over the background element

Figure 4.3: *Alpha Channels*

So the question people often ask is, "Which codec should I use?" In short, Sorenson Spark is the way to go when you want the greatest reach. The On2 VP6 codec is obviously the choice when you require better quality, increased size and performance, and more creative options. Or if you look at Adobe's published numbers on market penetration, simply use On2 VP6 because 93% of users have Flash Player 8 or above. The question then really becomes: Does the user have Flash Player 8 or Flash Player 9? Flash Player 9 offers ActionScript 3, which is significantly faster.

If you can identify your audience early in the game and what Flash Player the majority of them have installed, your decision becomes much easier.

Encoding Decisions

With your target bandwidth and player version known, it's time to look at the video you wish to deliver and analyze its:

1. **Pixel dimensions:** Is it standard definition (roughly 720 × 480) or high definition (1280 × 720 or larger)?

2. **Frame rate:** Is it 24, 25, or 30 frames per second (fps)?

3. **Aspect ratio:** Is it normal video with an aspect ratio of 4:3, or is it widescreen video with an aspect ratio of 16:9?

4. **Frame format:** Is it interlaced video with video fields interleaved to form a full frame or is it progressive video that has full frames of video?

5. **Content:** Does it have a lot of motion, fast cuts, and transitions?

Pixel Dimensions

Pixels (picture elements) are the tiny squares of color arranged on a two-dimensional grid that form an image. The aspect ratio of a single video pixel is its width relative to its height. One would imagine that video pixels would be perfectly square like the pixels on a computer screen. This could not be further from the truth! The NTSC and PAL digital video formats have rectangular (also referred to as non-square) pixels. A 4:3 NTSC video is 10% narrower than a computer's square pixel, whereas a 4:3 PAL video is roughly 7% wider than a computer's square pixel. These formats have rectangular pixels because of recent broadcast technology.

NTSC AND PAL VIDEO FORMATS
National Television Standards Committee (NTSC) is the video broadcast standard used in the United States, Canada, and Japan. Phase Alternate Line (PAL) is the video broadcast standard in Europe and parts of Africa and Asia. NTSC video plays at 29.97 fps at a resolution of 720 × 480 pixels. PAL video plays at 25 fps at a resolution of 720 × 576 pixels. Although NTSC has a slightly higher frame rate, PAL has slightly greater resolution and is closer to the frame rate of film, 24 fps. The two formats also have different pixel aspect ratios.

The frame rate of film is based on an integer—24. This is to say that the time base for film accurately correlates to real time. The frame rate for NTSC video, on the other hand, does not accurately correlate to real time because its frame rate is not based on a whole number. The frame rate for video is 29.97 fps. This discrepancy originated when color television was introduced in the United States. Black-and-white television broadcasts ran at a whole frame rate of 30 fps. When color was introduced to the broadcast signal, the frame rate had to be adjusted to maintain compatibility with the black-and-white standard to keep the picture and sound synchronized. As a result, running video at 29.97 frames per second without dropping frames does not correspond to real time—in one hour, there is a difference of 108 frames between 29.97 non-drop-frame video and real time. Dropping, or not counting, a pair of frame numbers every 66 seconds and 20 frames keeps NTSC video in step with real time.

NTSC video used to be 640 × 480 or 648 × 486. In the 1990s, the NTSC D1 video standard was defined to be 720 × 486. By packing more discreet blocks of resolution, more detail was made available. When DV and DVD were defined, however, 720 × 480 was considered preferable to 720 × 486 mostly because the compression algorithms used in DV and DVD rely upon DCT compression algorithms, which work on 858 pixel blocks.

Large frame sizes require higher bit rates and are larger in file size. When video contains detail that is crucial to the viewer's understanding, crop the video to focus on the important area, because shrinking the entire image down makes it practically worthless. Interviews, or "talking head" video, can be much smaller since the framing is usually tight on the subject and the audio is usually more important than the image. Video shot using a high-definition (HD) camera will look better. HD resolutions are either 1280 × 720 or 1920 × 1080.

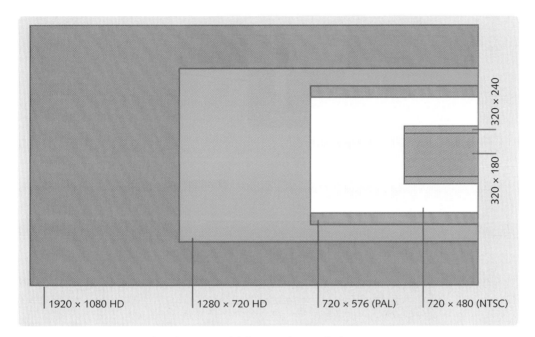

Figure 4.4: *Comparing the relative size of different video standards.*

Frame Rate

Frame rate is the number of frames shown per second. Higher frame rates create smoother motion but also larger file sizes, because there are more frames to compress and higher bit rates are required. It is recommended that you work in multiples of the source's original frame rate. For example, with 24 fps video, you can consider encoding at 24, 12, 8, or 6 fps, and with 30 fps video, you can consider 30, 15, or 10. When there is little motion in the video (such as talking head video), you can often get away with lower frame rates because the sound is often more important than image.

Aspect Ratio

Nearly all NTSC and PAL video is created with a 1.33 aspect ratio. This aspect ratio is referred to as the "standard" because it has been used for decades. Moving forward to today, most plasma and LCD televisions that support high-definition video

have a 16:9 or a 1.78 aspect ratio. This aspect ratio is referred to as "widescreen" because it is closer to film aspect ratios.

With the Mini DV and DVD-Video standards, standard-definition (SD) video can also have a 16:9 aspect ratio. Shooting 16:9 also gives you more of a film look, and in the future, when televisions are mostly 16:9 rather than 4:3, your footage won't be pillar-boxed, with black bars on both sides of the frame, which is how 4:3 footage is fit into a 16:9 display. Video footage at 16:9 is created by a video camera with a native 16:9 CCD or with an anamorphic lens adapter. The anamorphic process compresses the video image horizontally to a 4:3 video file that is stored on tape. During the capture process, you flag the video as anamorphic and the nonlinear editor (NLE) stretches the video back to the 16:9 aspect ratio during playback.

With Flash Video, you need not worry about action and title-safe margins because computer displays do not have underscan and overscan issues. This also means you can crop video to best suit your design or material. You may, however, want to use one of the standard aspect ratios if you are going after a specific look.

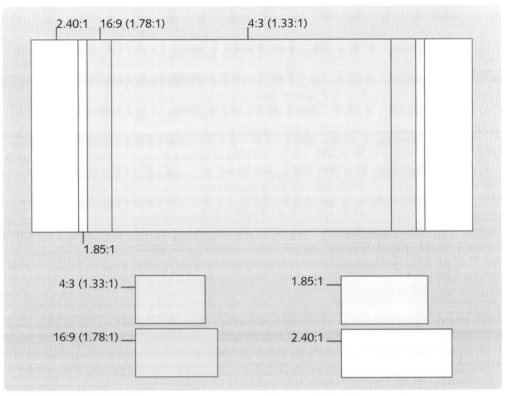

Figure 4.5: *Common aspect ratios used in film and television production.*

Interlaced and Progressive Frames

The largest drawback for NTSC and PAL video from a production and aesthetic standpoint is that their playback is interlaced. Video has been interlaced since the beginning of television. Three factors determined the frame rate for NTSC video: bandwidth constraints, AC current, and the introduction of color television.

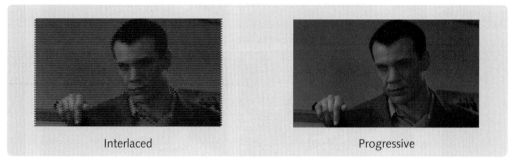

| Interlaced | Progressive |

Figure 4.6: *Interlaced and progressive footage.*

The initial goal for television was to have the frame rate be 60 fps, which easily produces an image without flicker. 60 fps was also chosen because it matches the frequency of AC electrical current, which is 60 hertz or cycles per second. Since cathode ray tube (CRT) televisions rely upon electricity to a great degree, having the timing of the display match the electrical current simplifies a lot of things.

Unfortunately, broadcasting 60 fps consumed too much bandwidth, and thus the engineers went back to the drawing board and came up with the method known as interlacing. Interlacing is the process of splitting each frame into two separate fields. Each field contains half of the vertical resolution of the original frame. It's as if the image is sliced horizontally into many layers, and the even slices create one field and the odd slices create the other. Since each field has half of the original resolution, it occupies half the bandwidth, and since the image is refreshed 60 times per second, flicker is not as noticeable. NTSC video is broadcast at 29.97 fps or 59.94 fields per second. PAL video is broadcast at 25 fps or 50 fields per second. The Europeans went for consistency with their film production methods, which call for film to be shot at 25 fps and to match the AC current in European countries, which is 50 hertz.

While interlacing saves transmission bandwidth and produces smoother motion due to its higher recording rate, it produces a less detailed image than progressive video. Interlaced fields are interleaved and recorded 1/60 of a second apart from one another. This shakiness is most noticeable when freezing on a frame of interlaced video of a quick motion like a bouncing ball. Before cameras such as the DVX100 and the XL2, most SD video cameras produced interlaced footage. With these new cameras, progressive footage can be shot and is better for film outs, blue screen and green screen compositing, and compression for DVD and streaming video.

To produce better Flash Video, shoot using a progressive frame rate wherever your camera supports it. It will compress better and faster since you will not have to de-interlace it. If you shoot in 24p mode, which is 24 fps, your video will be 20% smaller than if you shot at 30 fps. If you shoot interlaced video during production, be sure to de-interlace it before encoding to Flash Video.

24P VIDEO

The 24p format satisfies the needs of both those going to film and those requiring progressive footage for more efficient streaming video.

The majority of low-cost 24p cameras shoot in both interlaced and progressive modes. Interlaced footage is shot at 59.94 fields per second, or if you prefer to refer to the footage in frames, 29.97 fps. Progressive footage is shot at 29.97 fps or 23.976 fps. In either mode, video is captured progressively at 24 fps. Pulldown is then applied in the camera to convert the frame rate from 24 fps to 29.97 fps before being recorded to tape. The cameras offer two methods for applying pulldown: 24p standard and 24p advanced.

24p Standard

The 24p standard mode applies the same 3:2 pulldown cadence used when film is processed by a telecine for television broadcast. This mode is fine for video intended to be broadcast, but if this is not your goal, you are better served by shooting in the advanced mode. Despite offering the smoothest conversion between 29.97 and 23.976 fps, the integrity of the original progressive frames is sacrificed for compatibility with 29.97 material. Looking at the cadence diagram makes this more evident. The standard mode compromises the integrity of every third frame in the original progressive source because the original progressive frame has to be recreated by recombining fields from two interlaced frames. This is not as clean as the advanced mode because both frames have to be decompressed and then recompressed to create the third frame.

24p Advanced

The 24p advanced mode employs a pulldown method of 2:3:3:2. As with the standard mode, or 3:2 pulldown, the cadence begins by recording one frame onto two fields and the second frame on three fields. Instead of recording the third frame onto three fields, it is recorded onto two fields, and the fourth frame is recorded onto two fields. When the original frames are mapped to fields, the pattern is AA BB BC CC DD. Now the excitement around the advanced mode is that this cadence faithfully encodes the full progressive frames into an interlaced signal. The advance mode's cadence, 2:3:3:2, is subtly different than the standard pulldown of 2:3:2:3. This difference in rhythm allows for all the original frames to be recovered intact from single interleaved 60i frames. An NLE that understands the mode's pulldown pattern throws away the "23" frame and uses the remaining frames to restore the original progressive footage.

Frame Content

In order for active video (think sports, dance, or action scenes) to look good encoded, great care is required in the encoding process. This is simply because active video has more detail to preserve across multiple frames. By contrast, simpler video, such as a talking head against a stationary background, requires less care since there's less new detail in each successive frame.

To make active video look good, the encoding will often employ a higher bit rate, two-pass encoding, and variable bit rate encoding. The first method makes the

video larger since more bits per second add to the encoded video's file size. The second two methods can reduce the final size while improving overall quality, but they both increase the time to encode the video and sometimes they're not available in the encoding software. Two-pass encoding means the encoder looks at the video twice so it's bound to take longer. Variable bit rate encoding takes longer because the encoder has to more efficiently pack the video based on the current level of detail and the budgeted bit rate.

To help simplify the frame content, here are some things you can do during production: shoot using a tripod and limit handheld shots, light the subject evenly, set the proper exposure and white balance, and shoot in progressive mode if possible. In postproduction, use transitions and effects wisely and don't introduce intermediate compression steps.

Bit Rate

Bit rate is the amount of data (measured in bits or bytes) per second that the encoded video and audio require for smooth playback. The bit rate you choose is ultimately influenced by your audience's Internet access speed and the processing power of their computers, but it is also influenced by how you plan to deliver your video (via a streaming server, by progressive download, or by local playback on a DVD-ROM); the quality (inherent motion, frame size, and frame rate) of the video; and the quality of the audio (number of discreet audio channels and sample frequency). The more data footage occupies per second, the higher the quality and the slower it is to download. If the footage does not contain a lot of motion, you can choose a higher bit rate.

Voice-only recordings can also be heavily compressed if the original source audio was cleanly recorded. With good audio, you can encode a 64 Kbps mono audio track and everything will most likely be fine. If your soundtrack has important nature sounds or is showcasing a musical performance, however, you should devote more of the bit rate to the audio. In these cases, most viewers are willing to sacrifice video quality for better audio.

Constant and Variable Bit Rate

With the constant bit rate compression method, the data rate is held constant regardless of what is being compressed. Portions that do not require the full data rate waste space. Portions that require more than the full data rate suffer in quality. By contrast, the variable bit rate method analyzes content in multiple passes and varies the data rate based upon specified data rate targets. Portions that need detail are given the maximum amount of bandwidth, and less detailed sequences are given lower amounts. That all said, variable bit rate encoding is more efficient and tends to deliver better quality video but it takes longer to encode than constant bit rate encoding.

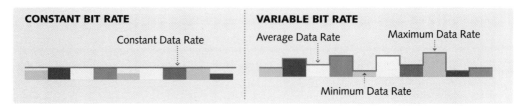

Figure 4.7: *Comparing constant and variable bit rates.*

Table 4.1: *Recommendations for choosing a delivery method based upon your video.*

Connection Speed	Width	Height	FPS	Keyframe Interval	Video Bit Rate	Audio Bit Rate
Source video includes a lot of motion, zooms, transitions, and action sequences						
1.5 Mbps (local area network)	320	240	30	60	750 Kbps	96 Kbps
768 Kbps (fast DSL)	320	240	30	60	575 Kbps	64 Kbps
384 Kbps (slow DSL)	320	240	30	30	340 Kbps	32 Kbps
56 Kbps (dial-up modem)	160	120	10	20	40 Kbps	8 Kbps
Source video includes little to no motion such as "talking head" video						
1.5 Mbps (local network)	320	240	30	60	650 Kbps	96 Kbps
768 Kbps (fast DSL)	320	240	15	30	230 Kbps	64 Kbps
384 Kbps (slow DSL)	320	240	15	20	150 Kbps	32 Kbps
56 Kbps (dial-up)	160	120	10	20	40 Kbps	8 Kbps

Disk Space and Bandwidth Quota

Disk space is the amount of data you can store on your web site at any given time. Network transfer is the amount of data your site can transfer per month. Both of these are set by your hosting provider as part of your hosting plan. While HTML and optimized graphics and Flash movies are fairly small, Flash Video can occupy a lot of space and can fill up your web site's disk space quickly. When thousands of users download videos from your site, once you have gone over the network transfer quota, your hosting provider may block additional visitors or charge you extra for any additional transfers. If you plan to serve a lot of video or if your site becomes very popular, you either will want to compress your video more or pay additional fees for a larger bandwidth quota.

Video Delivery Methods Supported by Flash Video

Flash Video supports three forms of delivering video: embedded, streaming, and progressive download. Embedded video should only be used for very short and

small video clips: usually no more than 10 seconds worth of video at thumbnail resolution (80 × 60 pixels, for example).

 Keeping FLV files external is considered a best practice since it offers better performance and memory management. External FLV files and the main SWF file can also have frame rates independent of one another.

Streaming Flash Video is delivered by sending the video directly to the desktop from a server equipped with the Flash Media Server. This machine is dedicated to streaming Flash content such as video. The server is suited for delivering video to many users simultaneously. If you cannot install a Flash Media server on your web site, Adobe has partnerships with a few Content Delivery Networks (CDNs) that are licensing Flash Video Streaming Services for streaming Flash Video; Akamai, VitalStream, and Mirror Image are a few. You may upload the FLV file to a server and use one of their skins or use a skin on your server that references the FLV on their server.

Progressive download is not to be confused with progressive video frames. With progressive downloads, the client computer downloads the video content from a web server. Progressive downloads are great when you don't have access to a Flash Media Server and simply want to put the files on your web site along with HTML, images, and other web documents.

Table 4.2: *Recommendations for choosing a delivery method based upon your video.*

Video	Embedded	Progressive	Streaming
is under 5 seconds	x	x	
is over 30 seconds but infrequent viewing		x	
is over 30 seconds and frequent viewing			x
requires instant start or playback			x
requires protection			x
is live video			x
is variable based upon visitor's bandwidth			x

Flash Video Encoders

There are now several convenient ways to encode Flash Video. This chapter covers the Adobe-provided encoding solutions.

1. **The Import Video Wizard in Flash Professional CS3.** It walks you through picking a video, setting compression options, and picking a skin (a user interface) for playing, pausing, skipping chapters, and adjusting sound.

2. **The Adobe Flash Video Encoder.** A stand-alone application for encoding a single file or a batch of video files. This utility can be installed separately on a dedicated video workstation.

3. **The Flash Video Encoding Settings Export Module for QuickTime.** This module is available to any product that supports QuickTime export modules such as Adobe After Effects, Adobe Premiere Pro, or Apple Final Cut Pro.

4. **Flix Standard and Flix Pro.** These are the encoders offered by On2, the developers behind the On2 VP6 codec available in Flash 8 and above. It has two-pass encoding and variable bit rate encoding.

5. **Sorenson Squeeze.** Sorenson Media created the Spark codec used in Flash Player 6 and above. Like Flix, it has two-pass and variable bit rate encoding.

 To learn more about these encoders, go to Adobe's Developer Center and read "Selecting a Flash 8 video encoder" by Elliot Mebane: http://www.adobe.com/devnet/flash/articles/selecting_video_encoder.html.

Flash Video Encoding Settings

When you run the stand alone Flash Video Encoder, you see a window with a table grid, several buttons, and a status area.

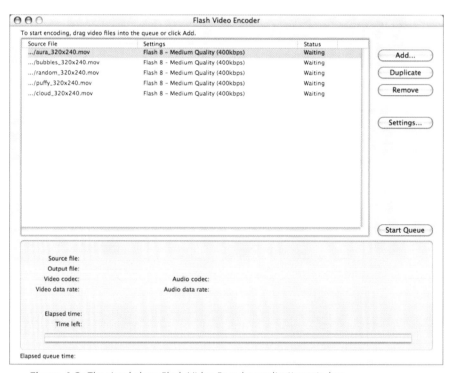

Figure 4.8: *The stand alone Flash Video Encoder application window.*

As you add videos to compress, they appear in the table that is referred to as the encoding queue. The queue has columns listing the source file name and location, the setting or encoding profile, and the encoding status. By default the medium-quality encoding profile is applied to each video clip. This window also contains:

1. **Add button:** This displays a Select dialog for choosing additional videos to add to the queue. Note that you can also drag and drop video files from a folder on your computer to the encoding queue.

2. **Duplicate button:** This does not physically duplicate the source video file. It duplicates the settings and facilitates creating different encoded videos from the same file. Typically you would create a high-bandwidth version, duplicate it in the list, and adjust the duplicate for lower bandwidth delivery or using a different codec. Sometimes you will want to experiment and try out different encoding settings for quality, performance, and size.

3. **Remove button:** This removes an instance from the queue. It does not remove the original source file from your computer.

4. **Settings button:** This button displays the encoding settings for the selected item.

5. **Start queue:** This starts the rendering process and renders the first item in the list and goes through the list until all items in the list have been encoded.

6. **Status group:** This shows up-to-date information while the Flash Video Encoder is processing clips.

The Settings Dialog

The Settings dialog is broken down into five tabs: Profiles, Video, Audio, Cue Points, and Crop and Resize.

Profiles

The Profiles tab lists the encoding profiles available inside the encoder. Profiles are preconfigured settings for video and audio compression, cue points, and crop and resize settings. The dropdown menu contains the default list of encoding profiles. Below the list of profiles is a summary of the currently selected profile. If you have altered any of the settings, the dropdown will display "custom" and the summary will reflect the changes you've made. To save the current encoding settings as a custom profile, click the Save button.

 Note that custom profiles do not appear in the dropdown menu. To use a custom profile, press the load profile button and select the profile from a location on your computer.

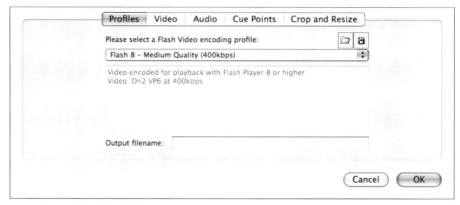

Figure 4.9: *The Profiles tab.*

Optimizing video for the Web shares similarities with optimizing graphics for the Web in that optimization presets (or in this case, profiles) are a great way to get started. You may find better results, however, in creating your own—especially if you need to custom sizes, cropping, or audio settings. My advice is to experiment with a few profiles, tailor them to your requirements, and apply them to the same video. You can then batch encode the variations and inspect the quality of each profile.

Video

Not surprisingly, settings for encoding the video are chosen in the Video tab. This tab also contains:

1. **Encode Video checkbox:** This enables video encoding for the file. Turn it off and there won't be a video track in the FLV file.

2. **Video codec:** Options are the On2 VP6 codec, which is supported by Flash Player 8 and above, or the Sorenson Spark codec, which is supported by Flash Player 6 and above.

3. **Encode alpha channel:** Only available for the On2 VP6 codec. This will encode and include an 8-bit alpha channel in the FLV file for compositing the clip over a background Flash movie. An alpha channel needs to be present in the source video file.

4. **Deinterlace:** New in Flash Professional CS3 is the ability to de-interlace video shot in interlaced mode (such as 60i or 50i). Turn this on when the video you are encoding is not progressive.

5. **Frame rate:** The frame rate for the movie. This defaults to the source's frame rate, but other rates are listed. Multiples of the frame rate works best.

6. **Quality:** Presets for the data rate field that controls bit rate and quality.

7. **Max data rate:** The higher the bit rate, the better the quality.

Chapter 4: Encoding Flash Video

8. **Key frame placement:** Automatic or custom. Automatic allows the encoder to pick the best interval for keyframes and custom allows you to pick the interval.

9. **Key frame interval:** The distance between unique frames. Lower numbers mean better quality but increase file size.

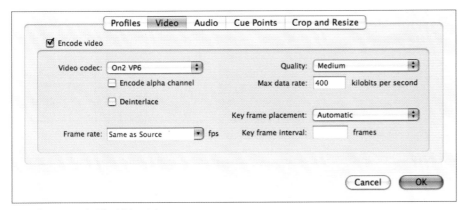

Figure 4.10: *The Video tab.*

Audio

The Audio tab operates like the Video tab in that there is a checkbox for encoding audio. If your source file has audio, this will be selected by default. Unchecking this will not include audio in the encoded FLV. If the file does not have audio, the controls in this tab are disabled. With Flash Video there is not a lot of choice when it comes to audio compression. The only audio codec available is MP3. The data rate pulldown menu lists the available data rates and stereo and mono combinations.

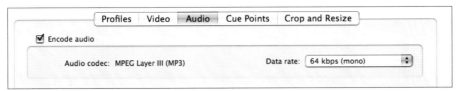

Figure 4.11: *The Audio tab.*

Setting Cue Points

Cue points are similar to chapter markers. A cue point marks a place in time and makes the point a destination that can be accessed by clicking a button or link, or it can be an event where ActionScript code is triggered. Setting cue points is done in the Cue Points tab of the Flash Video encoding interface. To set a cue point, position the playhead to a time in the video and press the Add Cue Point button. Cue points appear in the list and show the name, time, and type. To delete a cue point, select it and click the Delete button. The Save (folder icon) and Load (disk icon) buttons save and load the current list of cue points out as a file. This file can then be reimported later—handy if you have to encode the same clip again months later.

 The tutorial, Exporting Cue Points from an Existing FLV, *which is at the end of this chapter (see page 69), covers how to reclaim cue points from an encoded file in the case when the cue points were not saved as a list previously.*

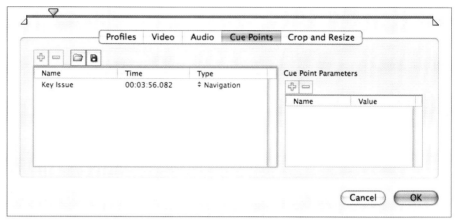

Figure 4.12: *The Cue Points tab.*

A cue point is a pointer to a specific time in a Flash Video file. Cue points facilitate navigation, synchronization, and interactivity. There are three types of cue points: ActionScript, navigation, and event.

ACTIONSCRIPT CUE POINTS

ActionScript cue points are added dynamically at run time via ActionScript. Since they are not added during the encoding process, dedicated keyframes are not created for them. This makes them less accurate. They are mentioned here merely for convenience.

NAVIGATION CUE POINTS

A navigation cue point, like a DVD chapter marker, is a destination to seek and navigate to. For example, a how-to video could have cue points for each instructional step. In most Flash Video interfaces, they are accessed via a next or previous chapter button, or a User Interface (UI) component that lists the video's existing navigation cue points.

During the encoding process, keyframes are created for each navigation cue point. By forcing a keyframe, viewers can more accurately access the time specified by the cue point. Cue points can be shown in a UI control once the metadata is fully loaded. Like event cue points, an ActionScript listener can respond to the occurence of a navigation cue point and trigger a function.

EVENT CUE POINTS

Like navigation cue points, event cue points are embedded in the FLV file during the encoding process. Since they are not exposed to navigational controls, they can be used exclusively for event-driven effects and interactivity.

For example, a video may need a cue point to show or hide a dynamic text field. If you used two navigation cue points to show and hide the text field, these cue points would also be accessible to the next and previous cue point buttons and would also show up in a list of cue points if there was one. This may not be desiraable if you want to keep your navigation cue points tidy. To work around this issue, you can place event cue points at times when you want to show or hide an element since they will not interfere with the navigation cue points.

While ActionScript can listen for and respond to either event or navigation cue points, event cue points should be used in cases where navigation cue points would be overkill.

Cue Point Parameters

All cue point types can have parameters. For those that are embedded, the encoding tools make it fairly easy to add parameters to individual cue points. Parameters are additional properties that can be added to a cue point. For example, a movie could have several cue points where each cue point has a list of parameters indexing the characters in each scene. It would then be possible to expose these parameters in a user interface. Parameters are added to a cue point by selecting the cue point and adding parameters to the **Cue Point Parameters** table, which is to the right of the cue point list.

Crop and Resize

Trimming allows you to set in and out points for the exported FLV. If you don't have an NLE on the machine on which you're encoding, or simply want to encode a known portion of video, this is the simplest way to encode a small portion of the source video.

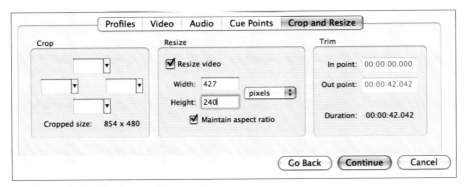

Figure 4.13: *The Crop and Resize tab.*

The cropping options work exactly like cropping a photograph in Photoshop. If you're encoding footage that has been letterboxed, you can use the crop options to remove the black bars that appear at the top and bottom of the frame.

The resize controls include an option to maintain the source material's aspect ratio, or its height to width ratio. This should remain checked unless your source material was shot anamorphic and that information is not available.

 When preparing video for distribution over the Internet, you do not have to worry about action and title safe areas that affect televisions. You can compose action and text close to the edges without fearing they'll be cropped off.

Encoding Tutorials

Tutorial: Encoding with the Import Video Wizard

The **Import Video wizard** in Flash Professional provides an efficient and simple interface for picking a video, encoding it, choosing a skin, and configuring the FLVPlayback component to properly play the video.

Figure 4.14: *The final video after using the Import Video wizard.*

1. Navigate to the **Tutorials > Chapter 4** folder. Copy the **Video Wizard** folder to your computer.

2. Open Flash Professional and choose **File > New**. Select **Flash File (ActionScript 3.0)** and click **OK**.

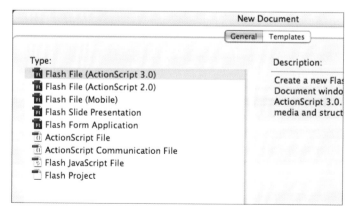

Figure 4.15: *Flash files for ActionScript 3 are the default document type.*

Chapter 4: Encoding Flash Video

3. Choose **File > Save** and save the file as **parkcity.fla** in the **Video Wizard** folder.

4. Select **File > Import > Import Video**. The first step in the wizard appears.

5. Select **On your computer** and click **Choose**. Select **festivalstreet.mov** in the **Video Wizard** folder and click **Select** (Windows) or **Open** (Mac OS X). Click **Continue**.

6. In the next step, select **Progressive download from a web server** (it should already be selected). Click **Continue**.

7. The Encoding step appears. Click the **Video** tab and adjust the **Max data rate** to **300** kilobits per second.

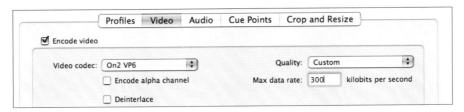

Figure 4.16: *Adjusting the video rate.*

8. Click the **Audio** tab and set the **Data rate** to **64 kbps (mono)**. Since the audio is merely background noise from the town, it's not that crucial.

Figure 4.17: *Setting the audio data rate.*

9. Click the **Crop and Resize** tab. The video is currently 854 × 480, which is too large for the video data rate set. Click **Resize video,** and with **Maintain aspect ratio** selected, change the height to **240** pixels. The width should update to **427** pixels and maintain the 16 × 9 aspect ratio.

Figure 4.18: *Resizing the video while maintaining the aspect ratio.*

10. Click **Continue**. The skinning step appears. In this step, you can pick from one of many skins with controls that reflect functional options you want to offer your audience or you can specify the URL for the skin file. In the **Skin** dropdown select **SkinOverPlayStopSeekFullVol.swf**. This skin offers play, pause, stop, seek, volume, and full-screen video controls.

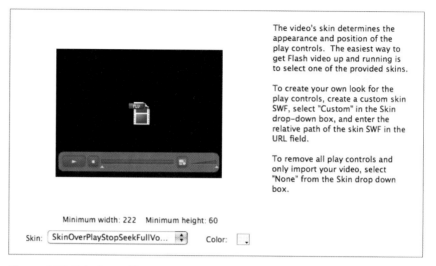

Figure 4.19: *Selecting a skin.*

11. Click the **Color** control, and set the **color** to **#CCCCCC** and the **alpha** to **50%**.

Figure 4.20: *Specifying the skin color and alpha (opacity).*

12. Click **Continue**. You should now see a summary of the encode settings. Click **Finish** and the **Flash Video Encoding Progress** dialog appears. It displays a status of how long the encoding will take. Since a name was not specified for the output file, it has the same name as the source file but with "flv" as its file extension. It is also saved in the **Video Wizard** folder alongside the original file. After the encoding is complete, the encoded file should be about 2.1 megabytes—a great reduction in size given the uncompressed version was close to 1 gigabyte!

 If we were to deploy this file to a web server, we wouldn't deploy the source file because it's not needed and it's incredibly bigger than the output file.

Figure 4.21: *The progress dialog displays a time estimate for the encoding process.*

13. When the encoding process is complete, you should see an instance of the FLV-Playback component on the stage. For best-practice purposes, we should give the instance a name. Select the component and in the **Properties Inspector** panel, name it **myFlvPlayback**. Naming the instance is important if the component will be used with ActionScript. Now would be a good time to set both the X and Y properties to 0 using the Properties Inspector panel too.

Figure 4.22: *Name the instance of the playback.*

14. More than likely, the size of the Flash movie and the video component are not the same size. In some cases this is fine, if there will be other content on the stage such as text, a logo, or other interface controls. In this instance, we simply want to publish the video and want the video to fill the stage. Select **Modify > Document**. The **Document Properties** dialog appears. Select the **Contents** radio button in the **Match** radio button group. This will quickly match the dimensions of the Flash file to the size of the FLVPlayback component.

Figure 4.23: *Matching the size of the file.*

15. Preview the movie by choosing **Control > Test Movie**.

Tutorial: Batch Encoding Several Clips

Given the time it takes to encode a single video, batch encoding is a must-have feature when you're frequently producing a lot of Flash Video. It allows you to select several files to encode, specify the settings, and have the software do the work while you have lunch, accomplish other tasks, or take a nap. In fact, many will batch process videos at night if they only have one machine while others will dedicate a machine to encoding.

1. Navigate to the **Tutorials > Chapter 4** folder. Copy the **Batch Encoding** folder to your computer.

2. Launch the **Adobe Flash Video Encoder**. It's a stand-alone application that is included with Flash Professional CS3.

Figure 4.24: *The application icon for the stand-alone Flash Video Encoder.*

3. Now it's time to add the videos we'd like to encode. Click **Add** in the main application window. Navigate to the **Batch Encoding** folder and select and open all the files.

Figure 4.25: *To add files to the queue, click Add.*

 You can also add files to the encoding queue by dragging files from the operating system to the Flash Video Encoder's main application window.

4. Now you could select individual files and adjust their encoding settings like the previous tutorial. Rather than covering the same ground again, let's start a batch encoding process using the default "Medium Quality" settings. Click **Start Queue** and the status area at the bottom of the window will indicate to you when the files are completely rendered. When a file has completely rendered, a green check appears in the **Status** column for each file.

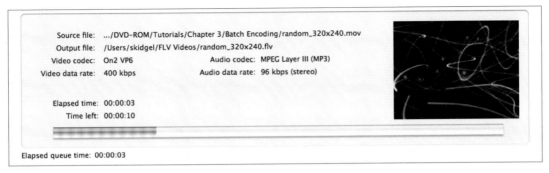

Source file: .../DVD-ROM/Tutorials/Chapter 3/Batch Encoding/random_320x240.mov
Output file: /Users/skidgel/FLV Videos/random_320x240.flv
Video codec: On2 VP6 Audio codec: MPEG Layer III (MP3)
Video data rate: 400 kbps Audio data rate: 96 kbps (stereo)

Elapsed time: 00:00:03
Time left: 00:00:10

Elapsed queue time: 00:00:03

Figure 4.26: *The status area displays progress and a preview of the current frame.*

Tutorial: Setting Cue Points

Cue Points are set in the Cue Points tab in the Flash Video Encoder. If you are working with long form material and need to provide navigation or synchronized interactivity, you will work in this part of the application probably more than you thought you would. The following tutorial gets you acquainted to how this works and suggests a few workflow enhancements. Following the tutorial is another helpful tutorial on extracting cue points from an existing Flash Video file in the event you need to encode the original material again but you don't have a cue point list.

1. Navigate to the **Tutorials > Chapter 4** folder. Copy the **Setting Cue Points** folder to your computer.

2. Launch the **Adobe Flash Video Encoder**.

3. Click **Add** and navigate to the **Setting Cue Points** folder. Open **gemini.mov**.

4. Select the file in the queue and click **Settings**.

5. Click the **Cue Points** tab.

6. Move the **playhead** until the current time is **00:00:03.504**.

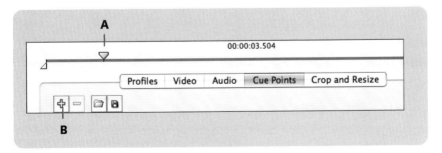

Figure 4.27: *(A) Playhead, (B) Add Cue Point button.*

7. Click the **Add Cue Point** (looks like a plus symbol) button and name it **ship**. Enter the name for the cue point in the table cell under the **Name** column.

8. Set the cue point type to navigation. Click the cell under the **Type** column and choose **Navigation** from the pop-up menu.

9. Set the remaining cue points according to the following screen capture.

Name	Time	Type
ship	00:00:03.504	↕ Navigation
helicopter	00:00:05.839	↕ Navigation
landing	00:00:17.768	↕ Navigation
recovery	00:00:20.354	↕ Navigation
capsule	00:00:22.731	↕ Navigation

Figure 4.28: *Names and time locations for the remaining cue points.*

To move the playhead more precisely, press the left and right arrow keys with the playhead selected. To move the playhead by ten-thousandths of a second, press Shift and one of the arrow keys. Pressing an arrow key down for a period of time will speed the seek substantially.

10. Click **OK** to apply the cue points. Click **Start Queue** to encode the file.

 In Chapter 9, we'll cover a few tutorials that will take advantage of the cue points set in this movie.

Tutorial: Exporting Cue Points from an Existing FLV

The following tutorial resulted from a problem I encountered while working on a project. I had encoded three 20-minute videos for a client and each video had several cue points. Originally I had encoded at a lower bit rate but the client felt a higher bit rate would be okay. Unfortunately, I didn't have a batch list or a cue point list file saved for any of the videos and I didn't want to enter all the cue points again by hand.

My solution was to write a few lines of ActionScript to trace all of the cue points in a video file. After a video had played through to the end, I would copy the trace statements from the Output panel, paste them into a text editor, and save it as an XML file that I could load in the Flash Video Encoder.

Figure 4.29: *Viewing the XML generated by the video's cue points in the Output panel.*

Chapter 4: Encoding Flash Video

1. Navigate to the **Tutorials > Chapter 4** folder. Copy the **Cue Points to XML** folder to your computer.

2. Open the file, **TraceCuePoints.fla** in the **Cue Points to XML** folder.

3. Preview the movie by choosing **Control > Test Movie**. Look at the text generated in the **Output panel.** Close the **Preview** window.

4. Select all of the text in the output panel and choose **Edit > Copy**. Launch the text editor of your choice and choose **Edit > Paste**. Save the file as **gemini_cuepoints. xml** in the **Cue Points to XML** folder.

5. To use this file, launch the **Adobe Flash Video Encoder**. Add the uncompressed movie, **gemini.mov,** that was used in the previous tutorial. It's in the **Tutorials > Chapter 4** folder on the book's DVD-ROM if you skipped over the last tutorial.

6. Click **Settings** and click the **Cue Points** tab. Click the **Load** button, 🗀, above the cue point list and navigate to **gemini_cuepoints.xml.** All the cue points appear in the cue point list. Feel free to encode the file if you wish.

7. Returning to Flash Professional, select the first frame in the **Actions** layer and open the **Actions** panel (**Window > Actions**). Below is a walkthrough of the code.

 The script begins by creating a new video object and adding it to the stage:

```
var myVideo:Video = new Video();
addChild (myVideo);
```

 It then creates an object that will handle the cue point events.

```
var customClient:Object = new Object();
customClient.onCuePoint=cuePointHandler;
```

 The following six lines are typical of bare-bones ActionScript code for video. It creates NetConnection and NetStream instances to load video into the movie and connects the custom client created earlier with the video.

```
var nc:NetConnection = new NetConnection();
nc.connect (null);
var ns:NetStream = new NetStream(nc);
ns.client=customClient;
myVideo.attachNetStream (ns);
ns.play ("gemini.flv");
```

This function traces information each time a cue point occurs as structured XML that the Flash Video Encoder can read.

```
function cuePointHandler (infoObject:Object):void {
    trace ("<CuePoint>" + "\n" + "   <Time>" + (infoObject.time*1000) + "</
Time>" + "\n" + "   <Type>" + infoObject.type + "</Type>" + "\n" +
"   <Name>" + infoObject.name + "</Name>" + "\n" + "</CuePoint>" + "\n");
}
```

This event listener listens for the beginning and end of the video and generates the XML required at the beginning and end of the XML file.

```
ns.addEventListener (NetStatusEvent.NET_STATUS, statusHandler);
function statusHandler (event:NetStatusEvent):void {
    switch (event.info.code) {
        case "NetStream.Play.Start" :
        trace("<?xml version=\"1.0\" encoding=\"UTF-8\" standalone=\"no\"
?>" + "\n" + "<FLVCoreCuePoints>" + "\n");
        break;
        case "NetStream.Play.Stop" :
        trace ("</FLVCoreCuePoints>");
        break;
    }
}
```

Wrapping Up

While some may argue that encoding Flash Video is the least creative process of authoring Flash Video, it's crucial to producing high-quality video, and it's not only about transcoding video from one codec to another. Creating cue points and cue point parameters as well as preserving an alpha channel occur at this time.

CHAPTER 5

...

Customizing
Flash Video Players

Using the stock FLVPlayback component is sufficient for most applications. However, there are times when you want to change their appearance or build your own player best suited to your needs.

Custom Player Development

In this chapter, we're going to write three custom Flash Video players. We'll start off simple and create a Flash Video banner. We'll architect the banner so it can be flexibly deployed in different web pages. Next we'll create a custom player using the FLVPlayback custom controls. We'll skin the custom controls and hook everything up using ActionScript. We'll add a few additional controls such as a timecode display and the ability to toggle the size of the video. Lastly, we'll create a player from scratch without using the components. We'll write methods to play, pause, and toggle full-screen playback. By the end of the chapter, you'll have a decent grab bag of knowledge and tricks when working with video, cue points, full-screen events, and timing.

 As with any tutorial covering a lot of code, it's crucial that you double-check for typos and use the naming suggested in the book. If things don't compile correctly, check the completed tutorials to double-check your work.

Tutorial: Creating a Flash Video Text Banner

In this tutorial, we'll create a Flash movie that accepts two external variables, a location for a Flash Video file, and text to draw over the video. Then this movie will be embedded as the banner at the top of several web pages.

Figure 5.1: *A web page with the Flash Video and text banner.*

1. Navigate to the **Tutorials > Chapter 5** folder. Copy the **Video Banner** folder to your computer.

2. Open Flash Professional and choose **File > New**.

3. In the **New Document** dialog, select **Flash File (ActionScript 3.0)** and click **OK**.

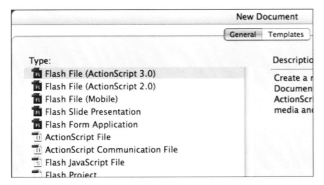

Figure 5.2: *The New Document dialog.*

4. Select **Modify > Document**. Set the dimensions to **766 × 72** and the movie's background color to **black**. To set the background color, click the color picker, ▇, and pick black from the pop-up color swatch control. Click **OK**.

5. In the **Timeline** panel above the stage, double-click the first layer, **Layer 1**, and rename it to **Actions**. Lock the layer by clicking the area below the **Lock** icon.

Figure 5.3: *Double-click the layer (A), rename it "Actions" (B), and lock the layer (C).*

6. Create two additional layers below the Actions layer and name them **Text** and **Video**. To create a layer, click the **Insert Layer** button.

Figure 5.4: *Click the Insert Layer button to insert the Text and Video layers (A).*

7. Select the **Text** layer. Choose the **Text** tool, T, and double-click the stage to create a text object. Don't worry too much about placement and size—we'll fix that next.

8. With the text object selected, modify its properties using the **Properties** panel. Change the text to a **Dynamic Text** field, set the name to **bannerTxt**, and set the width, height, and x and y positions to the values indicated in the following screenshot.

Figure 5.5: *The Properties panel.*

9. Pick a nice font on your system. In this example, I'm using Myriad Pro, which is installed as part of the Creative Suite. To embed the font in the Flash movie, click **Embed** and select both **Punctuation** and **Basic Latin**. **Control-click** (Windows) or **Command-click** (Mac OS) to select both. Click **OK**.

Figure 5.6: *Punctuation and Basic Latin is fine for Western languages.*

10. Set the font size to **24 point**, and the **font color** to **white**.

11. Lock the **Text** layer and select the **Video** layer.

12. Choose **Window > Library**. Click the **Panel Options** button, which is on the right-hand side of the tab area. Choose **New Video** from the menu.

Figure 5.7: *Click the Panel options button (A) and select New Video (B).*

13. In the **Video Properties** dialog, name the video object **backgroundVideo** and select **Video (ActionScript Controlled)**.

14. Drag an instance of the **backgroundVideo** movie clip from the **Library** panel to the stage.

Chapter 5: Customizing Flash Video Players

15. In the **Properties** panel, give the instance the name, **bgVideo**, and use the Prop-
erties panel to adjust it's properties to those shown in the following figure.

Figure 5.8: *Set the video object, bgVideo, to have the same dimensions as the Flash movie.*

16. With everything in place, it's time to write the ActionScript. In the **Timeline**, select
Keyframe 1 in the Actions layer, and open the **Actions** panel by pressing **F9** (Win-
dows) or **Option+F9** (Mac). If the panel is not large enough for coding, you should
resize and position it so coding is easier.

17. We first need to create a network connection between the Flash movie and the
video. To do that, we create an instance of the **NetConnection** class and we'll call
it **nc**. Using **nc** as the instance name for the NetConnection instance, by the way,
is fairly common practice. The **connect()** method is used when connecting to
a Flash Media Server. Since this example is using progressively downloaded video,
we turn this property off by passing **null** as its setting.

```
var nc:NetConnection = new NetConnection();
nc.connect(null);
var ns:NetStream = new NetStream(nc);
```

18. We then create a **NetStream** object, **ns**, and associate it with the **nc** NetConnec-
tion object. We then pass the **ns** object into **bgVideo**, the video instance on the
stage. Setting the source for **ns** is the last thing we do. In this case, we're setting it
to a **FlashVar**, **pageVideo**, that we will set in the HTML code. By doing this, we
can reuse this Flash movie as much as we'd like since we're not hard-coding the
video location into the movie.

```
bgVideo.attachNetStream(ns);
ns.play(root.loaderInfo.parameters.pageVideo);
```

19. The first line in the next code block automatically resizes the left edge of the text field, **bannerTxt**, to fit the text we'll pass in. The remaining code is a conditional statement that tests to see if we set the **pageHeader** FlashVar in the HTML. If it wasn't set, it will display a message reminding you to set it, and if it was set, it's used for the text we'll see on top of the video.

```
bannerTxt.autoSize = TextFieldAutoSize.LEFT;
if (root.loaderInfo.parameters.pageHeader == undefined) {
  bannerTxt.text = "Set the pageHeader flashVar in the HTML code.";
} else {
  bannerTxt.text = root.loaderInfo.parameters.pageHeader;
}
```

20. Compile the movie by pressing **Ctrl+Enter** (Windows) or **Command+Return** (Mac OS). You won't see any video play, but you will see the reminder to set the Flash-Var. This is actually okay. The real text and video location are set in the HTML page.

21. In **Windows Explorer** or the **Mac OS Finder**, open the **Video Banner** folder where the files are for this tutorial. You'll see a file named **header.swf**. This is the compiled version of the Flash document we'll reference in the HTML file, **index.html**.

22. Open **index.html** in the HTML editor of your choice. Dreamweaver, NotePad, TextMate, or BBEdit are all excellent choices. On lines 27 and 28, enter the following two lines of code and save the file. These two lines set FlashVars for the Flash movie. The first sets the text to use in the banner and the second sets the source location for the Flash Video behind the text.

```
so.addVariable("pageHeader", "About Us");
so.addVariable("pageVideo", "video/waves.flv");
```

In this example, we're using SWFObject, a JavaScript library for embedding Flash. We'll learn more about embedding Flash in HTML pages in Chapter 6.

23. Save the changes to index.html and preview it in a browser. You should see "About Us" and a short video animation in the banner.

This tutorial covered the basic building blocks for working with Flash Video without a component. The NetConnection and NetStream classes are the real workhorses of any Flash Video project that doesn't rely upon the FLVPlayback component.

Tutorial: Skinning the FLVPlayback Component

The FLVPlayback component is an amazing piece of engineering. The problem most designers have with it though is that they don't like the default skin, Corona. Maybe it looks too dated, screams a canned look, or doesn't has the Web 2.0 panache they're looking for. Whatever the reason, Adobe provides a set of independent playback controls that work with the FLVPlayback component that can be heavily customized. You can quickly add the custom playback components to the stage and open the component parts in the Library panel and change the shape, color, and size for each control.

This tutorial covers creating a custom video player with:

- A button that toggles between play and pause.
- A Stop button for halting playback.
- A buffering bar that indicates download progress and a seek bar to move the playhead to different locations in the video.
- Timecode text for the current time as well as total time.
- An audio mute button.
- A control that toggles between scaling and cropping the video to fit the window or maintaining the aspect ratio for the video.
- A control for entering full screen.

Figure 5.9: *A customized FLVPlayback player in normal (A) and full-screen mode (B).*

 The fully chromed FLVPlayback skins can also be customized. To skin these, go to your Flash application folder and look inside Configuration > FLVPlayback Skins > FLA. There are versions for both ActionScript 2 and 3.

Part 1: Adding Components to the Stage

In this first part of the tutorial, we will add all the elements required for the player to the stage. The tutorial will cover naming component instances, embedding fonts, and sizing controls.

1. Navigate to the **Tutorials > Chapter 5** folder. Copy the **Custom Player (Components)** folder to your computer.

2. Open Flash Professional. Choose **File > New** and create a new **Flash File (ActionScript 3)**. Save the file as **customplayer.fla** in the **Custom Player (Components)** folder.

3. Select **Modify > Document**. Set the dimensions to **480 × 406** pixels.

4. For this player, several layers need to be created for structuring the player's bezel, controls, and video. Create them according to the following screenshot.

Figure 5.10: *The required layers for this custom player.*

5. A *bezel* is the background surface for controls. This bezel will have a light steely-gray gradient and will have rounded corners at the bottom and be squared off at the top. Click the **control bezel** layer in the **Timeline** to make it the active layer.

6. Select the **Rectangle Primitive** tool. It resides under the **Rectangle** tool. Draw a rectangle that fits the lower 20 percent of the stage.

Figure 5.11: *The Rectangle Primitive tool is new to Flash Professional CS3.*

7. With the rectangle still selected, adjust its height, width, and x and y properties to match the following screen capture. To specify different rounding for the bottom corners, deselect the Lock icon located between the entry fields for corner rounding. With the constrained rounding off, enter 0 for the top left and right corners and 5 for the bottom left and right corners. Finally, set the rectangle's stroke to a 1-pixel solid.

Figure 5.12: *The Properties panel.*

8. Now let's set the fill and stroke colors. With the rectangle selected, open the **Color panel** (**Window > Color**). Select the **Stroke Color** chip (Fig. 4.13 A), and enter **#999999** in its color field (Fig. 4.13 B). Then select the **Fill Color** chip (Fig. 4.13 C), and set its **Type** to **Linear** (Fig. 4.13 D). Select the start color for the gradient (Fig. 4.13 E) and set its color to **#FFFFFF**. Select the end color for the gradient (Fig. 4.13 F) and set its **Alpha** to **35%** and its color to **#CCCCCC**.

Figure 5.13: *Setting the colors for the stroke and fill.*

9. With the bezel created, lock the **control bezel** layer by clicking the area below the **Lock** icon. Now select the **controls** layer.

Figure 5.14: *Locking a layer*

10. Let's add the player controls to the stage. Open the **Components** panel (**Window > Components**) and open the **Video** category.

Figure 5.15: *The FLVPlayback custom components.*

11. Click-drag the following components to the stage: PlayPauseButton, StopButton, BufferingBar, SeekBar, MuteButton, and FullScreenButton. Use the following table and the **Properties** panel to name, scale, and position the components on the stage. The BufferingBar component should appear on top of the SeekBar component. If it isn't, select the BufferingBar and choose **Modify > Arrange > Bring to Front**.

Table 5.1: *Settings for the Player Components*

Component	Instance Name	X	Y	Width	Height
PlayPauseButton	playPausePlayback	13	372.5	24	24
StopButton	stopPlayback	42	376.6	16	16
BufferingBar	bufferPlayback	64	380	200	6
SeekBar	seekPlayback	64	380	200	6
MuteButton	mutePlayback	360	372.5	24	24
FullScreenButton	fullScreenPlayback	450	372.5	24	24

12. In the **Components** panel, open the **User Interface** category and drag a **Button** component to the stage. Position it between the **mutePlayback** and **fullScreenPlayback** buttons. Name the button **fitToStageButton** and set its x and x position to **422** and **372.5**, respectively. Set both the width and **height** to 24 pixels.

13. Clear the text from the button. We'll place an icon inside the button later. Select the button and in the **Parameters** panel (normally docked with the **Properties** panel), delete the text from the **Label** attribute.

Figure 5.16: *Clearing the text label from the button component.*

14. Lock the **controls** layer and select the **timecode** layer.

15. Now let's add a text field for the current time. As the video advances, this text field will update to show the current time. Select the **Text** tool and create a text box to the right of the **bufferPlayback** instance. With it selected, adjust its settings using the Properties panel. Set the text type to **Dynamic Text** and name the instance **currentTimeText**. Select **Trebuchet MS** as the font, set the size to **14**, and click the **Bold** icon. Using the **Color Picker** control, ■, in the **Properties** panel, set the color to **#000000** and the opacity to **70%**. The following screen capture shows the Properties panel and settings for this text field.

Figure 5.17: *Properties for the currentTimeText text field.*

16. To embed the font Trebuchet MS in the document, click **Embed** in the **Properties** panel and select both **Punctuation** and **Basic Latin**. **Control-click** (Windows) or **Command-click** (Mac OS) to select both. Click **OK**.

17. This player will also have a text field displaying the video's total time. Duplicate the **currentTimeText** text field and rename it, **totalTimeText**. Set its x position to **316** and y position to **375**. Set its font size to **12**. Finally set its color to **#000000** and opacity to **35%**.

18. Let's create some additional separation between the two timecode displays by adding a vertical rule between them. From the Tools palette, select the **Zoom** tool, 🔍, and click-drag a marquee in between the **currentTimeText** and **totalTimeText** text fields.

19. From the **Tools** palette, select the **Line** tool, ╲. In the **Properties** panel, set the stroke weight to 1 and the cap style to **Round**.

Figure 5.18: *Adjusting the Cap style.*

20. In the **Color** panel, select the stroke color and set the fill type to **linear**. Set the first color in the gradient to **#CCCCCC** and the last color in the gradient to **#666666**.

21. With the Line tool, drag a ling between the timecode fields. The line should be about 24 pixels tall and have an x and y position of **313, 376**.

Figure 5.19: *The vertical stroke separating the timecode text fields.*

22. Lock the **timecode** layer and select the **video** layer. Return the current zoom level to 100% by double-clicking the **Zoom** tool in the **Tools** palette.

23. From the **Components** panel, open the **Video** category and drag the **FLVPlayback** component to the stage. Name the instance **vidPlayback** and set the x and y position to **0, 0** and the width and height to **480 × 360**.

24. Remove the FLVPlayback component's default skin. Select the component, and in the **Parameters** panel set the **Skin** attribute to **None**.

Figure 5.20: *Setting the skin to None in the Parameters panel.*

25. Save the file by choosing **File > Save**. The player's visual design is not where it needs to be, but we'll soon change that as we begin to skin the components.

Chapter 5: Customizing Flash Video Players

Figure 5.21: *The Custom Player after placing all the controls.*

Part 2: Skinning the Components

Now it's time to skin the components. In this tutorial, we'll be using more of Flash Professional's design tools. If you haven't worked with them before, I'll provide enough information in the form of step-by-step instructions and screen captures to get you through the material. If you feel you need more guidance, seek out *The Focal Easy Guide to Flash* by Birgitta Hosea.

We'll also be working with the **Library** panel extensively, so I would recommend increasing the panel's width and increasing the width of the **Name** column because we will be working with folders within the Library panel that are significantly nested.

Figure 5.22: *A widened Library panel with a wide Name column.*

Skinning the Base Button Appearance

1. Choose **Window > Library** to open the **Library** panel. Select the **FLVPlayback Skins** folder and click the **New Folder** button, , at the bottom left of the Library panel. Create a new folder named _CircleButton inside the FLVPlayback Skins folder.

2. Let's create the round buttons. Rather than replace the contents of the _Square-Button folder, we'll create a new folder and set of movie clips to use as a basis for our buttons. Select the **_CircleButton** folder and choose **New Symbol** from the Panel options menu, ⌐≡, at the top right of the Library panel. Select **Movie Clip** for the type and name the symbol **CircleBgNormal**. This will be the "normal" or "up" state for a button.

3. The CircleBgNormal symbol should already be open. If it is not open, in the **Library** panel double-click **CircleBgNormal**. To facilitate button construction, create three layers: one for the **Stroke**, another for the **Highlight**, and a third for the **Fill**. The stroke should be the topmost layer and the file should be the bottommost layer.

Figure 5.23: *The layer structure for the circular buttons.*

4. Select the **Fill** layer and select the **Oval Primitive** tool, 🔾, from the **Tools** palette. Draw a circle that is 24 × 24 pixels and place it at 0, 0. Press and hold the **Shift key** while drawing with the **Oval Primitive** tool to constrain the shape to a perfect circle.

5. With the circle selected, open the **Color** panel, set the **stroke** to **none** (Fig. 4.24 A), select the **fill** (Fig. 4.24 B), and set the fill type to **Linear** (Fig. 4.24 C). Select the **start** color (Fig. 4.24 D) and set it to **#EEEEEE** (Fig. 4.24 E). Select the **end** color (Fig. 4.24 F) and set it to **#555555** (Fig. 4.24 G).

Figure 5.24: *The Gradient fill.*

6. Select the **Gradient Transform** tool from the **Tools** palette. It's grouped with the **Free Transform** tool.

Chapter 5: Customizing Flash Video Players

Figure 5.25: *The Gradient Transform tool.*

7. We'll rotate the gradient so it runs vertically with the light end on top and the dark end on the bottom. Click the circle and drag-rotate the **gradient's rotation handle** (Fig. 4.26 A) counter-clockwise from the lower-right corner to the upper-left corner (Fig. 4.26 B).

Figure 5.26: *Rotating the gradient.*

8. Lock the **Fill** layer and select the **Highlight** layer.

9. In the **Tools** palette, select the **Fill Color** control and choose **black** as the fill color. In a later step, we'll change the fill to a semi-transparent gradient, but for now a dark color will help with sizing, shaping, and positioning the highlight.

Figure 5.27: *Select black or enter #000000 for the fill color.*

10. Select the **Oval** tool, ⬭. Turn **Object Drawing** mode off if it is currently on. The button is in the **Tools** palette near the bottom. When this mode is on, it makes shape creation work like it does in Adobe Illustrator or Fireworks, which we don't

need for this shape. We'll use the default behavior for shaping the highlight, so Object Drawing mode is better turned off.

Figure 5.28: *Turn off Object Drawing mode.*

11. Rulers and Grids will help to draw these shapes. Turn on **Rulers** by selecting **View > Rulers**. Turn on **Grids** by selecting **View > Grid > Show Grid**.

12. Use the **Oval** tool to draw a circle that is **18 × 18**. Pick the **Selection** tool, , double-click the circle, select the lower two-thirds of the circle, and press **Delete**.

Figure 5.29: *Select the lower two-thirds of the circle.*

13. With the highlight shape selected, open the **Color** panel, select the **fill** (Fig. 4.30 A) and set the fill type to **Linear** (Fig. 4.30 B). Select the **start** color (Fig. 4.30 C) and set it to **#FFFFFF** (Fig. 4.30 D). Select the end color (Fig. 4.30 E) and set it to **#B3B3B3** (Fig. 4.30 F) and the **Alpha** to **35%** (Fig. 4.30 G).

Figure 5.30: *Adjusting the highlight's fill style and colors.*

14. Select the **Gradient Transform** tool from the **Tools** palette. We'll rotate the gradient so it runs vertically with the light end on top and the dark end on the bottom. Click the shape and drag-rotate the **gradient's rotation handle** (Fig. 4.31 A) clockwise

from the top-right corner to the lower-right corner (Fig. 4.31 B). Then select the gradient's scale handle (Fig. 4.31 C) and drag it to the bottom of the shape (Fig. 4.31 D).

Figure 5.31: *Adjusting the gradient direction and scale.*

15. Chose **Edit > Deselect All**. Select the **Selection** tool from the **Tools** palette. Move the cursor just below the highlight shape until the cursor changes to the reshape cursor, ▾. Click and drag the bottom part of the highlight shape up about 3 pixels until the shape is crescent-shaped.

Figure 5.32: *Reshaping the highlight.*

16. Move the highlight into place. Position it near the top of the circle. Use the following screen capture to help in positioning it.

Figure 5.33: *Positioning the highlight shape.*

17. Lock the **Highlight** layer. Unlock the **Background** layer, select the circle, and chose **Edit > Copy**. Lock the **Background** layer and select the **Stroke** layer. Chose **Edit > Paste in Place**.

18. In the **Color** panel (**Window > Color**), select the **Fill** color control and select **None** for the type. Then select the **Stroke** color control and select **Linear** for the type and choose **#999999** for the gradient's start color and **#717171** for the end color.

Figure 5.34: *The final button.*

19. Choose **File > Save**. Click **Scene 1** in the **Edit** bar to close the **CircleBgNormal** movie clip and return to the document's default scene.

Figure 5.35: *Use the edit bar to navigate within a Flash document.*

20. In the **Library** panel, duplicate the **CircleBgNormal** movie clip twice and rename one **CircleBgOver** (the "over" button state) and the other **CircleBgDown** (the "down" button state). To duplicate it, **right-click** (Windows) or **Control-click** (Mac OS) on the movie clip and choose **Duplicate** from the context menu.

21. In the **Library** panel, double-click **CircleBgOver**. The movie clip opens and occupies the stage and timeline. Since we duplicated the normal state, we have all the same layers—we just need to modify them visually.

22. Select the **Stroke** layer and then select the stroked circle on the stage. Change the stroke color using the **Color** panel to **#FF9900**.

23. Double-click the **CircleBgDown** movie clip. Lock the **Stroke** layer and unlock the **Fill** layer. Select the fill shape and using the **Color** panel reverse the gradient. Drag the start color to the middle, drag the end color to the start position, and then drag what was the start color (but is now in the middle) to the end. We now have the base shape for all the buttons.

Customizing the Playback Icons

The next several steps cover redrawing the icons used inside the FLVPlayback buttons. We'll redraw the shapes and then move the circular button into the appropriate movie clips. We'll then align and center the icons within the button.

 While you can follow the steps I've provided, feel free to simply copy and paste them from the finished FLA file, customerplayer.fla in Completed Tutorials > Chapter 5 > Custom Player (Components).

1. The icons used inside the buttons are filled with white, which we will be changing to black. To simplify editing, choose **Modify > Document** and set the document's background color to middle gray or **#999999**. Choose **View > Grid > Edit Grid** and set the horizontal and vertical units to **1**. This will create a tight grid that is excellent for checking pixel-level accuracy and drawing icons sized for the screen.

Figure 5.36: *Setting the document's background color to gray.*

2. In the **Library** panel, open the **FLV Playback Skins > Play Button > Assets** folder. Double-click the **PlayIcon** movie clip. Turn on **Object Drawing** mode in the **Tools** palette. Delete the shape and redraw it with the **Pen** tool according to the following screen capture. Set the fill color to **#333333**. The stroke should be set to **none**.

Figure 5.37: *Redrawing the play icon.*

3. Open the **FLV PLayback Skins > Pause Button > Assets** folder. Double-click the **PauseIcon** movie clip. Delete the existing shapes and use the **Rectangle** tool to redraw the icon according to the following screen capture. Each rectangle should be 3 × 8 pixels and about 2 pixels apart. When they are both selected, their combined x and y coordinates should be **0, 0**. Set the fill color to **#333333.**

Figure 5.38: *Redrawing the pause icon.*

4. Open the **FLV Playback Skins > FullScreen Button > Assets** folder. Double-click the **FullScreenIcon** movie clip. Delete the existing shapes and use the **Rectangle** and **Pen** tools to redraw the icon according to the following screen capture. Set the fill color to **#333333**.

Figure 5.39: *Redrawing the full-screen icons.*

5. Open the **FLV Playback Skins > Mute Button > Assets** folder. Double-click the **MuteOffIcon** movie clip. Delete the existing shapes and use the **Ellipse** tool to redraw the icon according to the following screen capture. Set the fill color to **#333333**.

6. Open the **MuteOnIcon** and redraw the icon according to the following screen capture. Set the fill color for all the shapes to **#333333**.

Chapter 5: Customizing Flash Video Players

Figure 5.40: *The mute off and mute on icons.*

7. Open the **PlayButtonNormal** movie clip in the **Play Button** folder. Select the **button** layer and delete the existing movie clip. Drag a copy of the **CircleBGNormal** movie clip from the **_CircleButton** folder to the stage. Position the new button shape at **0, 0**. Center the play icon shape over the button shape—set the x position to **8** and the y position to **7**.

8. Choose **Edit > Select All** and then choose **Edit > Copy**. Open the **PlayButtonDisabled** movie clip. Delete the contents of the icon and button layers. Select the **button** layer. Choose **Edit > Paste in Place**. Cut the **PlayIcon** movie clip and paste it to the icon layer (using Edit > Paste in Place).

9. Adjust the opacity of both movie clips using the **Properties** panel. Select each movie clip (Fig. 4.41 A) and then select **Alpha** (opacity) from the **Color** drop down (Fig. 4.41 B) and set the alpha value to **50%** (Fig. 4.41 C).

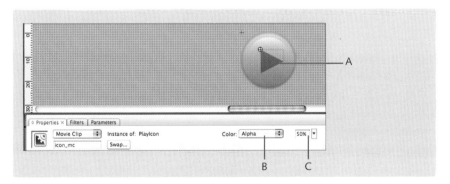

Figure 5.41: *Adjusting the opacity for the disabled state.*

10. Using the same set of steps, update the remaining two button states. Use **CircleBgOver** for the **PlayButtonOver** and **CircleBgDown** for **PlayButtonDown**. Once you have modified the play button, update the pause, stop, mute, and full-screen buttons using the same set of circle buttons with the redrawn icon movie clips. Customizing these buttons may take a while, but hang in there.

The Toggle Size Button

The toggle size button is not a native FLVPlayback component button like the play, stop, or full-screen buttons. That said, we will use an ActionScript 3 button component and simply copy and paste the circle button movie clips into the movie clip skins for this button. The icon we'll draw and assign using ActionScript, and we'll write the sizing code using sizing methods that were recently added to the new FLVPlayback component class.

1. When we added an ActionScript 3 button component to the stage, the application automatically added the assets for the component to the **Library** panel. They're in a folder named **Component Assets**. Open that folder.

Figure 5.42: *The Component Assets folder.*

2. Create a folder and name it **Fit Assets** inside the **Component Assets** folder. Create two empty movie clip symbols named **FitToStageOff** and **FitToStageOn**. These two symbols will be dynamically loaded into the fit-to-stage button. To facilitate the loading, both symbols need to be exposed to ActionScript as a class. In the **Symbol Properties** dialog, select **Export for ActionScript** and use the default class name, which is the same name as the symbol.

Figure 5.43: *Exporting a symbol for ActionScript.*

3. Open the **FitToStageOn** movie clip. Using the **Rectangle Primitive** tool, draw a rounded rectangle that is **15 × 12** pixels. Set the stroke color to **#333333** and the fill color to **#666666**. Set the corner radius to **2** and position the shape at **0.5, 0.5**.

Chapter 5: Customizing Flash Video Players

Figure 5.44: *The FitToStage icon.*

4. Select the shape and copy it. Now double-click the **FitToStageOff** movie clip. Choose **Edit > Paste in Place**. Remove the fill color by choosing the no-color swatch, 🔲, in the fill color picker control.

5. Draw a rectangle inside the larger rectangle that is **8 × 5** pixels. Position it at **4, 4**.

6. In the **Component Assets** folder open the **ButtonSkins** folder. We will now "port" the skin we created for the **FLVPlayback** components to the states for this button.

7. For each of these movie clips, turn off 9-slice scaling. You can do that by selecting the movie clip in the **Library** panel and clicking the **Properties** button, then at the bottom of the panel, clicking the **Advanced** button in the **Symbol Properties** dialog and deselecting **Enable Guides for 9-slice scaling**.

9-slice scaling uses two horizontal and two vertical guides to slice up a movie clip for proportional scaling. The four guides create nine regions that preserve the proportions of the four corners while scaling the remaining five middle areas to fit. For more information on 9-slice scaling, go to: http://www.adobe.com/go/vid0204 and http://www.adobe.com/go/vid0205.

8. Open the **Button_upSkin** movie clip and remove the contents. Open **CircleBgNormal,** copy its shapes, and paste them into the corresponding layers in the **Button_upSkin** movie clip.

9. Open **Button_selectedUpSkin**, drag an instance of **Button_upSkin**, and position it at **0, 0**.

10. Open the **Button_downSkin** movie clip and remove the contents. Open **CircleBgDown,** copy its shapes, and paste them into the corresponding layers in the **Button_downSkin** movie clip.

11. Open the **Button_selectedDownSkin** movie clip, remove the contents, drag an instance of **Button_downSkin,** and position it at **0, 0**.

12. Open **Button_overSkin,** remove its contents, and copy the corresponding shapes from **CircleBgOver** and paste them into **Button_overSkin.**

13. Open **Button_selectedOverSkin**, remove its contents, drag an instance of **Button_overSkin**, and position it at **0, 0**.

14. Open the **Button_disabledSkin** movie clip, remove the contents, drag an instance of **Button_upSkin** to the stage, and position it at **0, 0**. Set the **Alpha** property for the movie clip to 35%.

15. Open the **Button_selectedDisabledSkin** movie clip, remove the contents, drag an instance of **Button_downSkin,** and position it at **0, 0**. Set the **Alpha** property for the movie clip to **35%**.

Figure 5.45: *If you open the Button component in the Library, you'll see all the states.*

Skinning the Seek Bar

A seek bar displays the position of the current frame in relation to the video's duration. It also provides a way to move playback to any point of the duration by clicking in the seek bar or dragging the seek bar handle.

16. Open the **SeekBarProgress** movie clip. Delete the contents. Select the **Rectangle Primitive** tool. In the **Properties** panel, set the **Stroke** to **none** and the **Fill** to **Black**. Draw a rectangle that is **200 × 6** pixels and position it at **0, 0**. With the shape selected, change the corner rounding to **3.5** in the **Properties** panel.

Figure 5.46: *The seek bar shape.*

17. Use the Color panel (Window > Color) and set the Fill color to a **Linear** gradient. Use **#333333** as the start color and **#999999** as the end color.

18. Use the **Transform Gradient** tool to rotate and scale the gradient. The gradient should run vertically and the start (darker) color should be at the bottom and the end (lighter) color should be at the top of the shape.

Figure 5.47: *The gradient rotated and scaled.*

19. Open **CircleBgNormal** and copy the contents of all the layers at once (if necessary, unlock layers). Open the **SeekBarHandle** movie clip, delete the contents, and choose **Edit > Paste**. Group the collection of shapes by choosing **Modify > Group**. Scale the collection of shapes to **8 × 8** pixels and position it at **−4, −4**. This negative offset will center the handle vertically upon the seek bar.

Skinning the Buffer Bar

The buffer bar displays a "barber shop poll" animation when the streaming is delayed. In this case, we won't change the shape or animation. Instead we'll modify the color of the barber shop poll from nuclear day-glow green to a warm yellow.

1. In the **Library** panel, open the **BufferingPattern** movie clip in the **BufferBar** folder. The graphic is comprised of five groups. Each group consists of five diagonal shapes. Select the first group and choose **Modify > Ungroup**. With the shapes selected, set the fill color to **#FFCC00**. Choose **Modify > Group**. Repeat this for the remaining four groups.

2. Open the **Seek Bar** folder and double-click the **SeekBarProgress** movie clip. Copy the shape and then double-click the **BufferingBar** component in the **Library** panel. Look at the layers in the movie clip.

Figure 5.48: *The layer structure for the BufferingBar component.*

3. Select the mask layer and delete the contents inside it. Choose **Edit > Paste** and position the pasted shape over the pattern. The x and y position for the pasted shape should be **1, 1.4**. As a best practice, I like to fill shapes used as masks with red. Select the shape and set the fill to **#FF0000**.

Figure 5.49: *The mask shaped placed over the animated buffer pattern movie clip.*

4. When finished, click **Scene 1** in the **Edit** bar.

Figure 5.50: *To return to the player screen, use the Edit bar.*

5. The player should now look like the following screen capture. Choose **Modify > Document** to set the movie's background color back to white. Choose **File > Save**.

Figure 5.51: *The updated player.*

> [i] *If you're doing a double-take on the ActionScript 3 button component, don't be alarmed. It doesn't accurately show the updated skin at designtime. When the movie runs, it will load the correct skins.*

Part 3: Writing the ActionScript

Up to this point, we've laid out and customized the video player's interface. In this third section, we will connect code to the controls and add functionality missing from the component such as a timecode display and the scaling toggle.

1. Choose **File > New** and in the **New Document** dialog, select **ActionScript File**.

Figure 5.52: *Select ActionScript File from the Type list.*

2. Save the file as **CustomPlayer.as** in the **Custom Player (Components)** folder.

3. Document classes need to begin with the **package** statement. Enter:

```
package {
}
```

4. Inside the **package** statement, add the following five import statements:

```
import flash.display.MovieClip;
import flash.events.*;
import fl.controls.Button;
import fl.video.*;
import flash.text.TextField;
```

A Flash movie file with a timeline requires the **MovieClip** class to be imported. The **fl.events** class is used to listen for events triggered by interface controls. The **fl.controls.Button** class is needed for the scaling toggle button. The **fl.video** class contains the methods and properties for working with the **FLV-Playback** component. Lastly, the **flash.text.TextField** class is imported for the timecode text field.

After the import statements, add the class declaration:

```
public class CustomPlayer extends MovieClip {
}.
```

Note that the class name has to be the same name as the file name minus the file extension. A document class normally extends the **MovieClip** class. All of the methods and properties for this class have to reside within this declaration.

5. Choose **File > Save** to save your work.

6. Return briefly to the **customplayer.fla** file, and with nothing selected, show the **Properties Inspector**. Enter **CustomPlayer** in the **Document class** text field. This

associates the **CustomPlayer.as** with the timeline in this movie. Note that the ".as" extension is not needed.

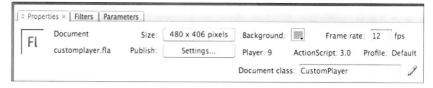

Figure 5.53: *Entering the Document class for the entire movie*

7. Save the file and then click the **Pencil** icon to the right of the **Document class** text field. This will switch to the **FLVPlayback.as** file.

ABOUT DOCUMENT CLASSES

A Document class is an external Action-Script class file that is paired with an FLA file. At compile time, the Document class in included with the compiled SWF. At run time, the Document class is constructed and run when the SWF's timeline is initialized.

Prior to ActionScript 3 and Flash CS3, the best practice was to place code in a layer named "actions" in the first frame. While this practice is better than having code sprinkled across movie clips, it still requires the code to reside in the FLA. When the code is inside the FLA file, quick reuse and version control is more difficult.

To set the Document class, make sure nothing is selected (choose Edit > Deselect All), and in the Property inspector for the Flash movie, enter the path and name of the class file in the Document class field or in the Publish Settings dialog (choose File > Publish Settings > Flash tab > Settings button).

To learn more about document classes, go to the Flash Developer Center on Adobe.com and read this article: http://www.adobe.com/devnet/flash/articles/flash9_as3_preview.html.

8. The next three lines of code create three variables for creating the timecode control.

```
private var currentTime:uint;
private var allTime:uint;
```

The video's current time is stored in the **currentTime** variable. This variable is declared as an **uint**, or an unsigned integer. An unsigned integer is essentially a positive number and requires less memory than a variable declared as a **number**. Likewise, the video's duration is stored inside the **uint** variable, **allTime**.

9. After the variables are declared, we need to write the constructor function. This is code that is automatically run when the document class is constructed by the Flash player. Add the following:

```
public function CustomPlayer () {
}
```

10. Inside the **CustomPlayer()** function (between the curly braces), enter:

Chapter 5: Customizing Flash Video Players

```
vidPlayback.playPauseButton = playPausePlayback;
vidPlayback.stopButton = stopPlayback;
vidPlayback.muteButton = mutePlayback;
vidPlayback.seekBar = seekPlayback;
vidPlayback.bufferingBar = bufferPlayback;
vidPlayback.fullScreenButton = fullScreenPlayback;
vidPlayback.fullScreenTakeOver = false;
```

The **FLVPlayback** component that we added to the stage in Part 1 is named **vid-Playback**. The first six lines of code are all that are required to connect the custom playback buttons and controls to the video. The last line in this code block will keep the interface controls on screen when the video enters full-screen mode.

11. We now need to set the source for the video. The file, **filmmakers.flv**, is located in the same directory as the **customerplayer.fla** file, so enter:

```
vidPlayback.source = "filmmakers.flv";
```

12. We can now test our efforts. Choose **Control > Test Movie**. You should see a video playing inside the player with several filmmakers briefly introducing themselves.

Figure 5.54: *The Flash Video Player running.*

You can play, pause, stop, mute the audio, and scrub with the seek bar. The timecode is not shown and you cannot enter full-screen mode. The timecode will be shown after we write two methods to populate the timecode text fields in steps 16 and 17. We could enter full-screen mode if the movie was playing inside a web page, so we'll test that at the end of the tutorial when we publish the movie and an HTML page with it.

13. One of the properties available to the **FLVPlayback** component is **autoRewind**. By setting it to **true**, the player will automatically rewind the video when the video reaches the end. To set it, enter:

```
vidPlayback.autoRewind = true;
```

14. Add an event listener to the video to listen for playhead updates:

```
vidPlayback.addEventListener (VideoEvent.PLAYHEAD_UPDATE, setTimeCode);
```

The **PLAYHEAD_UPDATE** occurs continuously as the movie plays. By listening to this event, we can keep track of the current time. The **addEventListner** method listens for the playhead to update, and when it does, it calls the **setTimeCode** method, which we will write shortly.

15. The button for scaling the video, **fitToStageButton**, is an ActionScript 3 component and has the **setStyle** method to add symbols or movie clips as an icon inside the button. Enter:

```
fitToStageButton.setStyle ("icon", FitToStageOff);
fitToStageButton.setStyle ("selectedUpIcon", FitToStageOn);
fitToStageButton.setStyle ("selectedOverIcon", FitToStageOn);
fitToStageButton.setStyle ("selectedDownIcon", FitToStageOn);
```

The **setStyle** method accepts two parameters: the button state in which to the use the icon and a named movie clip or symbol in the Flash document's Library to use as the icon.

16. The next three lines turn the button into a toggle button, select the button (toggles it on), and add an event listener.

```
fitToStageButton.toggle = true;
fitToStageButton.selected = true;
fitToStageButton.addEventListener (MouseEvent.CLICK, toggleFitToStage);
```

The ActionScript 3 button component has a property, **toggle**, that turns a button instance into a toggle button, a button that works like a switch. One click turns it on and another click turns it off. When the movie loads, **fitToStageButton. selected = true** runs and selects the button by default. The event listener listens for every time the button is clicked. When the **CLICK** event occurs, the **toggleFitToStage** method is called.

17. Place the cursor *after and outside* the entire **CustomPlayer** function. We will now write the first of three public methods for the class. Write the **setTimeCode** method:

```
public function setTimeCode (evt:VideoEvent):void {
    currentTime = Math.round(evt.playheadTime);
    allTime = Math.round(vidPlayback.totalTime);
    currentTimeText.text = timeCode(currentTime);
    totalTimeText.text = timeCode(allTime);
}
```

This method accepts an event of type **VideoEvent** as a parameter. The event is **PLAYHEAD_UPDATE**, which we wrote code to listen for in step 13. The method uses this event to set the **currentTime** variable to the **playheadTime** property. This property stores the playhead time in seconds. To simplify the processing, it's rounded to the nearest whole number using the **Math.round()** method, so instead of setting **currentTime** to 1.25, it sets it to 1. You may have also noticed that just before the opening curly brace, there is a colon followed by the keyword, **void**. Since this function does not return a value after it is executed, we use the **void** keyword.

The **allTime** variable is set in this method using the **FLVPlayback** component's **totalTime** property. This is a real convenience as it would normally require several lines of code to determine if we were not using this component. Similarly, **allTime** is rounded to the nearest whole number using **Math.round()**.

The next two lines of code set the text property of the two timecode text fields, **currentTimeText** and **totalTimeText**, to the result of passing **current-Time** and **allTime** to the **timeCode()** method.

18. The timeCode function is going to accept an input of milliseconds and return a nicely formatted timecode string, **tcString**. Let's begin writing this longer method by entering:

```
public function timeCode (theTime:uint):String {
}
```

The function statement for **timeCode()** accepts a parameter declared as an un-signed integer (uint), **theTime**, and returns a **String** once it completes.

19. Place the cursor inside the function and declare these three variables:

```
var theMin:uint = Math.floor(theTime/60);
var theSec:uint = theTime%60;
var tcString:String = "";
```

The first line declares a variable, **theMin**, to store minutes. We set it to the result of applying the **Math.floor()** method to the incoming parameter, **theTime** divided by 60, or the number of seconds in one minute. Flooring a number rounds

a number to the lowest available whole number. This ensures that the number of minutes is accurate.

The second variable, **theSec**, is the number of seconds when the method is called. Where the preceding function ignored the remaining seconds, this variable is all about the remaining number of seconds. It uses the operator **modulo (%)** to set **theSec** to the remainder of **theTime** divided by 60. For example, when **theTime** is equal to 119, the **theSec** will equal 59, or the remainder of dividing 119 by 60.

The **tcString** is a **String** or text-formatted variable for storing the timecode. It's a string and not a number because a timecode field contains a non-numerical character, the colon character (:), and is not a pure number.

20. After these internal variables are defined, enter the remaining code inside the method:

```
if (theMin < 10) {
    tcString += "0";
}
if (theMin >= 1) {
    tcString += theMin.toString();
} else {
    tcString += "0";
}
tcString += ":";
if (theSec < 10) {
    tcString += "0";
    tcString += theSec.toString();
} else {
    tcString += theSec.toString();
}
return tcString;
```

This series of if-else statements formats the time into a timecode string. It begins by first creating the minutes, appending a colon character, and by creating the seconds. In each stage, the result is appended to the string, **tcString**. This value is then returned to the function that called it.

21. The last bit of code we need to write is the code to toggle between displaying the video at actual size and scaling the movie to fit within the video component. On sites featuring Flash Video players, you will often see video that is scaled to fit the display area and a button to show the video at its smaller actual size. To create this functionality enter:

```
public function toggleFitToStage (event:MouseEvent):void {
    if (fitToStageButton.selected == true) {
        vidPlayback.scaleMode = VideoScaleMode.NO_SCALE;
    } else if (fitToStageButton.selected == false) {
        vidPlayback.scaleMode = VideoScaleMode.MAINTAIN_ASPECT_RATIO;
    }
}
```

This function is triggered when the **toggleFitToStage** button is clicked. It uses an if-else statement to respond when the button is selected. If it's selected, it sets the **vidPlayback** object's **VideoScaleMode** property to **NO_SCALE**. This presents the video at actual size. If the button is not selected, the **VideoScaleMode** is set to **MAINTAIN_ASPECT_RATIO**. This scales the video to fit the size of the **FLVPlayback** component.

22. Switch back to the **customplayer.fla** file. Choose **File > Publish Settings**. Click the **HTML** tab.

23. Choose **Flash Only - Allow Full Screen** from the **Template** dropdown menu and click **OK** at the bottom of the dialog.

Figure 5.55: *Select Flash Only - Allow Full Screen.*

ABOUT FULL-SCREEN MODE
Before Adobe introduced full-screen support in Flash Player 9.027, a lot of custom Flash Video players were implementing full-screen functionality by switching to a new Flash Video player in a web page scaled to fit the monitor.

When a SWF file enters full-screen mode in a web browser, the allowFullScreen parameter must be set to true, in the web page's embed code. If this parameter is not set, an exception is thrown when a viewer presses a button to enter the mode. The Flash Only - Allow Full Screen publishing template sets this parameter, but if you are writing the embed code, you'll need to set this paramter.

Note that full-screen mode can only be entered by a click or keyboard event. In addition, text fields cannot be modified while in full-screen mode. These limitations are to protect viewers from malicious code.

24. Choose **File > Publish Preview > Default (HTML)**. Your web browser should launch and display the Flash Video player. You should be able to click the full-screen button to enter full-screen mode. When the player enters full-screen mode, a message will appear saying that pressing the **Escape** key will exit full-screen mode. This message cannot be altered or removed.

 To review the final working code in case you run into errors, insert the book's DVD-ROM and look in the Completed Tutorials > Chapter 5 Complete > Custom Player (Components) folder. Open the file CustomPlayer.as.

Tutorial: Writing a Custom Player from Scratch

In this tutorial, we will create a Flash Video player without the FLVPlayback component. Instead, we will use two custom classes in ActionScript: one for basic video control that we will write and another for presenting and controlling the interface that is already written. This will give you more exposure to the methods and properties that are necessary for developing video applications with Flash. It will also introduce you to working with classes and packages. Classes represent objects and are the cornerstone of object-oriented programming. The key take-away, however, is that classes facilitate reusable code and make it easy to write a class once and use it for several projects.

I have already skinned the components so we can focus on the code. Feel free to open up the movie clips in the Library and see how the components are structured and to look at the changes I made to them. This tutorial's Flash document uses the new ActionScript 3 UI components—not the FLVPlayback components. They are incredibly lightweight and they are easy to customize and skin. Also, I've included the Adobe Illustrator CS3 document, **symbols.ai**, containing the icons used in this player. It's in the **Custom Player (Classes)** folder along with the other media for this tutorial.

The VideoController class, the prewritten file, is fully commented and uses some of the same code written in the previous tutorial. That said, we won't walk through it step-by-step. Do look at the source file, however, and look at the onMetaData method to see how it stores cue points into an array and later a data provider for the cue point dropdown.

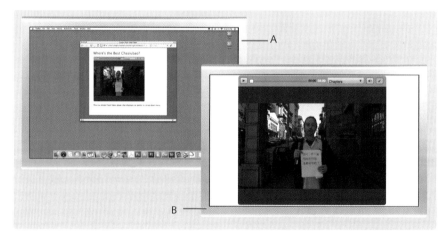

Figure 5.56: *Player running within the browser window (A) and running full screen (B).*

Writing the Base Video Player Class

The base video class will handle loading the video and managing playback. It will also provide methods to control the volume and share video metadata.

1. Navigate to the **Tutorials > Chapter 5** folder. Copy the **Custom Player (Classes)** folder to your computer.

2. Launch **Flash Professional CS3**. Choose **File > New**. In the **New Document** dialog, select **ActionScript File**. Choose **File > Save**. Navigate to the Custom Player (Classes) folder you just copied. In the Save dialog, open the com folder and then open the flv folder. Save this ActionScript file here and name it **VideoPlayer.as**.

i *You should also see the VideoController.as file in this same directory. This is the prewritten ActionScript file that will interface with the code you're about to write and connects it to the player's user interface controls.*

3. After saving the file, enter the package declaration:

```
package com.flv {
}
```

You'll notice that the **com.flv** reflects the directory structure of where the ActionScript files are located. This is a namespace for the package statement. When you write your own ActionScript libraries consisting of several classes or when you use several shared and open-source libraries, namespaces facilitate organization and prevent conflicts between code that might have similar method and property names.

i *It's considered best practice to use your own domain name when packaging classes. For example, if your domain was foo.org, you have a package starting org.foo.*

4. Next, let's import the Flash classes that are required to build our base functionality. Within the braces that define our package, type the following import statements:

```
import flash.display.Sprite;
import flash.media.Video;
import flash.net.NetConnection;
import flash.net.NetStream;
import flash.events.NetStatusEvent;
import flash.media.SoundTransform;
```

The **Sprite** class is actually lighter weight than the **MovieClip** class because a sprite doesn't require a timeline. Since this class doesn't need one, we'll import it and extend it when we write the class declaration.

The next three imported classes are prerequisite for working with video. In this chapter's first tutorial, we worked with **NetConnection** and **NetStream** classes and allow a Flash movie to open a connection to a video and play it.

The **NetStatus** event class will be used to capture metadata such as duration and cue points from the video file.

The video file we'll be using for this tutorial does not have sound associated with it. In the case you want to use a different video with audio, we'll import the **SoundTransform** class so we can use its methods to adjust the volume.

5. Now write the class declaration:

```
public class VideoPlayer extends Sprite {
}
```

Nothing new here. Remember that the class must have the same name as the file, minus the ".as" file extension. Since we imported the **Sprite** class to use as the basis for this code, we're extending this class to inherit the functionality and methods available to the **Sprite** class.

6. Next, let's declare the variables we'll need for this class:

```
private var _vid:Video;
private var _ns:NetStream;
private var _nc:NetConnection = new NetConnection();
private var _vidUrl:String;
private var _vidClient:Object = new Object();
private var _vidVolume:Number = 1;
```

In this file, we'll prefix class variables with an underscore character. This is considered a best practice among some ActionScript developers. It also helps with naming getter and setter methods that will allow other classes to access this class file's properties.

The **_vid** variable is a video object. It's the video we'll load and play. Back again to the first tutorial, we're using the customary variable names **_ns** and **_nc** to refer to the **NetStream** and **NetConnection** objects that will pipe the video into the SWF.

The URL for the video is stored in **_vidURL**. We won't set the location explicitly in the file, but we'll write a "setter" method so the **VideoController** class can modify it. A setter is a method that sets an object's property. To learn more about setter and getter methods in ActionScript, search for "setter" or "getter" in Flash CS3 Professional's help documentation.

When a Flash Video file has metadata inside it, one needs to create an additional object to listen to it and optionally process the information. If one is not set, the Flash Player will throw an exception and remaining code may not run and cause additional errors. The **_vidClient** variable is the object we'll define to listen for these events. Within the realm of this class, the object won't do anything, but we'll

expose this object to the **VideoController** class so it can process the video's metadata.

Lastly, we create a number for the volume and set it to 1 or full volume.

7. Now enter the constructor function for the class:

```
public function VideoPlayer(vidW:uint, vidH:uint) {
    _nc.connect(null);
    _ns = new NetStream(_nc);
    _vid = new Video(vidW, vidH);
    addChild(_vid);
    _vid.attachNetStream(_ns);
    _ns.client = vidClient;
    vidClient.onMetaData = onMetaDataEvent;
    startVideo();
}
```

The constructor accepts two parameters, the video's width (**vidW**) and height (**vidH**). This means the user can set the height and width for the video externally and promote reuse. Both parameters are declared as unsigned integers since heights and widths for video are always positive numbers.

The first several lines of the constructor are similar to the code we wrote in the first tutorial. They create a connection to an external video file, and facilitate its playback. What is unique however, are the **addChild()** method and the **client** property. The **addChild()** method is the ActionScript 3 way of adding movies to the **display list**, the stack of things currently on the Flash document's stage. The **client** property is a way to specify which object should be the recipient for the metadata received by the **NetStream** instance, **_ns**.

Lastly, The constructor function doesn't start video playback. Instead it calls the **startVideo()** method that starts the video and pauses it at the first frame.

8. Place the cursor outside and after the constructor function and create the first function. This function sets the **_vidUrl** variable. Since the method is declared as **public**, the **VideoController** class will be able to set the location easily.

```
public function set vidUrl(value:String):void {
    _vidUrl = value;
}
```

9. The **VideoController** will want access to the **NetStream** instance **_ns** for it's seek bar functionality. Enter:

```
public function get ns():NetStream {
    return _ns;
}
```

One thing you may have noticed about the past two functions are the words **get** and **set** in between the function keyword and the method name. This is how getter and setter methods are written in ActionScript 3. Getter and setters, as they are often referred to, allow you to keep variables private to the class while providing a simple and controlled way for other classes to read and write to these variables. For example, the **VideoController** class creates a new instance of this class and names it **_myVideo**. To access the **ns** object, one writes **_myVideo.ns**.

10. Let's write a getter method that will return the client object, **_vidClient**, attached to the NetStream object, **_ns**. Enter:

```
public function get vidClient():Object {
    return _vidClient;
}
```

To see how the **VideoController** class will make use of this getter method, look at the methods **setupProgress()**, **getVideoTime()**, and **onEnterFrame()** in VideoController.as.

11. Add the method to load the stream and show the first frame of video:

```
public function startVideo():void {
    ns.play(_vidUrl);
    ns.seek(0);
    ns.pause();
}
```

The **play()** method begins playback of the video defined by **_vidURL**. It doesn't, however, make it appear on stage, the **attachVideoStream()** and **addChild()** methods do that back in the constructor function.

Since it may not be desirable to have the video start playback automatically, we use the **seek()** and **pause()** methods to go to the first frame and pause when the video has loaded.

12. To toggle between play and pause states, write the following method:

```
public function playVideo():void {
    _ns.togglePause();
}
```

13. There are two controls that will need the ability to seek to a portion of the video:

```
public function seekToVideo(seekTime:Number):void {
    _ns.seek(seekTime);
}
```

The player's user interface contains a slider User Interface component and a drop down menu. The slider is extended to work like the **seekBar** FLVPlayback component: as the user drags the slider, the player seeks to different parts of the video. The dropdown or combo box User Interface component holds all the video's cue points and their corresponding location in time. It will use this method to move the playhead to a cue point.

14. Write the method to adjust volume:

```
public function adjustVolume(newSoundVolume:Number):void {
    var st:SoundTransform = new SoundTransform();
    st.volume = newSoundVolume;
    _ns.soundTransform = st;
    _vidVolume = newSoundVolume;
}
```

The **Video** and **NetStream** objects do not have methods for controlling audio. Instead, we need to create a **SoundTransform** object and associate it with the **_ns** object using the **soundTransform** method to adjust the sound.

15. Write the dummy method for ignoring metadata:

```
private function onMetaDataEvent(info:Object):void {
    // Do nothing. Here to prevent errors.
}
```

This method will ignore metadata associated with the video. This will prevent possible errors when the player encounters the metadata. Two forward slashes, **//**, create commented code that is ignored by the Flash compiler.

16. Save the file. Open the file **player.fla** in the **Custom Player (Classes)** folder you copied to your computer. Choose **Edit > Deselect All** in case something is selected. In the **Properties** panel, notice that the file has a document class associated with it. It's the prewritten file, **VideoController.as**.

17. Choose **Control > Test Movie** to compile the movie. No video plays. That's because the video location is actually set in HTML in a FlashVar. To preview the movie, launch a web browser and open the file **index.html** in the **Custom Player (Classes)** folder.

> ℹ️ *In addition to looking over the VideoController.as file, check out the index.html file in the text editor of your choice. If you encounter issues, look at the completed tutorial on the DVD-ROM.*

Wrapping Up

By now, you should be more familiar with the methods and properties for the FLV-Playback component class and the **Video**, **NetStream**, and **NetConnection** classes. As you gain more experience with these, feel free to extend these project files further.

CHAPTER 6

Interactive Video Concepts

A short primer on how to design interactive Flash Video projects.

Designing Navigation and Interaction

On one end of the spectrum, a Flash Video project is like putting in a video tape and pressing play. Beyond that are players that have playback controls like a DVD-remote: play, pause, next chapter, previous chapter, current time, etc... And beyond that are rich internet applications that involve presenting data with video or video with data. This section guides you through designing Flash Video navigation and interaction. I explain working methods and the tools used to create navigation and point out things you can do to make your projects easier to use.

Flowcharts

A flowchart or sitemap, shows all the links between every screen in your Flash Video application or how Flash Video integrates within a larger website. It is a bird's-eye view of the your project, and it is crucial to interactive design and production. For example, a Flash designer uses a flowchart to design screens and animations while an ActionScript developer uses it to write navigation and functional code.

ℹ️ *Figures 6.3 and 6.21 are examples flow charts for Flash Video applications. They were drawn using Adobe Illustrator CS3, but OmniGraffle or Microsoft Visio would have been fine, too.*

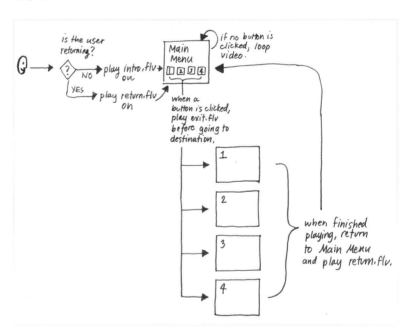

Figure 6.1: *Whiteboard flowchart.*

Developing a flowchart should begin soon after you understand the project's scope. I like to begin flowcharts early. When talking with the client or team, I will go up to a white board or use pen and paper and sketch a flow. As I draw the diagram, I talk through it, asking questions as needed. When using a whiteboard,

it's easy to erase one idea and sketch a new idea quickly. When the session is done, I take a picture of the whiteboard with a digital camera.

 When you photograph a white board, be careful to not catch too much glare, or parts of the whiteboard will be obscured. Also, write legibly and use markers that create solid lines.

Once you have the flowchart recorded, draw it in a program like OmniGraffle, Microsoft Visio, or Adobe Illustrator. Having the flowchart in a digital form allows you to make updates quickly, and you can reuse flowchart components. If you can, always sketch the initial flowchart. Although this sounds contradictory to the previous paragraph, a sketch is often faster to produce, it can be done anywhere and by anyone, and it is judged fairly because of its rough appearance.

Prototyping

Prototyping is creating a functional version of the project for evaluation purposes. The goal is to gain valuable feedback on the project's features before production. When prototyping a Flash Video project, you have the following options:

- Create a prototype from sketches, Illustrator, Visio, or Omnigraffle wireframes.
- Author a small subset of the project and run it locally or post it on a site for testing.

Paper Prototyping

This option can be produced in a few hours. Usually, you want to test to see whether people get the idea and purpose of the project, test your naming scheme, and test overall functionality. You can create prototypes at any stage of development, but prototyping with paper at the beginning has the most bang for the buck because paper prototypes are produced quickly and cheaply, and yield a lot of valuable feedback. There is no need to make huge investments in production and design when an hour's worth of sketching and a few interviews will do.

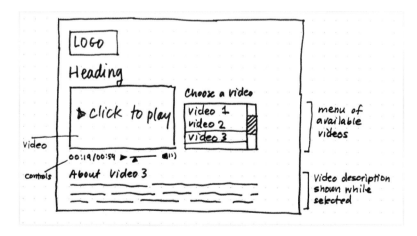

Figure 6.2: *Paper prototype.*

You can use either hand-drawn sketches or the wireframes for paper prototypes. I usually conduct two to three rounds of quick testing with paper sketches before moving to the more finished designs.

Authoring a Functionally Limited Prototype

Putting together a prototype that exhibits portions of the functionality you envision for your Flash Video application is a good way to test user experience, feasibility, or performance. Determine which and how much video content to show early. If you include video for the sake of feedback on both the presentation and content of the video, include as much as you need. If you are only testing design and navigation, use short video clips to make moving between screens and video quick.

When you prototype a small test, your options are to run it locally on your machine or deploy it your web site. Viewing the prototype locally on a computer is faster than waiting for it to deploy to a site, but it won't give you an accurate indication of network latency and playback performance. If your material is time-sensitive or shouldn't be released just yet, a local prototype is a good alternative or you could deploy the material to an unpublished or password protected directory. Publishing to a site is also good for testing performance across several browsers, operating systems, and older computers.

When testing a functionally limited prototype, you test for the same things—does the viewer get the idea and purpose? More importantly, with the benefit of designing a few screens, you are testing whether the visual design makes interacting with the content easy.

Usability Testing

Usability should not be left until the end because it is, hands down, the best method for discovering potential interface problems. Ideally, it begins as up-front research and continues throughout production with testing. By testing iteratively, you learn from the viewers what makes the project easy to use and enjoyable. The usability testing process involves the following steps:

1. **Planning.** Write the screening questionnaire used in recruiting and the test plan, which covers the goals and content of the usability tests.

2. **Recruiting.** Find test participants who match the audience criteria.

3. **Testing.** Run tests and make note of usability issues and opportunities to improve interaction.

4. **Analyzing.** Examine and report test results and make recommendations for improvements.

Helpful Interaction Design Questions

Designing navigation and interaction is not always straightforward. When I have a hard time deciding what to design, I keep the viewer's needs in mind and phrase questions in terms of what they may need:

- What is the most logical organization of the content? Does your project have one video segment? Are there ways to break it into logical chapters? If there will be more than one video, what is the best way to provide access to the video content?

- What does the viewer see first?

- Does the user need to interact with the movie using the keyboard? What other forms of rich interaction or assistive technology need to be supported? Will data be used? Are closed captions needed?

- On any screen, what is this most important button? Give it additional prominence. How much time should the user spend on this screen? Is the screen still or dynamic? Will it remain on screen until the user interacts with it, or will it time out and display something else if no user-driven event occurs?

Interaction Design Tips

The following design rules can help put into practice your navigation and interaction. They are not complete, and some can be broken, but they can bring order and clarity to wayward designs.

- **Keep it simple.** Remember that often, less is more. A cluttered interface is hard to use, and given limited screen real estate, you cannot provide links to everything. Do not overload the screen with too much stuff.

- **Be consistent.** Place buttons in the same place. Keep selection and activation colors consistent. Use the same wording for buttons that have the same link or function.

- **Provide adequate feedback.** When a viewer rolls over a button, the visual state of the button should change and appear different from the remaining buttons that have not been selected. Treat selected buttons and nonselected buttons consistently.

- **Use simple language that viewers understand.** Do not succumb to irony and use clever wording that the viewer will not understand. For specialized projects, do research and ask participants what terminology and wording is understood in their community of interest.

- **Create logical cue points in videos and provide an interface to access them.** This gives the viewer the ability to continue when they are not able to watch the entire video in one session. If there are no logical cue points in the content, set them at the same interval so the viewer can skip through the video more quickly.

Backgrounds, Loops, and Flash Video

If you can recall the menus for a Hollywood-produced DVD you enjoyed, you are most likely familiar with looping video and how it can be applied to Flash Video. When used as a background design element, looping video provides a continuously animated background. Four common patterns for looping video are:

1. Loop continuously.

2. Loop a set number of times and then do something else.

3. Play once completely and then continuously loop back to a point other than the first frame of video.

4. Play once completely and then do something else.

Tutorial: Repeating Loops

In this tutorial we'll create a FLA with four screens. Each screen will have video in the background but each screen will behave differently in each instance.

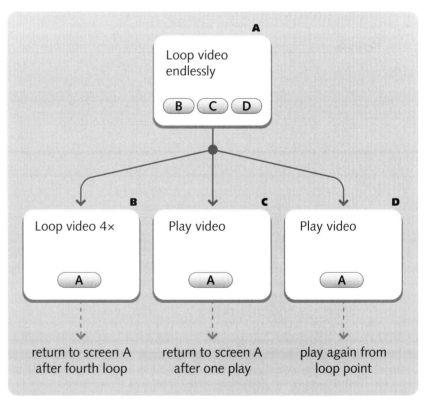

Figure 6.3: *The flow we'll create in this tutorial.*

On the first screen, the video will loop continuously. In the second screen, the video background will play four times and then return to the first screen. In the third screen, the video will play once and then go to a loop point, bypassing the

Chapter 6: Interactive Video Concepts

first few seconds of the movie. In the fourth screen, the video will play once and then return to the first screen. In all screens there are navigation buttons that the viewer could click at any time to go to another screen. On the first screen, there are buttons that link to each of the three other example screens and on each of these three screens is a button that links back to the first screen. Figure 6.3 shows a flow diagram of this FLA file.

Part 1: Setting Up the FLA File

1. Open the DVD-ROM folder **Tutorials > Chapter 6**. Copy the folder **Looping Video** to your computer.

2. Launch Flash Professional. Choose **File > Open**. Open the file **looping.fla** in the **Looping Video** folder on your computer.

3. In the **Properties** panel, click the **Background** color chip button and enter **A4B7EB** as the background color. This color is used in the background videos we will use and setting this color now will help with creating the titles until we set a preview frame. It also helps to set the background color in the case the video is loaded over a slow connection and is not immediately viewable.

Figure 6.4: *Setting the background color for the FLA file.*

4. For this FLA file, several layers need to be created for structuring actions, labels, text, buttons, and video. Using the **Timeline** window, create them according to the following screenshot.

Figure 6.5: *The layer structure for this FLA file.*

5. Layout the four screens across the timeline according to the following screenshot. Instructions follow it.

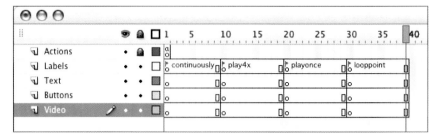

Figure 6.6: *The timeline layout for the four screens.*

6. Select the **Actions** layer and click the dot in the **Lock** column. This will allow us to enter code in the frame but will prevent us from inadvertly placing elements on this frame.

7. Create the frame labels. Select **frame 1** in the **Labels** layer. In the Properties panel enter **continuously** for the frame label.

Figure 6.7: *Labeling the frame.*

8. Select **frame 10** and choose **Insert > Timeline > Blank Keyframe**. Label this frame **play4x**. Select **frame 20** and insert a blank keyframe and label it **playonce**. Select **frame 30** and label it **looppoint**. Select **frame 39** and choose **Insert > Timeline > Frame**.

9. Lock the **Labels** layer. Choose **File > Save** to save your work.

Part 2: Adding Text, Button, and Video Elements

1. Select **frame 1** in the **text** layer.

2. Click the **Text** tool, \boxed{T}, in the **Tools** panel. In the **Properties** panel, set the **text options** to **static text**. Set the **font** to **Myriad Pro** (this assumes the font was installed with your copy of Flash Professional CS3. If it wasn't installed, pick a font you like). Set the **size** to **36** and the **color** to **#FFFFFF** (white).

Figure 6.8: *Set the font properties.*

3. With the **Text** tool, click on the **Stage** and enter **Loop Continuously**. Click the **Selection** tool, , in the **Tools** panel. Using the **Properties** panel, change the text element's **x** and **y** position to **18**, **18**.

4. Apply a drop shadow to the text element. Choose **Window > Properties > Filters**. In the **Filters** panel, click the **Add Filter** button and select **Drop Shadow**. Set the drop shadow settings according to the following screen shot.

Figure 6.9: *Apply a drop shadow filter to the text.*

The Stage should now look like the following screen shot.

Loop Continuously

Figure 6.10: *The first screen with text.*

5. Let's use this text element on the three other screens. Select the text element and choose **Edit > Copy**. Select **frame 10** in the **Text** layer. Choose **Edit > Paste in Place**. Use the **Text** tool to change the text element to **Play 4x**. Using this same sequence of steps, select **frame 20** in the **Text** layer and change the text to **Play Once**. Select **frame 30** and change the text to **Loop Point**. Lock the **Text** layer.

6. Select **frame 1** in the **Buttons** layer.

7. We will now add navigation buttons to the screens. In the **Library** panel is a button symbol, **Text Button**, that shows a diamond and has up, over, and down states. Drag the **Text Button** symbol from the **Library** panel to the **Stage**.

8. Use the Properties panel to name the button symbol **button1** and set the **x** and **y** position to **48**, **180**.

9. Drag two additonal buttons to the **Stage** and name them **button2** and **button3**. Set the **x** and **y** position for **button2** to **48, 228**. Set the **x** and **y** position for **button3** to **48, 280**.

10. Select the **Text** tool and set the text properties according to the following screen shot. The type should be **Static Text**, the font should be **Myriad Pro Bold** (or another if it is not installed), the size should be **24**, and the color should be **333333** (dark gray).

Figure 6.11: *Text properties for the button text.*

11. Create a text element next to **button1** (the top button) and enter **Play 4x**. Create another text element next to **button2** (the middle button) and enter **Play Once**. Create a third text element next to **button3** (the bottom button) and enter **Loop Point**. The screen should now look like the following screen shot.

Figure 6.12: *The first screen with buttons.*

12. With the buttons created for this screen, it's time to create buttons for the remaining screens. Select the **Play 4x** text and the **button1** instance and choose **Edit > Copy**.

13. Select **frame 10** in the **Buttons** layer and choose **Edit > Paste in Place**. Change to the **Text** tool and change the text to **Return**. Select the button instance and change the instance name to **button4**.

14. Select both the text element and the button and choose **Edit > Copy**. Select **frame 20** and choose **Edit > Paste in Place**. Select the button instance and change the

instance name to **button5**. Select **frame 30** and choose **Edit > Paste in Place**. Select the button instance and change the instance name to **button6**. We now have buttons across all the screens. Lock the **Buttons** layer.

15. The last elements we need to add to the screens are FLVPlayback components. Select **frame 1** in the **Video** layer. Choose **Window > Components**. Open the **Video Category** and drag the **FLVPlayback** component to the **Stage**.

Figure 6.13: *The Video components category.*

16. Select this instance of the FLVPlayback component. Using the **Properties** panel, set the component's **width** to **480** and the **height** to **360**. Set the **x** and **y** position to **0, 0**. Name the instance **myVideo**.

Figure 6.14: *Instance name and geometric properties for the FLVPlayback component.*

17. Choose **Window > Components Inspector** to open the **Components Inspector** panel. With the **myVideo** instance selected, click the **Parameters** tab.

18. Set the **autoPlay** property to **true**.

19. Click the **skin** property and then click the **magnify** button on the right side of the **skin** property's attribute field.

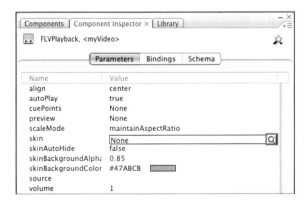

Figure 6.15: *Click the magnify button to open the Select Skin dialog.*

20. In the **Select Skin** dialog, choose **None** from the **Skin** menu and click **OK**.

Figure 6.16: *Setting the FLVPlayback to not use a skin.*

21. In the **Component Inspector** panel, click the **source** property and click the **magnify** button on the right side of the **source** property's attribute field. This displays the Content Path dialog. We'll use this to pick a video to play. Click the **folder** button at the right side of the field and navigate to the **Looping Video** folder on your computer. Select the file **bluetile.flv** and click **Open**.

Figure 6.17: *Set the source for the FLVPlayback component.*

22. Now that the source is set, let's improve the quality of the preview. New to Flash Professional CS3 is the author time preview of Flash Video. You can pick a frame from the video and use that frame as a placeholder on the stage while you are authoring your Flash Video content.

In the Components Inspector panel, select the **preview** property and click the **magnify** button on the right side of the **preview** property's attribute field. This displays the **Select Preview Frame** dialog. It has a video player with a controller to pick a frame to use as the author time preview. Hover over the video and use the **timebar** control to move the **playhead** to **2.500**.

Select Preview Frame

OK

Cancel

Export...

2.500

The preview image is displayed at authoring time only. To generate a runtime preview image, use the export button and load the image back by writing your own ActionScript.

Figure 6.18: *Selecting the Preview frame.*

23. We can use the **myVideo** instance with most of the same properties in the **play4x** and **playonce** frames. Select the **myVideo** instance and choose **Edit > Copy**. Select **frame 10** in the **Video** layer and choose **Edit > Paste in Place**. Select the video instance and change the instance name to **loop4xVideo**. Select **frame 20** in the **Video** layer and choose **Edit > Paste in Place**. Select the video instance and change the instance name to **play1Video**.

The **looppoint** screen will use a different video with a cue point set as a loop point. Before we do the next step, however, look at figure 6.19.

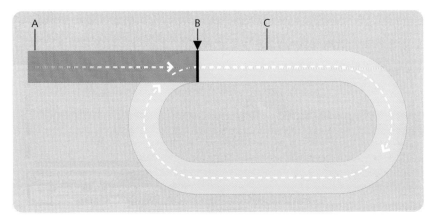

Figure 6.19: *This represents one video loop. The first part (A) is the opening part of the animation. The point after which it ends is the loop point (B). The remaining portion of the video (C) is the is played continuously when the video is played again, skipping over the frames defined by (A).*

24. Select **frame 30** in the **Video** layer. Drag another instance of the **FLVPlayback** component from the **Components** panel to the **Stage**. Set the **x** and **y** location to **0, 0**, set the dimensions to **480 × 360**, and name the instance **loopPointVideo**.

25. Using the **Component Inspector** panel, set the **autoPlay** property to **true** and the **skin** property to **none**. Set the **source** to **clock.flv** (this FLV file is also in the **Looping Video** folder on your computer). Set the **preview** property to **2.000**. The **looppoint** screen should now look like the following screenshot.

Figure 6.20: *The looppoint screen.*

26. Lock the **Video** layer. Choose **File > Save** to save your work.

Part 3: ActionScript Code for Loops and Navigation

1. Select **frame 1** in the **Actions** layer. Choose **Window > Actions** to display the **Actions** panel. Our strategy is to have the video automatically rewind and play again. In the Actions panel, enter the following code:

```
import fl.video.VideoEvent;
stop();

myVideo.autoRewind = true;
myVideo.addEventListener(VideoEvent.AUTO_REWOUND, loopVideo);

function loopVideo(event:VideoEvent):void {
    myVideo.play();
}
```

The first line imports the **VideoEvent** class. This class contains events that video objects trigger, like playing or rewinding, and it's needed so we can listen for the **AUTO_REWOUND** event. The **stop()** method holds the playback head on this frame. The third line sets the **myVideo's autoRewind** property to **true**, which automatically rewinds the video when it finishes. The fourth line attaches an event listener for the **AUTO_REWOUND** event to occur. This listener calls the **loopVideo()** function when it does and this callback function plays the video again.

Chapter 6: Interactive Video Concepts

2. After the **loopVideo()** function, enter the following ActionScript for the buttons:

```
addEventListener(MouseEvent.CLICK, clickHandler);

function clickHandler(event:MouseEvent):void {
    myVideo.removeEventListener(VideoEvent.AUTO_REWOUND, loopVideo);
    switch (event.target.name) {
        case "button1" :
            gotoAndStop("play4x");
            break;
        case "button2" :
            gotoAndStop("playonce");
            break;
        case "button3" :
            gotoAndStop("looppoint");
            break;
    }
}
```

The first line assigns an event listener to the entire stage and listens for mouse clicks. When a **CLICK** event occurs, the **clickHander()** function is called. The clickHandler function begins by removing the event listener from the video. This prevents this event listener from causing an error when a similiar event occurs on a different video object elsewhere in the FLA. The **switch** statement uses the name of the item (the **target**) that was clicked and runs through the cases. The three **cases** within the **switch** statement provide navigation commands to go to three other frames in the FLA file.

3. Choose **Control > Test Movie** to preview the FLA file. Notice that the movie does loop continuously and clicking any of the buttons moves the playhead to one of the three remaining screens. You'll also notice that the **Return** buttons and the loop interactivity do not work on the remaining screens. We'll fix that next.

4. Close the **Preview** window. Select **frame 10** in the **Actions** layer and choose **Insert > Timeline > Keyframe**. In the **Actions** panel enter the following code:

```
var loopCounter:uint = 1;
removeEventListener(MouseEvent.CLICK, clickHandler);

loop4xVideo.autoRewind = true;
loop4xVideo.addEventListener(VideoEvent.AUTO_REWOUND, loopVideo4x);

function loopVideo4x(event:VideoEvent):void {
    loopCounter += 1;
    if (loopCounter == 4) {
        gotoAndStop("continuously");
    } else {
        loop4xVideo.play();
    }
}
```

This frame script begins by stopping the playhead on this frame. A counter, **loop4xCounter**, is then set to 1. To avoid errors being thrown, the **CLICK** event and **clickHandler()** function are removed using **removeEventListener**.

The loop4xvideo FLVPlayback instance is set to automatically rewind and an event listener is attached to it that calls the **loopVideo4x()** function.

When then video rewinds, the **loopVideo4x()** function adds 1 to **loop4xCounter** and then tests to see if the counter equals 4. When it does, it returns to the first screen and if it doesn't, it plays the video again.

5. Add an event listener for the **button4** instance. When **button4** is clicked, the playhead goes to the frame labeled **continuously**.

```
button4.addEventListener(MouseEvent.CLICK, click4);

function click4(event:MouseEvent):void {
    gotoAndStop("continuously");
}
```

6. Test the movie (**Control > Test Movie**). Click the **Play 4x** button on the first screen and notice how the video loops four times before returning to the first screen.

7. Close the **Preview** window. Select **frame 20** in the **Actions** layer and choose **Insert > Timeline > Keyframe**. In the **Actions** panel, enter the following code:

Chapter 6: Interactive Video Concepts

```
removeEventListener(MouseEvent.CLICK, clickHandler);

play1Video.autoRewind = true;
play1Video.addEventListener(VideoEvent.AUTO_REWOUND, play1x);

function play1x(event:VideoEvent):void {
   gotoAndStop("continuously");
}
```

This frame script begins by stopping the playhead on this frame. Like in the previous frame script, the **CLICK** event and **clickHander()** function are removed and the **autoRewind** property is set to **true**. An event listener is attached to the **play1Video** instance and calls the **loop1x()** function when it is rewound. The function returns the playhead to the first screen.

8. Add the event listener for button5. When **button5** is clicked, the playhead goes to the frame labeled **continuously**.

```
button5.addEventListener(MouseEvent.CLICK, click5);

function click5(event:MouseEvent):void {
   gotoAndStop("continuously");
}
```

9. Test the movie (**Control > Test Movie**). Click the **Play Once** button on the first screen and notice how the video only plays once before returning to the first screen.

10. Close the Preview window. Select frame 30 in the **Actions** layer and choose **Insert > Timeline > Keyframe**. In the **Actions** panel enter the following code:

```
removeEventListener(MouseEvent.CLICK, clickHandler);

loopPointVideo.autoRewind = true;
loopPointVideo.addEventListener(VideoEvent.COMPLETE, playFromLoopPoint);

function playFromLoopPoint(event:VideoEvent):void {
   loopPointVideo.seekToNavCuePoint("loop");
   loopPointVideo.play();
}
```

This frame script begins by stopping the playhead on this frame. Like in the previous frame script, the **CLICK** event and **clickHander()** function are removed and the **autoRewind** property is set to **true**. An event listener is attached to the **loopPointVideo** instance and calls the **playFromLoopPoint()** function when playback is complete. The function returns the playhead to the cue point named loop and plays the video again.

11. Add the event listener for button6. When **button6** is clicked, the playhead goes to the frame labeled **continuously**.

```
button6.addEventListener(MouseEvent.CLICK, click6);

function click6(event:MouseEvent):void {
    gotoAndStop("continuously");
}
```

12. Test the movie (**Control > Test Movie**). Click the **Loop Point** button on the first screen and notice how the video plays once before looping back to the loop point.

13. Close the **Preview** window. Choose **File > Save** to save the file.

Tutorial: Intro, Exit, and Return Loops

Intro and exit loops (also called interstitials) add continuity to a Flash Video application. For example, a longer introductory video plays first. When a button is clicked, another video plays in its place in response to the click before doing something else. Upon returning to the screen, a different video is played in place of the introductory video.

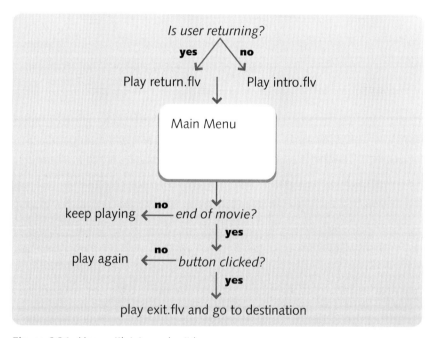

Figure 6.21: *Menu with intro and exit loops.*

 If you want to create DVD-style Flash Video applications in a few clicks, look in Encore CS3. It now offers Flash Video output in addition to DVD-Video and Blu-Ray output. To learn more, go to: http://www.adobe.com/products/premiere/encore/.

Part 1: Setting Up the FLA File

In this tutorial, we will author a news application called "Flash CS3 Video News." It will consist of a main menu and four news segments. When the main menu plays for the first time, it will play a longer video where the newscaster introduces the show. This first video clip is the intro loop. When a button is clicked, the main menu plays a video in response to the clip before showing one of the news segments. This is the exit loop. After playing a news segment, the application returns to the main menu and plays a shorter video clip prompting the viewer to select another news segment. This is the return loop.

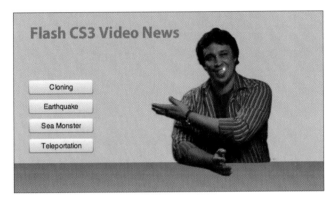

Figure 6.22: *The Flash CS3 Video News main menu.*

1. Open the DVD-ROM folder **Tutorials > Chapter 6**. Copy the folder **Advanced Looping** to your computer.

2. Launch Flash Professional. Choose **File > Open**. Open the file **newscast.fla** in the **Advanced Looping** folder on your computer.

3. For this FLA file, several layers need to be created for structuring actions, labels, text, buttons, and video. Using the **Timeline** window, create them according to the following screenshot.

Figure 6.23: *The layer structure for this FLA file.*

4. Layout the five screens across the timeline according to the following screenshot. Instructions follow it.

Figure 6.24: *The timeline layout for the four screens.*

5. Select frame 1 in the **Actions** layer and choose **Insert > Timeline > Blank Keyframe**. Select frame 2 in the same layer and choose **Insert > Timeline > Blank Keyframe**. Insert additional blank keyframes in frames 10, 20, 30, and 40.

6. Create the frame labels. Select **frame 2** in the **Labels** layer and choose **Insert > Timeline > Blank Keyframe**. In the **Properties** panel, enter **menu** for the frame label.

Figure 6.25: *Labeling the frame.*

7. Select **frame 10** and choose **Insert > Timeline > Blank Keyframe**. Label this frame **cloneFrame**. Select **frame 20** and insert a blank keyframe and label it **quakeFrame**. Select **frame 30** and label it **monsterFrame**. Select **frame 40** and label it **teleport-Frame**. Select **frame 49** and choose **Insert > Timeline > Frame**.

8. Lock the **Labels** layer. Choose **File > Save** to save your work.

Part 2: Adding Backgrounds, Buttons, and Video

1. Select **frame 1** in the **Background** Layer. Choose **Window > Library** and drag the **mainBackground** movie clip from the **Library** panel to the **Stage**. Set its **x** and **y** position to **0,0**.

Figure 6.26: *The background for the main screen in the Library panel.*

2. Select **frame 10** in the **Background** layer. Choose **Insert > Timeline > Blank Key-**
frame. Drag a copy of the **GradientBackground** graphic symbol from the **Library** to
the **Stage**. Set its **x** and **y** position to **0, 0**.

3. Select **frame 2** in the **Buttons** layer. Choose **Window > Components** to open the
Components panel. Open the **User Interface** group and drag an instance of the
Button component to the **Stage**.

Figure 6.27: *The User Interface components category.*

4. Using the **Properties** panel, name the button **btnCloning**. Set the button's **x** and **y**
position to **24, 100** and set the **width** and **height** to **100 × 22**.

Figure 6.28: *Setting the button properties.*

5. Choose **Window > Component Inspector**. In the **Parameters** tab, set the **Label**
property to **Cloning**. This sets the button text.

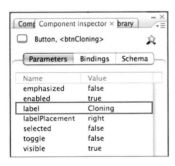

Figure 6.29: *Labeling the button in the Component Inspector panel.*

6. Drag three additional buttons to the stage. Using the **Properties** panel, name
these buttons **btnQuake**, **btnMonster**, and **btnTeleport**. Position them below the
btnCloning button and align their left edges. Use the **Component Inspector** panel
to set their labels to **Earthquake**, **Sea Monster**, and **Teleportation**. See Figure 6.22
for reference.

7. Select **frame 2** in the **Video** layer. Using the **Components** panel, drag an instance
of the **FLVPlayback** component from the **Components** panel to the **Stage**. The
FLVPlayback component is located in the **Video** category.

Figure 6.30: *The Video components category.*

8. Use the **Properties** panel to adjust the settings for the component. Select the component if the properties do not appear in the **Properties** panel. Name the instance **theVideo**. Set the **width** and **height** to **480 × 270**. Set its **x** and **y** position to **92**, **0**.

Figure 6.31: *Setting properties for the FLVPlayback component.*

9. Since this movie is a background design element, it doesn't need a skin, or playback user interface. Choose **Window > Component Inspector**. In the **Parameters** tab click the **skin** property and then click the **magnify** button on the right side of the **skin** property's attribute field.

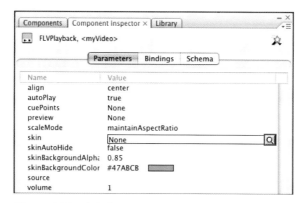

Figure 6.32: *Click the magnify button to open the Select Skin dialog.*

10. In the **Select Skin** dialog, choose **None** from the **Skin** menu and click **OK**.

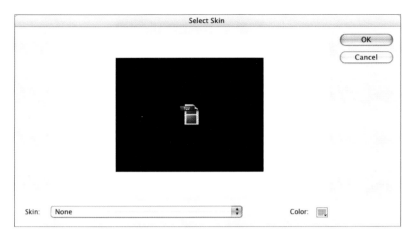

Figure 6.33: *Setting the FLVPlayback to not use a skin.*

11. Select **frame 10** in the **Video** layer. Drag an instance of the **FLVPlayback** compo-
nent to the **Stage**. Name the instance **myVideo**. Set the **width** and **height** to 480 ×
270. Set its **x** and **y** position to **0, 0**.

12. Repeat the last step for frames **20**, **30**, and **40** in the **Video** layer. You should now
have video components for each of the news segments frames.

13. In each of the news segments frames, a unique video is displayed. Instead of set-
ting the source attribute for these videos with ActionScript, let's set the attribute
using the **Components Inspector** panel.

 In **frame 10,** select **theVideo** and using the **Component Inspector** panel, set the
source attribute to **flv/cloning.flv**. Select **theVideo** in **frame 20** and set the source
attribute to **flv/quake.flv**. Select **theVideo** in **frame 30** and set the source attribute
to **flv/monster.flv**. Select **theVideo** in **trame 40** and set the source attribute to
flv/teleport.flv.

14. Choose **File > Save** to save your work.

Part 3: ActionScript Code for Intro, Exit, and Return Loops

1. Earlier in this tutorial, we inserted blank keyframes on the first two frames in the
Actions layer. Select **frame 1** in the **Actions** layer, show the **Actions** panel (**Win-
dow > Actions**) and enter:

```
var returning:Boolean;
```

 This variable is a Boolean and its possible values are either true or false. It's set in
this frame and not the menu frame (frame 2) because establishing it in frame 2
would reset it everytime the playhead returned to frame 2 from one of the news
segments.

2. Select **frame 2**, the frame that will contain the bulk of the ActionScript, and enter:

```
import fl.video.*;
import flash.events.*;

stop();
```

The **fl.video** package is imported because this frame script will play video as well as respond to the **COMPLETE** event which is specific to video. The **flash. events** package because the script listens for the **CLICK** event.

The **stop()** method stops the playhead on this frame.

3. After the **stop()** method, create a new line and enter:

```
if (returning == true) {
    theVideo.source="flv/return.flv";
    theVideo.play();
} else {
    theVideo.source="flv/intro.flv";
    returning=true;
}
```

This conditional statement checks to see if the **returning** boolean we set in frame 1 is true or false. When it is true, it plays **return.flv**. If the boolean is false, it plays **intro.flv** and sets the **returning** variable to true, which will cause it to play the return loop upon returning from one of the news segments.

4. For each of the buttons on stage, an event listener needs to be assigned. Add the event listeners to each button and use the same callback function, **click-Hander()** for all of them.

```
btnCloning.addEventListener(MouseEvent.CLICK,clickHandler);
btnQuake.addEventListener(MouseEvent.CLICK,clickHandler);
btnMonster.addEventListener(MouseEvent.CLICK,clickHandler);
btnTeleport.addEventListener(MouseEvent.CLICK,clickHandler);
```

5. After the event handlers, create a new line and enter:

```
var destinationFrame:String;
function clickHandler(event:MouseEvent):void {
    destinationFrame=event.target.name;
    theVideo.source="flv/cutaway.flv";
}
```

The string variable **destinationFrame** stores the name of the button clicked. The **clickHandler()** function sets **destinationFrame** to the name of the button clicked and then plays the exit loop video, **cutaway.flv**.

Chapter 6: Interactive Video Concepts

6. After the **clickHandler()** function enter the following lines of code.

```
theVideo.addEventListener(VideoEvent.COMPLETE,videoHandler);

function videoHandler(evt:VideoEvent):void {
   if (destinationFrame != null) {
   switch (destinationFrame) {
      case "btnCloning" :
         gotoAndStop("cloneFrame");
         break;
      case "btnQuake" :
         gotoAndStop("quakeFrame");
         break;
      case "btnMonster" :
         gotoAndStop("monsterFrame");
         break;
      case "btnTeleport" :
         gotoAndStop("teleportFrame");
         break;
   }
   destinationFrame = null;
   } else {
      theVideo.play();
   }
}
```

The first line attaches an event listener to **theVideo**, the FLVPlayback component on the stage. When the component finishes playing a video, the **COMPLETE** event occurs. This event listener calls **videoHandler()** when the video finishes playing.

Inside the **videoHandler()** function are a few conditional statements. The **if** statement checks whether or not the **destinationFrame** variable is set. Recall that it is set once a button is clicked. If the variable is set, its value is used in a switch statement to determine what frame to show next. For each button name is a corresponding frame label to play. If the value is not set, it simply plays whatever video (intro.flv or return.flv) is playing again.

7. Choose **Control > Test Movie** to try the movie out. The intro.flv video plays first and when you click a button, it plays the exit.flv file before going to one of the labeled frames. When the video finishes on any of these labeled frames, the play-head does not return to the **main** frame. Close the **Preview** window. In the next step, we'll add code to return to the **main** frame from each news segment frame.

8. On frames **10**, **20**, **30**, and **40** in the **Actions** layer, enter the following frame script in the **Actions** panel.

```
myVideo.addEventListener(VideoEvent.COMPLETE,cloneHandler);

function cloneHandler(evt:VideoEvent):void {
    gotoAndStop("menu");
}
```

This script checks to see if the video playing on each frame has finished playing. When it has finished, it returns the playhead to the **menu** frame.

9. Choose **Control > Test Movie**. The movie should now return to the main frame from all of the labeled frames.

10. Close the **Preview** window. Choose **File > Save** to save the file.

Wrapping Up

The concepts of looping and the steps required to make a video loop once, infinitely, or a set number of times can be applied to almost any project. Creative combininations of video can make your Flash Video project take on a new level of production value and experience. The topics in this chapter will help you make your video truly interactive with Flash and a small amount of ActionScript.

CHAPTER 7

Video Transparency and Effects

Flash Video can be creatively enhanced through transparency, masking, and effects.

Flash Video and Transparency

An alpha channel facilitates combining a foreground element with a background plate into a single image. A video with an alpha channel can be incorporated in a Flash application by roughly following these steps:

1. An actor is shot in front of a properly lit green or blue screen (see Figure 7.1).

2. The footage is captured in an NLE, and sent to a compositing program such as After Effects, Fusion, Motion, or Shake. In the compositing application, the green is removed, the remaining edges are softened, and secondary keys or mattes may be created through the use of rotoscoping or garbage mattes. A final matte is created from these efforts and saved with the video footage as a separate channel alongside the video's three other color (red, green, and blue) channels. What remains of the foreground element may require additional color correction to compensate for color cast (referred to as "spill") from the background.

3. This full-color video with alpha video file is compressed using the On2 VP6 codec and special attention is given to preserve the alpha channel in the encoding process.

4. The encoded video file is incorporated in a Flash movie and the alpha channel's transparency is used to composite the video on top of a background element.

Tutorial: Creating Flash Video with Transparency

For many years Adobe After Effects has been described as "Photoshop for video." It's earned this title from its incredible power and the creative flexibility it offers FX artists and motion designers. In this tutorial, we'll take HD footage shot in a green screen studio, remove the background, and output a Flash Video file with an 8-bit alpha channel.

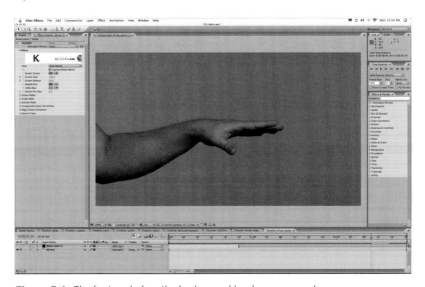

Figure 7.1: *The footage before the background has been removed.*

Section One: Chroma-Key Talent in After Effects

1. Navigate to the **Tutorials** > **Chapter 7** folder. Copy the **superpowers** folder to your computer.

2. Launch **Adobe After Effects**. A blank After Effects project file is created.

3. Choose **File** > **New** > **New Folder**. Name this folder **Source**. We'll place the source QuickTime files in this folder. Create an additional folder named **Comps**.

4. Choose **File** > **Import**. Navigate to the **superpowers** directory on your computer. Inside the folder are two subfolders containing source video: DVC-Pro HD and JPEG2000. If you have Final Cut Studio installed, open **DVC-Pro HD** and select **throw_dvcprohd.mov**. If you do not have Final Cut Studio installed or are on a Windows PC, open **JPEG2000** and select **throw_jpg2000.mov**.

The footage was shot with the Panasonic AG-HVX200, which uses the DVC-Pro HD codec. This codec is not part of QuickTime or QuickTime Professional. This codec is installed with Final Cut Studio.

5. Click **OK**. The files then appear in the **Project** window.

6. In the **Project** window, drag the movie to the **New Composition** button at the bottom of the window. This creates a new composition and places the movie inside it. It also automatically sets the composition settings to use the size, frame rate, and duration of the movie—a real time saver.

Figure 7.2: *Creating a composition automatically from imported footage.*

7. A composition is created, **throw 2**. Rename it **throw_comp**. To rename a comp, select it and press **Return** (Windows) or **Enter** (Mac OS X). Drag these compositions into the **Comps** folder in the **Project** window.

8. Double-click **throw_comp** to open it. The composition now appears in the **Composition** and **Timeline** windows.

9. Display the **Effects & Presets** palette. Choose **Window** > **Effects & Presets**. In the **Contains** field, type "**Keyl**." The **Keylight** effect appears.

Figure 7.3: *Filtering the Effects options by searching.*

10. Click-drag the **Keylight** filter to the **Composition** window and drop it on the throw movie.The **Effects Controls** palette then appears. Click the **Screen Colour** (yes, the plug-in developer is British) eyedropper and then click 20 pixels to the right of the hand. The composition window updates and the green background is removed.

Figure 7.4: *Picking a color to key out.*

11. Keylight includes several options for previewing in **View**, the first effect setting. As you work with this effect, change the View setting from **Source** to **Combined Matte** to **Final Result**. For now, select the **Combined Matte** mode.

12. Open the **Screen Matte** group in the **Effects** palette. Adjust the **Clip Black** to **13** and the **Clip White** to **95**. This will increase contrast and remove noise in the opaque and transparent areas of the matte.

13. In the **Screen Matte** group, change the **Screen Shrink/Grow** to **–1.0**, and set the **Screen Softness** to **1.0**. These settings will improve the matte by bringing the matte edges in slightly and by softening the edges.

Figure 7.5: *Use the Screen Matte controls to fine-tune a matte.*

> *When shooting foreground elements (actors and props) against a green or blue screen, "spill" can occur. This results from the green/blue background reflecting onto the foreground. To remove spill, use the Despill and Alpha bias settings. Pick a skin tone with the Despill option. If the affected area becomes too transparent, use Alpha bias to remove the transparency.*

14. Choose **File > Save**. Save the file in the **After Effects and Flash Video** folder. Name the file **FLV_Alpha.aep**.

15. To export the movie, choose **File > Export > Flash Video (FLV)**. Click **OK** in the dialog that appears.

16. In the **Flash Video Encoding Settings** dialog, click the **Video** tab. The **Video codec** selected should be **On2 VP6**, and if it isn't, select it. Check **Encode alpha channel**. Set the **Quality Settings** to **medium**, keep the **Frame rate** set to **Same as source**.

Figure 7.6: *The Video Tab settings.*

17. Click the **Crop and Resize** tab. Check **resize video**. Since we want to preserve the 16:9 aspect ratio, set the dimensions to **480 × 270**. Click **OK**.

18. Save the file as **throw.flv** in the **superpowers** folder.

Section Two: Using Transparent Video in Flash

In this section, we will write a small Flash Video application that will reference the video exported from After Effects in the last section. In this application we will layer two videos with transparency on top of the stage. Buttons next to the video area will play different videos. The lower video will play one of two videos of an arm shot in front of a green screen. The upper video will play one of four effect videos. Instead of producing and loading eight videos, we will only need siz.

Figure 7.7: *The Flash Video application.*

1. On the DVD-ROM, copy the folder **Video Transparency** to your computer. Launch Flash Professional and open the file **superpower.fla**.

2. In the Timeline, select **frame 1** in the layer named **ActionScript**. Choose **Window > Actions.** Let's begin by assigning graphics to each of the buttons on the side.

```
fireBtn.setStyle("icon", fireGlyph);
atomicBtn.setStyle("icon", atomicGlyph);
magicBtn.setStyle("icon", magicGlyph);
waveBtn.setStyle("icon", waveGlyph);
```

In the **Library** are four movie clip symbols: **fireGlyph**, **atomicGlyph**, **magicGlyph**, and **waveGlyph**. If you display the **Symbol Properties** dialog for any of these movie clips, you will see that they have the **Export for ActionScript** Linkage property set. Setting this property will create a class for it and expose this symbol to ActionScript. These four lines of code reference each symbol and use the **Button** classes' **setStyle()** method for these symbols as icons inside the buttons.

Figure 7.8: *The Symbol Properties dialog.*

3. Attach event listeners for each of the four buttons.

```
fireBtn.addEventListener(MouseEvent.CLICK, clickBtn);
atomicBtn.addEventListener(MouseEvent.CLICK, clickBtn);
magicBtn.addEventListener(MouseEvent.CLICK, clickBtn);
waveBtn.addEventListener(MouseEvent.CLICK, clickBtn);
```

An event listener is code that watches for specific interactivity or processes to occur. When the specified interaction occurs, a method is called. This process of listening for events and running code in response to the events is known as event handling. Event handling requires three things: the event source, the event, and the response the Flash application gives.

In this code block, an event listener is attached to each of the four buttons. Each listener watches for the **CLICK** event and will execute the **clickBtn** method when this event occurs on any of these four buttons.

> *When attaching an event listener, the event that occurs, CLICK in this case, is also passed to the response function. This allows the response function to use the event to alter or reference the object, one of these four buttons in this case, that created the event.*

4. Write the method **clickBtn()** that will respond to the **CLICK** event.

```
function clickBtn(event:MouseEvent):void {

}
```

In the method's declaration, it begins by accepting a **MouseEvent**, which will be referred to as **event** within the method.

5. Inside the method, enter the following **switch()** statement:

```
switch (event.target.name) {
   case "fireBtn" :
      fxVideo.source = "fire.flv";
      handVideo.source = "hold.flv";
      fxVideo.play();
      handVideo.play();
      break;
   case "atomicBtn" :
      fxVideo.source = "atomic.flv";
      handVideo.source = "hold.flv";
      fxVideo.play();
      handVideo.play();
      break;
   case "magicBtn" :
      fxVideo.source = "magic.flv";
      handVideo.source = "throw.flv";
      fxVideo.play();
      handVideo.play();
      break;
   case "waveBtn" :
      fxVideo.source = "wave.flv";
      handVideo.source = "throw.flv";
      fxVideo.play();
      handVideo.play();
      break;
}
```

A **switch** statement establishes a high-level condition. In this example, the name of the target creating the event (the button's name) is the high-level condition. **Case** statements within the switch statements instruct the Flash Player how to respond to specific conditions. The first case statement responds to the **atomicBtn** being clicked. It sets the source of the **fxVideo** video object to **fire.flv**. It also sets the source of the **handVideo** video object to **hold.flv**. It ends by playing both video clips. The remaining case statements respond to the remaining buttons being clicked.

6. Choose **File > Save** to save the movie. Test the movie by choosing **Control > Test Movie**. Click the buttons on the right to see the different effects. Notice how the movies have transparency and the Flash Movie appears in the background.

Creating Transparent Video on a Web Page

Flash movies, like transparent GIF and PNG graphics, can have a transparent background. The overall effect is that the Flash movie has no solid background and its elements seamlessly composite over the web page that contains it. Most modern browsers support this feature, but the following list is what Adobe officially supports:

- Internet Explorer 3.0 or higher (Windows)
- Internet Explorer 5.1* and 5.2* (Macintosh OS X)
- Netscape 7.0*
- Mozilla/Firefox 1.0 or higher*
- AOL*
- CompuServe*

 * Adobe Flash Player version 6,0,65,0 (Windows) or 6,0,67,0 (Macintosh) or higher is required.

Transparency mode is not supported in Mac OS Classic (anything prior to OS X) or in a Flash stand-alone projector. Transparency mode may affect your Flash movie's performance. If performance is poor, you could use the same background color in the Flash movie and the web page.

Tutorial: Exporting Transparency from Flash

In this tutorial we'll place video on the stage in Flash and export it using the transparent window mode embed parameter.

Figure 7.9: *Example web pages with transparent mode off (left) and on (right).*

Chapter 7: Video Transparency and Effects

1. Open the DVD-ROM folder **Tutorials > Chapter 7**. Copy the folder **Web Page Transparency** to your computer.

2. Launch Flash Professional. Choose **File > New**. Select **Flash File (ActionScript 3)**. Click **OK**. A new Flash document opens.

3. Choose **Modify > Document**. Set the dimensions to **500 × 500**. Click **OK**.

Figure 7.10: *Setting the dimensions for the Flash movie.*

4. Choose **File > Save**. Save the file as **transparency.fla** in the **Web Page Transparency** folder on your computer.

5. Choose **File > Import Video**. In the **Import Video** dialog, select **On your computer** and click **Choose**. Navigate to the **Web Page Transparency** folder on your computer, select the file **glow.flv**, and click **Open**. Click **Continue**.

6. In the **Deployment** stage of the **Import Video Wizard**, select **Progressive download from a web server**. Click **Continue**.

7. In the **Skinning** stage of the wizard, select **SkinOverPlaySeekStop.swf** for the player skin and set the color to **#999999** and the alpha to **35%**.

Figure 7.11: *Selecting a color and transparency setting for the player skin.*

8. In the last stage of the wizard, click **Finish**. An instance of the FLVplayback component appears on the stage. Select it and name it **myVideo** in the **Properties** panel.

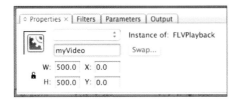

Figure 7.12: *Name the FLVPlayback component instance.*

9. Choose **File > Publish Settings**. Click the **HTML** tab.

10. Select **Transparent Windowless** from the **Window Mode** menu. This sets an embed/object parameter of wmode equal to transparent.

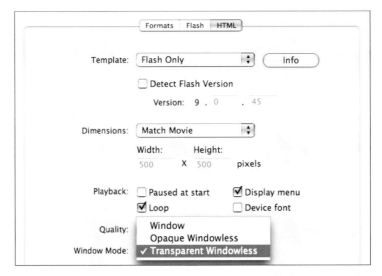

Figure 7.13: *Setting the Window Mode in the HTML publishing options tab.*

11. Choose **File > Save** to save the document.

12. Choose **File > Publish Preview > Default.** You should see the video in the page. The video plays against a white page, but it's not clear really if the background is transparent.

13. Open the HTML or text editor of your choice and open the file **transparency.html** that is located in the Web Page Transparency folder on your computer. Add the following before the end **</head>** tag:

```
<style type="text/css">
<!--
body { background: #FF9900 url(stipple.gif); }
-->
</style>
```

This will set the web page's background to use a Cascading Style Sheet (CSS) background color and image.

Chapter 7: Video Transparency and Effects

14. Save the file and open it in a web browser. Refresh the browser view if needed. You should see the movie play against a stippled yellow-orange background.

 If you are editing an existing web page, you need to add <param name="wmode" value="transparent"> to the Flash movie's OBJECT tag and add wmode="transparent" inside the EMBED tag.

Masking Video

A mask layer is like an alpha channel—it removes portions of an image. In Flash Professional, a mask layer is placed above the content to be masked. Any filled shape or text can be used on a mask layer.

Tutorial: Masking Video

In this tutorial, we'll add video to an existing Flash movie and mask it.

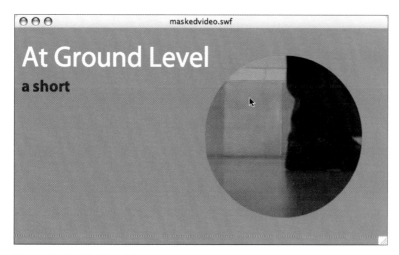

Figure 7.14: *Masking video.*

1. Open the DVD-ROM folder **Tutorials > Chapter 7**. Copy the folder **Masking Video**, to your computer.

2. Launch Flash Professional. Choose **File > Open**. Open the file **maskedvideo.fla** in the **Masking Video** folder on your computer.

3. Create two layers below the **text** layer and name them **mask** and **video**. The mask layer should be on top of the video layer.

Figure 7.15: *The layer order is important when masking elements.*

4. Lock the **mask** layer and select the **video** layer. This will ensure that content we add to the stage appears on the correct layer. Since a mask layer affects the layer below it, it's important to place content on the correct layer.

5. Open the **Components** panel. Drag an instance of **FLVPlayback** onto the stage. Using the **Properties** panel, name it **myVideo**.

6. Using the **Component Inspector** panel, set the **source** parameter to **feet_traffic.flv**, a file that is in the **Masking Video** folder.

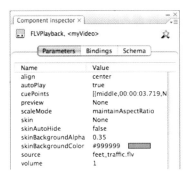

Figure 7.16: *Setting the source for the video playback component.*

7. Lock the **video** layer and unlock and select the **mask** layer.

8. Open the **Library** panel. Drag an instance of the **circle** graphic symbol to the stage.

9. Position it at 0, 9.3 using the **Properties** panel.

10. **Right-click** (Windows) or **Control-click** (Mac OS X) on the **mask** layer and choose **Mask** from the context menu. Lock the **mask** layer and the preview can be viewed at authoring time. Note that the mask layer and layer being masked both must be locked in order for the mask effect to work.

Figure 7.17: *Mask and masked layers must be locked.*

11. To make the video more noticeable, let's write an event listener to listen for the end of the video and a function to loop the video. Choose **Window > Actions**. Select frame 1 in the **actions** layer. In the **Actions** panel enter:

```
import fl.video.VideoEvent;
myVideo.addEventListener(VideoEvent.COMPLETE, loopVideo);
function loopVideo(evt:VideoEvent):void {
    myVideo.play();
}
```

12. Choose **File > Save**.

Chapter 7: Video Transparency and Effects

13. Choose **Control > Test Movie**. The video is now masked by the circle shaped layer.

Applying Blend Modes and Effects to Video

Flash Player includes three methods for composing images: blend modes, color effects, and bitmap effects. Alone and combined, they offer nearly unlimited possibilities for tinting, overlaying, and blending graphic symbols, bitmap images, text, and video.

○ **Blend modes** in Flash are like transfer modes in Photoshop or After Effects. They work by applying a compositing mode to a foreground element and its colors then blend with the background element's colors to create interesting visual effects.

There are nearly a dozen blend modes available in Flash. To see a full description of each, look up "blend modes" in Flash CS3 Professional's online help.

○ **Color effects** can also be applied to any element on the stage. Color effects include tinting, alpha, brightness, and an advanced mode that let you manipulate individual red, green, blue, and alpha channels.

○ **Bitmap effects** are filters that can be applied to text elements and movie clips. They cannot be applied to graphic elements and groups. Flash includes filters for creating drop shadows, blurring and image, creating glows, and creating custom filters from convolution kernels.

Tutorial: Applying Blend Modes and Color Effects

In this tutorial we'll modify a video's blend mode and apply a color effect. The end result will create transparency as well as color interaction between the video and the background image.

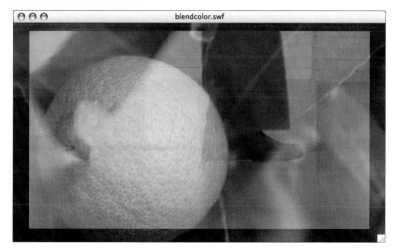

Figure 7.18: *Applying blend modes and color effects to a video clip.*

1. Open the DVD-ROM folder **Tutorials > Chapter 7**. Copy the folder **Blend Modes and Color Effects** to your computer.

2. Launch Flash Professional. Choose **File > Open**. Open the file **blendcolor.fla** in the **Blend Modes and Color Effects** folder on your computer.

3. On the stage is a video, **myVideo**, on top of a background image. Select the **myVideo** instance. In the **Properties** panel, select **Screen** from the **Blend** menu.

4. With **myVideo** selected, choose **Tint** from the **Color** menu. Set the **Tint** amount to **25%** and the **RGB** color values to **153**, **51**, and **0**.

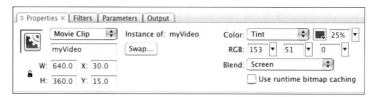

Figure 7.19: *Selecting a color and amount for the tint.*

5. Choose **File > Save**. Choose **Control > Test Movie** to preview the movie with the blend mode and color effects applied to it.

Tutorial: Applying Bitmap Effects Directly

In this tutorial, we will apply a bevel and a drop shadow to a video component.

Figure 7.20: *Bitmap effects can be applied to any movie clip symbol or text element.*

1. Open the DVD-ROM folder **Tutorials > Chapter 7**. Copy the folder **Bitmap Effects** to your computer.

2. Launch Flash Professional. Choose **File > Open**. Open the file **bitmap.fla** in the **Bitmap Effects** folder on your computer.

3. On the stage is an instance of an FLVPlayback component named **myFLVPlayback**. Select it and choose **Modify > Convert to Symbol**. In the **Convert to Symbol** dialog, name the symbol **myVideo** and set the type to **Movie clip**.

Figure 7.21: *Creating a movie clip from the FLVPlayback component.*

4. The component on the stage is replaced with the new movie clip. If you select it and look at the **Properties** panel, you'll see that the object is now a movie clip and an instance of **myVideo** and not **FLVPlayback**. Name the instance **fxClip**.

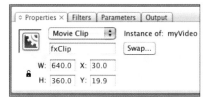

Figure 7.22: *Name the movie clip.*

> Converting an element to a symbol in Flash is like precomposing a layer in After Effects. The original element is placed inside a new timeline and can be reused in several places.

5. Select **fxClip** and open the **Filters** panel (**Window > Properties > Filters**). Click the **Add Filter** icon and choose **Bevel**. Set both the **Blur X** and **Y** values to **8**, the **Strength** to **50**, the **Quality** to **High**, the **Angle** to **90**, and the **Distance** to **8**.

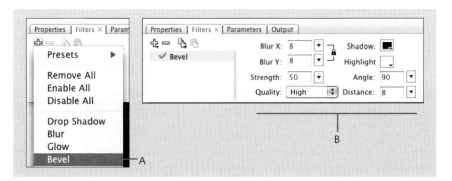

Figure 7.23: *Choose Bevel (A) and the set the filter parameters (B).*

6. Click the **Add Filter** icon again and select **Drop Shadow**. Set the **Blur X** value to **16**, the **Blur Y** value to **8**, and the **Strength** to **100%**. Select **High** for the **Quality** setting, enter **90** for the **Angle**, and enter **8** for the **Distance**.

7. Choose **File > Save**. Choose **Control > Test Movie** to preview the movie with the drop shadow and bevel filters applied to it.

Tutorial: Applying Bitmap Effects Dynamically

Bitmap effects can also be applied using ActionScript. In this tutorial, we will create a Flash movie that applies different bitmap effects using the **filters** class and the ActionScript 3 user interface components. The Flash document is partially complete: elements are on the stage and symbols and components have been added to the document's library. All that is left to do is write the ActionScript.

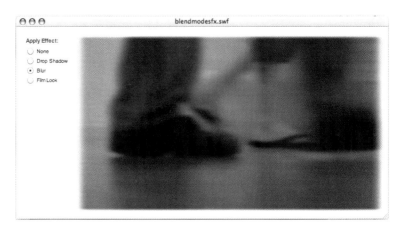

Figure 7.24: *A sample application that applies different effects to video.*

1. Open the DVD-ROM folder **Tutorials > Chapter 7**. Copy the folder **Bitmap Effects and ActionScript** to your computer.

2. Launch Flash Professional. Choose **File > Open**. Open the file **bitmap_actionscript. fla** in the **Bitmap Effects and ActionScript** folder on your computer.

3. Choose **Window > Actions**. Select **frame 1** in the **actions** layer. Let's begin by importing classes we'll be using.

```
import fl.controls.RadioButton;
import fl.controls.RadioButtonGroup;
import fl.controls.Label;
import flash.text.TextFormat;
import fl.managers.StyleManager;
import flash.filters.BlurFilter;
import flash.filters.DropShadowFilter;
import flash.filters.ColorMatrixFilter;
```

The first three import statements facilitate working with the ActionScript 3 user interface components: radio button, button group, and label. A radio button occurs in a group of at least two radio buttons that are mutually exclusive of one another. Within a group, only one can be selected, and selecting one deselects the other. The **RadioButtonGroup** class enforces this exclusivity. The **Label** class is for managing labels used for combo boxes, groups of controls, or text fields. In this application, there is one label, Apply Effect, for the application's four radio buttons. The **TextFormat** and **StyleManager** classes are for setting typographic attri-

butes for text fields and for text used in user interface components. The **filters** class includes the bitmap effects classes we'll use in this Flash application: **BlurFilter**, **DropShadowFilter**, and **ColorMatrixFilter**.

4. Let's add a **TextFormat** object to change the font color, weight, and font family for the label **fxLabel**. Enter:

```
var tf:TextFormat=new TextFormat;
tf.color=0x555555;
tf.bold=true;
tf.font="Arial";
fxLabel.setStyle("textFormat",tf);
```

The first creates an instance, **tf**, of the **TextFormat** class. The next three lines set the color to medium gray, set the label in bold, and change the font to Arial. The fifth line uses the **setStyle()** method to apply this new style to the label.

5. If you look at the stage, you'll notice that there are no radio buttons on it. Instead, we'll create them dynamically with ActionScript. Enter:

```
var noneRadio:RadioButton = new RadioButton();
noneRadio.label = "None";
noneRadio.group = myRadioGroup;
noneRadio.move(20, 40);
addChild(noneRadio);

var dropRadio:RadioButton = new RadioButton();
dropRadio.label = "Drop Shadow";
dropRadio.group = myRadioGroup;
dropRadio.move(20, 60);
addChild(dropRadio);

var blurRadio:RadioButton = new RadioButton();
blurRadio.label = "Blur";
blurRadio.group = myRadioGroup;
blurRadio.move(20, 80);
addChild(blurRadio);

var toneRadio:RadioButton = new RadioButton();
toneRadio.label = "Film Look";
toneRadio.group = myRadioGroup;
toneRadio.move(20, 100);
addChild(toneRadio);
```

Each block begins by creating a new instance of the **RadioButton** class. The label, radio button group, and position are then set. Lastly, each button is added to the stage's display list by calling the **addChild** method.

6. With the label created, create a radio button group. Enter:

```
var myRadioGroup:RadioButtonGroup = new RadioButtonGroup("options");
myRadioGroup.addEventListener(Event.CHANGE, changeHandler);
```

This creates a radio button group named **myRadioGroup** and adds an event
listener to it. The change event will occur anytime a different button within the
group is chosen. When the event occurs, the **changeHandler** method will run.
We'll write that function at the end of the tutorial.

7. The drop shadow filter in Flash has parameters for distance, angle, color and opac-
ity, blur settings for X and Y directions, strength, and quality.

The last two parameters, strength and quality, need additional explanation.
Strength is how much shadow color is used in the shadow. Higher values can
increase the contrast between the shadow and the background. Zero to 255.0 is
the range of possible values. Quality is the shadow's rendering quality, but note
a value of 1 generates a low-quality shadow while 3 generates a higher-quality
shadow. Enter:

```
function addShadow(shadowDistance:uint, shadowAngle:uint,
shadowColor:uint, shadowAlpha:Number, blurX:uint, blurY:uint, strength:uint,
quality:uint, videoMC:MovieClip) {
    var myFilter:DropShadowFilter = new DropShadowFilter(shadowDistance,
    shadowAngle, shadowColor, shadowAlpha, blurX, blurY, strength, quality);
    videoMC.filters = [myFilter];
}
```

The function declaration includes all the parameters for the filter as well as the
movie clip that will receive the filter. The code inside the function begins with cre-
ating a new drop shadow filter object according to the parameters that are passed
to the function. Filters work by creating them, creating an array and adding the fil-
ter object to the array, and then associating a movie clip's filters property with the
array. By using an array, a movie clip can have more than one filter applied to it.

8. Next, let's write the **addBlur** method. It includes parameters for the distance to
blur a movie clip in X and Y and the quality.

```
function addBlur(x:uint, y:uint, bQuality:uint, videoMC:MovieClip):void {
    var myFilter:BlurFilter = new BlurFilter(x,y,bQuality);
    videoMC.filters = [myFilter];
}
```

This method accepts all the filter settings and the target movie clip as parameters
for the function. It creates a new blur filter object, creates an array and adds the
filter object to it, and associates the array with the movie clip.

9. The next filter uses the color matrix filter. The color matrix filter works by manipu-
lating the color and transparency values of every single pixel in an element. The

Chapter 7: Video Transparency and Effects

red, green, blue, and transparency components of the pixel are manipulated by a matrix or array of 20 numbers.

```
function addTone(a1:Number, a2:Number, a3:Number, a4:Number, a5:Number,
a6:Number, a7:Number, a8:Number, a9:Number, a10:Number, a11:Number,
a12:Number, a13:Number, a14:Number, a15:Number, a16:Number, a17:Number,
a18:Number, a19:Number, a20:Number, videoMC:MovieClip):void {
   var matrix:Array = [
   a1, a2, a3, a4, a5, a6, a7, a8, a9, a10,
   a11, a12, a13, a14, a15, a16, a17, a18, a19, a20
   ];
   var myFilter:ColorMatrixFilter = new ColorMatrixFilter(matrix);
   videoMC.filters = [colorMatrix];
}
```

The add tone function, like the previous two functions, pass in the filter parameters and the target movie clip. Since there are 20 numbers in a color matrix, this method has a lot of input parameters. Finally, like the other functions, it works by creating a new filter object.

 Many different effects can be created with the filter. To see a few examples, review the Adobe Developer Center article at: http://www.adobe.com/devnet/flash/articles/matrix_transformations.html.

```
function changeHandler(event:Event):void {
   var rg:RadioButtonGroup = event.target as RadioButtonGroup;
   switch (rg.selection) {
      case noneRadio :
         blurVideo(0, 0, 0, myVideo);
         vidDropShadow(0, 90, 0x000000, 0, 0, 0, 1, 1, myVideo);
         setTone(1, 0, 0, 0, 0, 0, 1, 0, 0, 0, 0, 0, 1, 0, 0, 0, 0, 0, 1, 0,
myVideo);
         break;
      case dropRadio :
         vidDropShadow(8, 90, 0x000000, 0.75, 16, 8, 1, 3, myVideo);
         break;
      case blurRadio :
         blurVideo(16, 4, 3, myVideo);
         break;
      case toneRadio :
         setTone(0.8, 1.1, -0.7, 0, -77, 0.1, 0.9, 0.3, 0, -78, 0.8, 0, 0.4,
0, -78, 0, 0, 0, 1, 0, myVideo);
         break;
   }
}
```

This function accepts an event as a parameter and uses the event's target to create a radio button group for the switch statement that follows. Inside the switch statement are conditions for each of the radio buttons created earlier. The radio button, **noneRadio**, resets the effects and restores the video to its original state. The drop shadow radio button, **dropRadio**, calls the **addShadow()** method that applies

a shadow to the video. The blur radio button, **blurRadio**, calls the **addBlur()** method that blurs the video. Finally, the color matrix radio button, **toneRadio**, calls the **setTone()** method that applies a film processing treatment to the video.

Wrapping Up

In this chapter we covered the creative options a Flash Video developer can do to blend, composite, and creatively enhance video. By combining several of these techniques you can make your Flash Video applications more expressive and you can use a lot of the same masking, filtering, and blend modes on nonvideo movie clip symbols too.

CHAPTER 8

Enhancing Flash Deployment

While all the fun occurs while authoring Flash content and preparing video, integrating Flash with HTML can't be avoided. This chapter covers issues you should know about when deploying to the Web.

Deploying Flash with HTML

Let's face it, Flash Video is primarily embedded in web pages. Given that relationship, there are several issues to wrangle when publishing video on a web site: web browser compatibility, ensuring the correct Flash Player is installed, making the content search engine friendly, displaying alternative content for those who don't have Flash or JavaScript enabled, and overcoming the "click to activate experience" caused by recent changes to Microsoft Internet Explorer. As a developer you can:

- Use standards-compliant markup.
- Use proprietary markup to solve browser compatibility.
- Use JavaScript to dynamically embed the video.
- Use combinations of the aforementioned methods.

None of these directions are perfect and there are several implementation approaches for each. In this chapter we'll cover the issues that affect publishing Flash on web pages and present tutorials that cover some of the popular methods.

How Flash Video Is Embedded

Flash Video (FLV) is "housed" inside a container Flash movie (SWF). The housing SWF streams the FLV and provides methods to control playback (either on its own or through a skin SWF). The housing SWF is embedded inside a web page (HTML). When a viewer visits a page with Flash Video, the browser loads the Flash Player plug-in and viewing begins.

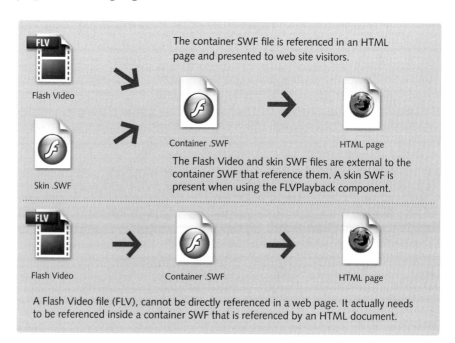

Figure 8.1: *Relationship between an FLV, SWF, and HTML document.*

Browser Compatibility and Web Standards

The Internet is not viewed by only one browser alone. Yes, Microsoft Internet Explorer commands a large portion of the browser market share, but there are millions of viewers who also use the Firefox browser, Opera, or Safari on Mac OS X. The problem is not in how each browser supports Flash, but really how they support non-HTML (or plug-in) content in general. Flash like QuickTime, Real Media, or Windows media is placed on a web page using the <embed> tag, the <object> tag, or both tags.

What Are Web Standards?

At the peak of the first Internet bubble, most web pages were created by mixing structure and presentation, did not use semantic markup, and used a variety of proprietary, hack-derived, and inaccessible technologies. The result was sites that worked for some and appeared broken to others. Coincidentally, many of these hacked-together pages are not optimized for search engines. The term and movement "Web Standards" grew from the desire for long-term universal access and interoperability on the World Wide Web.

Figure 8.2: Visit http://www.webstandards.org to learn more best practices.

Web standards promotes the use of semantic markup, open standards (XHTML, CSS, JavaScript, microformats, and XML), and accessibility among developers and designers. The movement also works closely with browser manufacturers and web tooling companies such as Adobe to increase standards support.

Semantic Markup

Semantic markup is the practice of marking web pages using appropriate HTML tags in marking up content. For example, paragraphs are enclosed inside a paragraph tag, **\<p\>**, a first-level heading is placed inside a heading 1 tag, **\<h1\>**, and a numbered list is marked up using the ordered list and list item tags, **\<ol\>** and **\<li\>** respectively. When markup reflects the organization and meaning of content, it future-proofs the content, makes it easier to find via a search engine, and greatly facilitates changes and updates to both the content and the design.

The practice of applying semantic markup is a best-practice alternative to building web pages completely with tables. While tables were an effective layout mechanism in the early days of the Web, they should be avoided today. Tables should only be used for displaying tabular data. Pages should use **\<div\>** tags along with other block-level HTML tags and cascading style sheets (CSS) to create layouts.

 Digital Web also has an excellent primer on writing HTML using semantic markup by Joshua Porter and Richard MacManus. It's at: http://www.digital-web.com/articles/writing_semantic_markup/.

Open Standards

Open standards are web technologies such as HTML, CSS, and JavaScript. They are standards because they are managed by international nonprofit organizations with representation from educational institutions, corporations, and the open source community. These technologies have specification and review processes that are open to anyone. When a technology reaches a final draft, browser manufacturers and tool developers are encouraged to support the specifications. By using open standards and avoiding proprietary markup, universal access is achievable.

 A List Apart has many articles on designing web sites using standards. It can be found at: http://www.alistapart.com.

While not an open standard, Flash, like all other rich-media technologies, has its place when it is implemented responsibly. Responsible implementation means using unobtrusive techniques for inserting content and providing alternative content and assistance for those who cannot view the material being presented.

Web Page Validation

Having pages validate is sort of like passing a grammar quiz. While there may be a few correct answers to a question, there's no doubt when an answer is wrong. That said, it's not surprising that many developers do not or conveniently forget to validate their pages using the W3C's (World Wide Web Consortium) page validator. To ensure your page passes validation, here are a few things your markup needs to do:

- Properly declare a document type and character encoding. The document type declares what version of HTML you are using. The character encoding is important when using mathematical or foreign language characters.

- All tags should be well-formed. This means items have opening and closing tags such as a **\<p>**A line of text**\</p>**. For single tags such as the line break tag, a closing slash should be used: **\
** instead of simply **\
**.

- Avoid deprecated or nonstandard tags and attributes. Use **\**important **\** rather than the deprecated **\**important**\** tag. If you do use non-standard attributes and tags, be sure to namespace them.

- Do not improperly nest tags. For example, an **\<h2>** tag should not be inside a **\<p>** tag.

 To learn more about page validation, read Ethan Marcotte's article, Where Our Standards Went Wrong *at: http://alistapart.com/comments/whereourstandardswentwrong/. To validate a page, go to http://validator.w3.org/.*

Accessibility

Accessibility has taken on two different but related meanings. Pages are *accessible to those with disabilities* when they provide hooks for assistive technologies. Pages are *universally accessible* when they are viewable by a wide range of user agents, for example, computers, mobile phones, and consumer electronic devices such as a Sony PS3 or Nintendo Wii.

To achieve accessibility, here are general things you can do:

- Set properties such **alt** and **title** on **\<image>** and **\<link>** tags. These make the page easier to read by screen-readers for the visually impaired.

- Include closed captions for video content. This makes it accessible to the hearing impaired.

- Properly set tab order and specify access keys on form elements and links. These two things make it easier to control a web page using a keyboard.

- Implement the page using standards-based markup. This will ensure that a wide variety of user agents can display the content.

 These are just some of the things you can do to make your web pages more accessible. To learn more, visit: http://www.webstandards.org/action/atf/ and http://www.w3.org/TR/ WAI-WEBCONTENT/.

Making web pages accessible is not just for assisting those with disabilities, but also for making content readable by machines. Setting alt and title properties as well as metadata in SWF files help with indexing, search engine optimization, and natural language search.

Object and Embed Tags

Flash is embedded with two tags: **\<embed>** and **\<object>**. The former is a non-standard tag that originally found its way into HTML when Netscape introduced

browser plug-ins. The tag unfortunately never was adopted by the W3C, the body that governs the HTML specification.

The **embed** tag, however, has better cross-browser and cross-platform support since it was fairly well defined at the beginning and all the browser manufacturers implement it the same way. Besides having an unknown future, it invalidates HTML because it's not part of the HTML spec, and it has horrible support for showing alternative content. Its **<noembed>** tag counterpart only works when the client technology doesn't support the tag, which is the case with some mobile web browsers. When the client supports the tag (as is the case with all desktop web browsers), it shows an outline with a broken plug-in and ignores the content set inside the **noembed** tag.

The W3C instead developed the **object** tag because it was less prone to patent issues (see *EOLAS Patent and Active Content* on the following page). The problem with the object tag has been how browser manufacturers have implemented it. Everyone but Microsoft implemented it using the **type** property, which uses MIME file-type descriptions to indicate the object's file type and helper application or plug-in technology. (MIME types have been used since the beginning of the Web to describe file formats to web servers.) Instead of going with this standards-based approach, Microsoft created the proprietary property, `classid`, to identify what Active-X control to use when displaying the plug-in content.

Hopefully the day when Internet Explorer deprecates `classid` while supporting the **type** property will come soon. While the support for the object tag is not as good as the embed tag, it does support alternative content. Assuming the object tag is used for inserting Flash, the content placed between the opening and closing object tags is not rendered when browsers support Flash. When there is no support available for Flash, the content appears. This content can contain a description of the Flash movie and a picture serving as a preview. This content is, however, visible to web crawlers and search engines.

Flash Player Version Detection

The Flash Player is updated with major releases every 12–18 months. When a new release comes out, it takes less than a year for that version to be on the majority of computers connected to the Internet. While Adobe improves the update process with each new release, there is still the need to detect the player version when serving content that relies upon the latest Flash Player release. For example, after the release of Flash Player 8, player detection was crucial when serving Flash Video that used the On2 VP6 codec as it is only available in Flash Player 8 and above.

Player detection is implemented by including JavaScript code that can detect the version of the Flash Player installed on the viewer's computer and comparing it to a variable indicating the player version required to view the content. When the

installed version is equal to or greater than the required version, everything works. When the installed version is less than the required version, viewers see a message communicating that they need to upgrade their player. For users using Microsoft Internet Explorer on Windows, there is Express Install, an Active-X script that does a seamless install for the Flash Player.

The EOLAS Patent and Active Content

This patent lawsuit caused Microsoft to alter the way active content (Active-X controls and plug-ins) are experienced. To comply with the lawsuit, Microsoft had to add a click-to-activate feature inside Internet Explorer. This speedbump, or pane of glass, interrupts and complicates the Web experience for all viewers. To circumvent the click-to-activate feature, web developers can insert the object and embed tags dynamically using JavaScript. While this takes a bit more programming effort, it is far better to do than to force users to have to click a few more times to view content.

Figure 8.3: *What happens when active content is not inserted dynamically.*

Tutorial: Using SWFObject

The following tutorial covers inserting Flash content using the JavaScript library: SWFObject. Back in Chapter 5, we published the custom video player using the Flash Detection Kit, which is a part of Flash CS3. This tutorial will walk you through using markup that is unobtrusive, preserves validation, and provides alternative content. For it we'll use the custom player created in Chapter 5.

SWFObject is a JavaScript library created by Geoff Stearns. To use it, you download the library from http://blog.deconcept.com/swfobject/, include it with your

web site, reference it in the page containing Flash content, and write a few lines of JavaScript and HTML.

ADDITIONAL LIBRARIES

Besides SWFObject, there are other libraries one can use for inserting Flash dynamically. All these libraries help skirt the EOLAS issue, can be applied using unobtrusive scripting, and can be used to replace alternative content. Choosing one is akin to choosing a wine: it partly depends upon your preferences and the entree (or project) you're about to have.

Here are a few other libraries you can consider:

UFO.js, or Unobtrusive Flash Object, was written by Bobby van der Sluis. It's similiar to SWFObject in practice and adoption.

http://www.bobbyvandersluis.com/ufo/

flash.jquery.js was written by web developer and designer Luke Lutman. It's a plug-in for the popular Ajax framework, jQuery. If

you plan to work with Ajax, XML, or dynamic HTML, I recommend it. It's frequently updated, so check it out for revisions.

http://jquery.lukelutman.com/plugins/flash/

Adobe's **Flash Detection Kit** is good for those who don't want to write a lot of JavaScript and HTML code and are not concerned with validation and standards compliance. It's built into Flash Professional CS3.

The **SWFFix** library, which is a collaboration between Geoff Stearns and Bobby van der Sluis to offer a best-in-class approach to inserting Flash content. It's still in development, but might be available by the time you read this book.

http://www.swffix.org

Figure 8.4: *Download SWFObject from Geoff Stearns' blog, blog.deconcept.com.*

1. Navigate to the **Tutorials > Chapter 8** folder. Copy the **SWFObject Embed** folder to your computer.

2. Using the HTML editor of your choice, open **index.html**.

3. Insert a new line after line 7 and enter the following script tag:

```
<script src="js/swfobject.js" type="text/javascript"></script>
```

This tag references the SWFObject JavaScript library. By including it in the page, the page can access all the functionality defined within the library.

4. After the opening **<body>** tag, insert:

```
<div id="flashcontent">

</div>
```

This **<div>** tag will contain the Flash movie as well as the alternative content. The id (identifier) attribute is a hook for the SWFObject script to replace the content inside it with the Flash movie we will soon specify. For now, we'll use an identifier of **flashcontent**.

5. Let's now place the alternative content inside this <**div**> tag. Place the cursor inside the <**div**> tag, and enter the following lines of code:

```
<p><img src="assets/alternative_content.jpg" width="480" height="268"
alt="video still from one interview"></p>
    <h2>The video is a short clip from several filmmaker interviews.</h2>
    <p>In order to view it, you need to enable JavaScript and install or
upgrade <a href="http://www.adobe.com/go/getflashplayer" title="Get Adobe
Flash Player">to a newer version of the Adobe Flash Player</a>.</p>
    <p>
        <a href="http://www.adobe.com/go/getflashplayer">
            <img src="http://www.adobe.com/images/shared/download_buttons/
get_flash_player.gif" title="Get Adobe Flash Player" />
        </a>
    </p>
```

The first paragraph tag contains a graphic showing a still from the video and includes a message stating that the video cannot be played. It instructs the user to download the latest version of Flash Player and to enable JavaScript. The text that follows essentially says the same and the code ends with Adobe's Get Flash Player button. With JavaScript off or when an obsolete browser is installed, the page will appear like the following screenshot.

Figure 8.5: *How the page appears when the browser cannot display the Flash content.*

6. Now let's insert the JavaScript to insert the movie. Place the cursor after the closing **<div>** tag (probably at the end of line 20 if all is going to plan) and insert:

```
<script type="text/javascript">
  // <![CDATA[

  // ]]>
</script>
```

This script block will contain the JavaScript code for inserting the Flash content. The two forward slashes are single-line JavaScript comments. They prevent the JavaScript engine inside the web browser from interpreting the code on that line. The brackets and CDATA statement instructs any HTML page validator to ignore the content inside the statement and helps with validating the page against a particular document type. So this double-comment technique is a good snippet to use whenever you're writing JavaScript code inside the page.

 Ideally most code should be written in an external file and referenced for clear separation of structure and behavior. Since this is a small tutorial, however, it's perfectly okay to mix them up a little.

7. The code to insert the Flash video is quite simple, if not a little terse. Inside the CDATA block, enter:

```
var so = new SWFObject("assets/customplayer.swf", "flvplayer", "480",
"406", "9", "#FFFFFF");
so.addParam("allowFullScreen", "true");
so.write("flashcontent");
```

The first line creates a new SWFObject named **so**. When it creates the object, it
specifies the location for the Flash content it will use as well as its identifier, width,
height, required Flash Player version, and background color. The second line adds
an additional parameter for allowing full-screen mode to work. The last line calls
the write method, which does the hard work of taking all the attributes we just
passed to it and dynamically writing this content to the web page when it loads
inside a capable web browser.

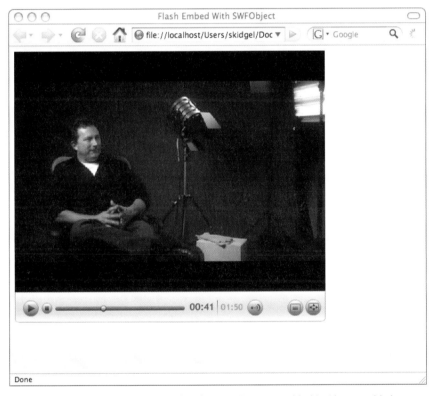

Figure 8.6: *The page displays properly when JavaScript is enabled inside a capable browser.*

 *On the DVD-ROM are examples of inserting Flash Video using the UFO.js and the
flash.jquery.js JavaScript libraries. Look in > Additional Content > Inserting Flash.*

Ensuring Your Web Site Can Serve Flash Video

In the case your hosting provider or internal IT-supported web server hasn't reg-
istered the Flash Video file format with its servers, you won't be able to serve the
files. Flash Video, like JPEG, GIF, or SWF files, are complex file formats (anything

beyond simplified text) and web servers need to be instructed on how to serve them. That's where MIME types (Multipurpose Internet Mail Extensions) come in. A mail client, web server, or web browser uses MIME types to correctly interpret complex file formats. The MIME type for Flash Video is video/x-flv.

 If you're running Microsoft Windows 2003 and IIS Server 6.0 and cannot see Flash Video correctly, check out: http://www.adobe.com/go/tn_19439.

Wrapping Up

This chapter covered the issues you'll encounter when integrating Flash Video in a web page. By following open standards, offering alternative content, and using unobtrusive insertion techniques, you ensure that your content is future proof, better optimized for search engines, and more accessible.

CHAPTER 9

..

More Flash
Video Applications

The tutorials presented in this chapter will improve your ActionScript skills and take your Flash Video skills to a new level. You'll be ready to create a variety of custom Flash Video applications by using one or more of the concepts covered.

Displaying Closed Captions

A lot of audio and video content on the Web today is distributed using the Flash platform. To make this content more accessible, closed captions (CC) should be used whenever the audio portion of the content contains essential information. With Flash CS3, it's much easier to produce video that is more accessible to the hearing impaired with the FLVPlayback Captioning component.

WHAT IS ACCESSIBILITY?

As you produce and distribute content for the Web, you should consider how you can make your content more accessible to those with disabilities. Closed captioning is just one way video content can become more accessible. Other ways include: keyboard navigation, context menus, or high-contrast modes.

To learn more about accessibility best practices, visit Adobe's Developer Center at: http://www.adobe.com/accessibility/.

The FLVPlayback Captioning Component

The FLVPlayback Captioning component displays closed captions in the Timed Text (TT) XML file format for video played back with the FLVPlayback component. The component works by dynamically creating ActionScript cue points for each caption. Through ActionScript, the component can manage closed captions for more than one video file and the display of the captions can be toggled on or off.

These cue points are prefixed with "_caption_" to prevent any conflicts. When you add cue points as part of the encoding process, it's advised to not use this prefix.

Tutorial: Adding Captions to Flash Video

In this tutorial, we'll quickly add captions to video using the FLVPlayback and FLVPlayback Captioning components and the Property panel. By the end of it, you should have something that looks like the following movie.

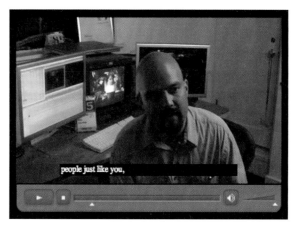

Figure 9.1: *Flash Video with closed captions.*

Chapter 9: More Flash Video Applications

1. Navigate to the **Tutorials > Chapter 9** folder. Copy the **Closed Captions** folder to your computer. Open the folder and double-click **captions.fla**.

2. Once the file opens in Flash CS3, open the **Components** panel by pressing **F7** (Windows) or **Command+F7** (Mac OS). Open the Video category and drag a **FLV-Playback** component to the **Stage**.

Figure 9.2: *The playback and captioning components.*

3. If the **Properties Inspector** is not open, press **F3** (Windows) or **Command+F3** (Mac OS). Select the playback component and enter **vidPlayback** for its instance name.

Figure 9.3: *Setting the instance name for the FLVPlayback component.*

4. Click the **Parameters** tab in the **Properties Inspector** and double-click the **skin** attribute. In the **Select Skin** window, choose **SkinUnderPlayStopSeekMuteVol.swf**.

Figure 9.4: *The Select Skin dialog.*

5. In the **Parameters** tab scroll the properties list until the **source** attribute is in view and double-click it. In the **Content Path** dialog, click the **Folder** icon and select **eric. flv** in the **Chapter 9** folder. Once the FLV file appears in the dialog, select **Match source FLV dimensions** and click **OK**.

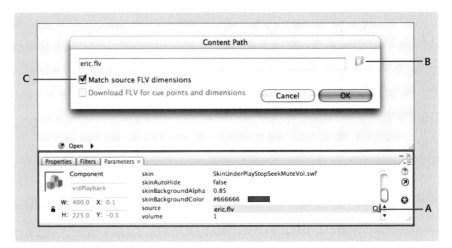

Figure 9.5: *Click the magnify icon in the source field (A). Click the Folder icon to pick the file (B). Check Match source FLV dimensions (C).*

6. Set the **X** and **Y** coordinates for **vidPlayback** to 0, 0 in the **Properties** panel.

7. From the **Components** panel, drag a **FLVPlaybackCaptioning** component to a location just off the **Stage** so it does not obscure the video during authoring time. Using the Properties panel, give this instance a name of **myCaptioning**.

8. Select the captioning component, and open the **Parameters** tab. Set **autoLayout** to **false**, the **flvPlaybackName** to **vidPlayback**, **showCaptions** to **true**, and the **source** to **captions.xml**. Press **Control+Return** (Windows) or **Command+Return** (MacOS) to preview the movie.

Flash CS3 Support for Timed Text

The last tutorial gave a quick introduction into using the captioning component, but you probably noticed that the text was not styled. Beyond supporting timed locations for captions, the captioning component's support for the Timed Text format includes attributes for:

- Character formatting
 - ▶ Size with absolute sizes (in pixels) or with delta values (+2 or −2)
 - ▶ Color
 - ▶ Font
 - ▶ Normal, bold, or italic
 - ▶ Justification
- Paragraph formatting
 - ▶ Alignment: center, left, or right
- Background formatting
 - ▶ Background color, or removing the background color entirely
 - ▶ Turning word wrap on or off

Chapter 9: More Flash Video Applications

How Timed Text Files Are Structured

A TT file intended for distribution with a captioned Flash Video file should include a document declaration, a head section, and a body. The document declaration section simply states the file is an XML file and follows the Timed Text standard. You should never need to edit the declaration. The head includes optional styling information inside **`<styling>`** and **`<style>`** tags. If you decide to keep the styling inside the TT file, you will edit the contents of this area a lot and you should learn about style tags and inheritance. The body section includes languages inside **`<div>`** tags and each language includes one or more captions inside separate paragraph or **`<p>`** tags. If you prepare or style the captions, you will find yourself working frequently with this section of a TT document too.

 To learn more about the Timed Text format, go to http://www.w3.org/AudioVideo/TT/ and http://www.w3.org/TR/ttaf1-dfxp/.

Tutorial: Setting Timed Text Styling Options

In this next tutorial, we'll tour a Timed Text file and then create and apply styles to the captions. For this tutorial, you will need a text editor. On the PC, I'd recommend using Dreamweaver or NotePad. On the Mac you could use Dreamweaver, TextMate, BBEdit, or TextEdit. If an editor you like is not listed, feel free to use that if it can edit plain text files.

Figure 9.6: *Captions that have been styled.*

1. Navigate to the **Tutorials > Chapter 9** folder. Copy the **Caption Styling 1** folder to your computer. Open the folder and open **captions.xml** in the text editing application of your choice.

2. Beginning at line 4, you'll see the **`<styling>`** tag. It contains individual **`<style>`** tags that define the available caption styling. In this document, there is currently one style, with an **id** (think identification or name) of 1. It specifies that any caption that references it will be centered and have a font size of 18 pixels.

```
<styling>
   <style id="1" tts:textAlign="center" tts:fontSize="18"/>
</styling>
```

3. And if you look at line 9, the **<div>** tag contains an attribute-value pair of **xml:lang="en"**. This means the following captions enclosed within the **<div>** and **</div>** tags are in English. Additional languages are added by appending a new **<div>** block with a different language. You can learn the language abbreviations in the cheat sheet on the DVD.

```
<div xml:lang="en">
```

4. Look at the first paragraph tag on line 10. It has attributes for the caption's beginning, its duration, and the style it's using. Between the opening and closing paragraph tags is the text used for the caption. The **begin** attribute is in the form of hours:minutes:seconds:frames where frames is measured in hundreds of a second. The **dur** attribute sets the caption's duration. The **style** attribute references a **<style>** tag from the head of the document.

```
<p begin="00:00:00.00" dur="1400ms" style="1">
   The one thing I would recommend to
</p>
```

5. Now that we've looked at the basic structure of a Timed Text file, let's get down to styling. Enter (replacing the existing **<style>** tag) in the following lines of code between the **<styling>** tag that begins on line 4.

```
<styling>
   <style id="base" tts:fontFamily="Arial" tts:fontSize="14"/>
   <style id="left" style="base" tts:textAlign="left"/>
   <style id="center" style="base" tts:textAlign="center"/>
   <style id="right" style="base" tts:textAlign="right"/>
   <style id="bold" tts:fontWeight="bold"/>
   <style id="italic" tts:fontStyle="italic"/>
   <style id="red" tts:color="#ff0000"/>
   <style id="orange" tts:color="#ff9900"/>
   <style id="yellow" tts:color="#ffee00"/>
</styling>
```

These nine **<style>** tags are a basic set one could use for most captioning situations. The set includes a base style that sets the primary font and size, three styles for alignment, two styles for emphasizing text with bold or italic text, and three color styles. The Timed Text format includes a few conveniences for marking up captions efficiently. If you look at the alignment styles, you'll notice that they

reference the base style. While captions styled with each would appear to be left, centered, or right aligned, they would all share the same font and size.

6. To make this point clear, let's apply these styles to the paragraphs below. For the first caption beginning at 00:00:00.0, type **style="left"** as the last attribute in the opening paragraph tag. In the next caption, type **style="right"** as the last attribute in the opening tag. You should now have something like:

```
<p begin="00:00:00.00" dur="1400ms" style="left">
   The one thing I would recommend to
</p>
<p begin="00:00:01.50" dur="1400ms" style="right">
   all filmmakers, short filmmakers,
</p>
```

7. To preview the changes made to the captions file, save the captions file. In the **Captions Styling 1** folder, open **captions.fla**. Test the movie to see the changes. Double-click that file to open it in a Web browser. Notice how the captions shift from the left to the right and they both have inherited the font and size information from the base style.

8. Now we're going to format spans of caption text. This is helpful to do when you want to emphasize a couple of words in a sentence. Inside the first paragraph node, place an opening and closing **** tag around one thing as follows:

```
The <span style="bold red">one thing</span> I'd recommend to
```

The style attributes contain two values, bold and red, which set the text inside the span to be bold and red. A space between them is all that is needed to indicate that this text span should use both styles—commas are not needed.

9. In the **Captions Styling 1** folder, open **captions.fla**. Test the movie.

Code: *Complete listing for captions.xml*

```xml
<?xml version="1.0" encoding="UTF-8"?>
<tt xml:lang="en" xmlns="http://www.w3.org/2006/04/ttaf1" xmlns:tts="http://www.w3.org/2006/04/
ttaf1#styling">
<head>
   <styling>
      <style id="base" tts:fontFamily="Arial" tts:fontSize="18"/>
      <style id="left" style="base" tts:textAlign="left"/>
      <style id="center" style="base" tts:textAlign="center"/>
      <style id="right" style="base" tts:textAlign="right"/>
      <style id="bold" tts:fontWeight="bold"/>
      <style id="italic" tts:fontStyle="italic"/>
      <style id="red" tts:color="#ff0000"/>
      <style id="orange" tts:color="#ff9900"/>
      <style id="yellow" tts:color="#ffee00"/>
   </styling>
</head>
<body>
   <div xml:lang="en">
      <p begin="00:00:00.00" dur="1400ms" style="center">
         The <span style="strong red">one thing</span> I would recommend to
      </p>
      <p begin="00:00:01.50" dur="1400ms" style="center">
         all filmmakers, short filmmakers,
      </p>
      <p begin="00:00:03.00" dur="1900ms" style="center">
         or people starting out as filmmakers,
      </p>
      <p begin="00:00:05.00" dur="2000ms" style="center">
         is to go to <span style="bold red">film festivals.</span>
      </p>
      <p begin="00:00:07.40" dur="1900ms" style="center">
         Film festivals are the only place
      </p>
      <p begin="00:00:09.40" dur="1000ms" style="center">
         to see the work of your peers,
      </p>
      <p begin="00:00:10.50" dur="1900ms" style="center">
         people just like you,
      </p>
      <p begin="00:00:12.50" dur="1800ms" style="center">
         who want to break into filmmaking,
      </p>
      <p begin="00:00:14.30" dur="2000ms" style="center">
         that have a story they want to tell,
      </p>
<p begin="00:00:16.50" dur="2400ms" style="center">
         or want to <span style="italic yellow">learn how</span> to make films.
      </p>
<p begin="00:00:19.00" dur="2800ms" style="center">
         Go there and see what other people are doing.
      </p>
```

```
<p begin="00:00:22.00" dur="1900ms" style="center">
  You see the <span style="italic yellow">really great things</span> they did,
</p>
<p begin="00:00:24.00" dur="1900ms" style="center">
  and you see the <span style="italic yellow">really bad things</span> that they did,
</p>
<p begin="00:00:26.10" dur="1200ms" style="center">
  so you know what to avoid.
</p>
<p begin="00:00:27.50" dur="2000ms" style="center">
  Plus, you get to hear other people's war stories,
</p>
<p begin="00:00:30.00" dur="1700ms" style="center">
  things that they've already figured out.
</p>
<p begin="00:00:31.80" dur="2500ms" style="center">
  There are tens of thousands of people,
</p>
<p begin="00:00:34.30" dur="2500ms" style="center">
  probably hundreds of thousands of people,
</p>
<p begin="00:00:37.00" dur="2000ms" style="center">
  in this country that are out making
</p>
<p begin="00:00:39.00" dur="1500ms" style="center">
  short films every single day
</p>
<p begin="00:00:41.60" dur="1500ms" style="center">
  trying to tell stories <span style="bold red">visually.</span>
</p>
<p begin="00:00:44.00" dur="1900ms" style="center">
  Be a <span style="italic yellow">part of that big community,</span>
</p>
<p begin="00:00:46.00" dur="2000ms" style="center">
  join organizations, there's always
</p>
<p begin="00:00:48.20" dur="1800ms" style="center">
  filmmaking organizations in your
</p>
<p begin="00:00:50.30" dur="2000ms" style="center">
  area through colleges, arts
</p>
<p begin="00:00:52.50" dur="2000ms" style="center">
  organizations, places like that.
</p>
    </div>
  </body>
</tt>
```

Targeting Dynamic Text Fields for Use with Captions

For the times when you'd like to use a custom font, you can link the captioning component to a dynamic text field above the movie. The advantages to this are that you can position the captions somewhere else on the stage and you can apply a drop shadow filter.

Tutorial: Using a Dynamic Text Field for Captions

In this last tutorial on closed captioning, we'll link the captions to a custom-positioned dynamic text field that has a drop shadow filter applied to it.

Figure 9.7: *Assigning captions to dynamic text with a filter applied.*

1. Navigate to the **Tutorials > Chapter 9** folder. Copy the **Caption Styling 2** folder to your computer. Open the folder and open **captions_styling2.fla.**

2. From the **Tool palette**, select the **Text Tool**, T, and draw a text box at the top of the stage.

3. With the text box still selected, go to the **Property Inspector** and change the text type to **Dynamic Text**, name the instance, **captionsText**, and set the width, height, x and y positions to the values shown in the following screenshot.

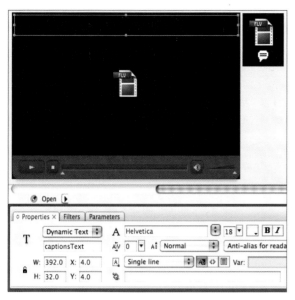

Figure 9.8: *Position the text field at the top of the stage.*

4. Now click the Filters tab and click the Plus button, ⊕, to add the Drop Shadow filter. Set the filter's parameters to the values shown in the following figure.

Figure 9.9: *Set the text field's Drop Shadow options.*

5. Select the captioning component, and select the **Parameters** tab. Set the **caption-TargetName** attribute to **captionsText**. Save and preview the movie.

WHAT ABOUT OTHER FONTS?

In the cases where you want something other than a default system font, you can set the captioning component's simpleFormatting property to true, and use a text field with the desired font, color, and size. Be sure to embed the fonts by clicking the **Embed** button in the **Property Inspector** and selecting Uppercase, Lowercase, Numerals, and Punctuation.

Note that if the captioning component's simpleFormatting property is set to true,

the following attributes are ignored in the Timed Text file: backgroundColor, color, fontSize, fontFamily, and wrapOption. The following properties, however, are still used: fontStyle, fontWeight, and textAlign. This can work to your advantage because color and font size are not meant to convey emphasis, but font style, weight, and alignment are used to stress words or suggest character changes through alignment. If you go the custom route, these more important style settings will still work without cramping your style.

Displaying Cue Points

It's often recommended to set navigational cue points in long-form material because it helps the viewer quickly skip over previously watched material. It's also helpful to show cue points as they occur so the viewer knows she has reached that section in the material.

Tutorial: Displaying Cue Points over Video

In this tutorial we'll take an ordinary video with embedded cue points and add a movie clip and ActionScript to display the names of each cue point as they occur. In order to display the names of each cue point, we need to listen for them. This is accomplished by writing an event listener that dutifully listens for cue points to occur and triggers a function each time one is found. The function does the work of displaying the cue point.

The footage contains snippets of a capsule recovery mission from the Gemini space program. My father was stationed on one of the carriers doing the recovery work and I had his 8mm film telecined to 24 fps standard-definition digital video. In the encoding process, I added several chapter points.

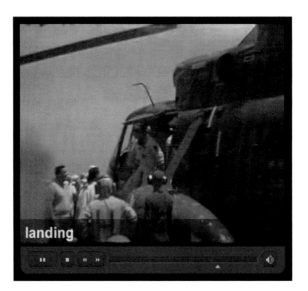

Figure 9.10: *Displaying navigational cue points.*

For a refresher on how to set cue points and name them, review Chapter 4.

1. Navigate to the **Tutorials > Chapter 9** folder. Copy the **CuePoint Overlay** folder to your computer. Open the folder and open **cuepoints.fla.** Preview the movie and watch it. The stage contains an instance of the FLVPlayback component named **myVideo**.

2. If it is not already shown, open the Library panel by pressing **Ctrl+L** (Windows) or **Command+L** (MacOS). Drag the **cuePointRect** movie clip to the stage. This

　　　　　　　　　　　　　　　Chapter 9: More Flash Video Applications

will create an instance of the movie clip on the stage. The **cuePointRect** movieclip contains a black rectangle and a dynamic text field named **cpText**.

3. Position it above the video playback controls and name it **cpOverlay**. By giving it a name, we will be able to access and manipulate it from ActionScript. Use the Property Inspector to adjust its properties shown in the following screenshot.

Figure 9.11: *Name the instance cpOverlay.*

4. With everything in place, it's time to write the ActionScript. In the **Timeline**, select Keyframe 1 in the Actions layer, and open the **Actions** panel by pressing **F9** (Windows) or **Option+F9** (Mac).

Figure 9.12: *Lock the Actions layer to prevent objects from being placed on it.*

5. Let's first set the **cpOverlay** instance to be fully transparent by default. To do that enter the following comment and line of code:

```
cpOverlay.alpha = 0;
```

We can set the alpha property since **cpOverlay** is a movie clip and inherits all the properties of the **MovieClip** class, including alpha transparency.

6. Write the event listener that will respond each time a cue point occurs:

```
myVideo.addEventListener("cuePoint", displayCuePoints);
```

myVideo is the playback component on the stage. We add an event to it by calling the **addEventListener** method and instructing this method to listen for cue point events and to run the **displayCuePoints** function when one occurs.

7. Now we will write the **displayCuePoints** function.

```
function displayCuePoints(videoObject:Object):void {
    cpOverlay.alpha = .72;
    cpOverlay.cpText.text = videoObject.info.name;
    var overlayTimer:Timer = new Timer(41, 36);
    overlayTimer.start();
    overlayTimer.addEventListener(TimerEvent.TIMER, fadeOverlay);
}
```

In the function declaration we're passing in an object, **videoObject:Object**. This object is the cue point that just occurred. It is passed to the **displayCue-Points** function so its metadata will be accessible inside the function.

The first line within the function sets the **cpOverlay** movie clip to .72 opacity. This has the effect of turning the movie clip's visibility back on when a cue point occurs. The second line says, "In the movie clip **cpOverlay**, set the text property of the dynamic text field **cpText** to the name property of the cue point that just occurred." Cue point names are stored in the FLV file's metadata and are accessed using dot notation. The third line creates a new timer named **overlayTimer** and tells it to have a countdown of 41 milliseconds (or roughly 1/24 of a second) and to repeat 36 times. The fourth line starts the timer. This roughly equates to one and a half seconds of 24 frames per second video, which is the frame rate of the encoded video. The fifth line has another event listener, but this time it is listening for each time the overlayTimer resets and it calls the **fadeOverlay** function each time this event occurs.

THE NEW TIMER CLASS
Prior to ActionScript 3, creating a timer involved using the setInterval() or setTimeout() methods. ActionScript 3 introduces the Timer class (flash.utils.Timer), which is more object oriented and cleaner to access than the older methods. Because of its several advantages, Adobe also suggests using the Timer class as a best practice when creating countdown or other timer-based functionality.

8. It's time for the last function. Write the function that fades the cue point text.

```
function fadeOverlay(event:TimerEvent) {
    cpOverlay.alpha = cpOverlay.alpha - .02 ;
}
```

This function reduces the opacity of **cpOverlay** by subtracting two-hundreths of a percent each time it is run. Since this function is run 36 times, the opacity level will be reduced by 0.72 after the **overlayTimer** finishes. This will make the cue point text disappear once again.

9. Save and test the movie.

```
cpOverlay.alpha = 0;
myVideo.addEventListener("cuePoint", displayCuePoints);
function displayCuePoints(videoObject:Object):void {
    cpOverlay.alpha = .72;
    cpOverlay.cpText.text = videoObject.info.name;
    var overlayTimer:Timer = new Timer(41, 36);
    overlayTimer.start();
    overlayTimer.addEventListener(TimerEvent.TIMER, fadeOverlay);
}
function fadeOverlay(event:TimerEvent) {
    cpOverlay.alpha = cpOverlay.alpha - .02 ;
}
```

Creating Video Playlists

A common-use case is to have one video player play back several videos. A single video player has several advantages: only one page URL for viewers to remember, similarly you create one page rather than several, and adding another video can be as easy as updating an XML playlist file and uploading new video without having to republish the SWF file.

In the next two tutorials, we'll cover playing back multiple files through an array and through an XML file. Both implementations can present similar user experiences, but they differ, however, in maintenance. An array-based video player involves republishing when new movies are added and redeploying the SWF along with the new videos. An XML-based video player is simpler to maintain because anyone with a text editor and file transfer (FTP) application can add new videos because XML files are relatively easy to edit. So, in general, if routine maintenance is a concern, use XML. If the project will never be updated, use an array.

Arrays

You can think of an array as a container or a list. Contained within the array are elements. For example, all elements within an array are URLs to video files. Arrays behave like a list. You add items, you remove items, you sort items, and so on.

Tutorial: Playback Several Videos Sequentially with an Array

In this example, the array will be a playlist and its elements will be URLs to different Flash videos. The compiled SWF will begin playback immediately and sequentially play the videos from the array. Since this use case as is does not require anything fancy, we'll simply use a video object. This will keep our file size down. In the XML player tutorial we'll use the FLVPlayback and user interface components to make a player with playback controls and a select list to choose the video.

Figure 9.13: *The array-based player plays back several effects sample movies.*

The code in this tutorial will: create the array, add elements to the array, feed elements from the array to a dynamically created video player, listen for the end of a video, and then play the next video. After the last video plays, it will loop back to the first video in the array.

1. Navigate to the **Tutorials > Chapter 9** folder. Copy the **Array Playlist** folder to your computer. Open the folder and open **array_playlist.fla.**

2. In the **Timeline**, Select **frame 1** in the **Actions** layer, and open the **Actions** panel by pressing **F9** (Windows) or **Option+F9** (Mac).

3. Let's begin by creating the array that will act as the video playlist. On line 3, enter:

```
var vidList:Array = new Array();
var vidInt:uint = 0;
```

The first line creates a new array named **vidList**. This array will contain the four videos used in this example. The second line creates a number (or a non-negative integer to be more precise) called **vidInt**. It's going to keep track of which video is currently playing and we set it initially to zero since the first element in an array has an index value of zero.

4. Now we can add some items to the array. While we could add all the video locations when constructing the array, that isn't too readable when potentially long strings are involved. For this reason, I'm going to use the **push()** method of the **Array** class to add the videos to the array. Press return to create a blank line after the last two lines of code and add this:

```
vidList.push("video/poof.flv");
vidList.push("video/bubbles.flv");
vidList.push("video/random.flv");
vidList.push("video/smoke.flv");
```

These four lines add the four video locations as elements to the **vidList** array. Each item that is pushed onto the array is appended at the end.

5. Since we're using the basic video object, we need to wire it up to the **NetConnection** and **NetStream** classes so the movie can display streaming content. Enter the following four lines of code:

```
var nc:NetConnection = new NetConnection();
nc.connect(null);
var ns:NetStream = new NetStream(nc);
ns.play(vidList[0]);
```

The first line creates a new **NetConnection** object. It's customary to simply call this object **nc**. The second line instructs the Flash Player that the movie is not connecting to a streaming server such as Adobe Flash Media Server.

6. The next thing to create is a new video object (which is new as of ActionScript 3) and attach the **NetStream ns** object to it and attach it to the current timeline's display list. Add a carriage return and then type:

```
var vid:Video = new Video(320, 240);
vid.attachNetStream(ns);
this.addChild(vid);
```

When creating a new video object, the width and height are optional parameters. The x and y position will default to 0, but you could specify a new position by setting **vid.x** and **vid.y** properties. The **Video** class's **attachNetStream()** method is used to associate **ns** to **vid**. This portion of code ends with adding the **vid** video object to the stage using the **addChild()** method.

7. This large block of code checks for the end of each video and plays the next video from the **vidList** array. Add a carriage return and then type:

```
ns.addEventListener(NetStatusEvent.NET_STATUS, onNetStatus);
function onNetStatus(event:NetStatusEvent) {
   switch (event.info.code) {
      case "NetStream.Play.Stop" :
         if (vidInt < (vidList.length - 1)) {
            vidInt += 1;
            ns.play(vidList[vidInt]);
         } else {
            ns.play(vidList[0]);
            vidInt = 0;
         }
         break;
   }
}
```

Since we cannot explicitly listen for discreet **NetStatus** events, we use a switch statement to run code if the **ns** object returns **NetStream.Play.Stop**. When this is returned, it's safe to assume that the playhead has stopped and a video has completely played back. It is safe to assume this because no controls have been added that would stop playback. Once this code is returned, a **switch** statement checks to see what element from the array is playing. When the current element is not the last one, the code plays the video for the next element. When the last element from the array is being played, it loops back to the first element.

8. This last code snippet is a bit of overhead due to changes in ActionScript 3. With ActionScript 3, the **NetStream** class requires a callback function for the **onMeta-Data** event or a few errors will be thrown. The way to address this is to create a generic object that will act as a client for the **NetStream** object. Add a carriage return and then type:

```
var nsClient:Object = new Object();
nsClient.onMetaData = function(info:Object) {
  trace(info.duration);
};
ns.client = nsClient;
```

A generic object, **nsClient**, is created and then a function is created when this object returns metadata. For simplicity's sake we trace the duration. The trace method is not necessary, but listening for meta data is. If there isn't code present to respond to the onMetaData event, the Flash Player will throw errors if it does come across meta data and there is no function to respond to it.

9. Choose **File > Save**. Choose **Control > Test Movie** to preview the movie.

Code: *Complete listing for array_playlist.fla*

```
// ActionScript goes below
var vidList:Array = new Array();
var vidInt:uint = 0;
vidList.push("video/poof.flv");
vidList.push("video/bubbles.flv");
vidList.push("video/random.flv");
vidList.push("video/smoke.flv");
var nc:NetConnection = new NetConnection();
nc.connect(null);
var ns:NetStream = new NetStream(nc);
ns.play(vidList[0]);
var vid:Video = new Video(320, 240);
vid.attachNetStream(ns);
this.addChild(vid);
ns.addEventListener(NetStatusEvent.NET_STATUS, onNetStatus);
function onNetStatus(event:NetStatusEvent) {
    switch (event.info.code) {
        case "NetStream.Play.Stop" :
            if (vidInt < (vidList.length - 1)) {
                vidInt += 1;
                ns.play(vidList[vidInt]);
            } else {
                ns.play(vidList[0]);
                vidInt = 0;
            }
            break;
    }
}
var nsClient:Object = new Object();
nsClient.onMetaData = function(info:Object) {
};
ns.client = nsClient;
```

XML

Extensible Markup Language (XML) is a simple and very open tag-based language for storing structured data. If you've ever written HTML by hand, you're 95% of the way there. Like HTML, XML has opening and closing tags like **<caption>** and **</caption>**, attributes inside of tags like **<caption time="100" type="dialog">**, and text content inside of tags like **<caption>Hello World</caption>**. An XML Document Type Definition (DTD) can be defined for almost any kind of data.

For our purposes, we will want to create an XML file that defines a list of videos to playback in succession. To create this using ActionScript, we use the **URLLoader** class and the new **XML** class to load an external XML file, parse it into recognizable chunks, and use those chunks to populate a list for selecting which video to play.

With ActionScript 3, the Flash Player has a more powerful and easier way to work with XML data. The new XML class follows the ECMAScript for XML (EX4) specification. (ECMAScript is the standard upon which JavaScript is based.) By implementing EX4, the Flash Player makes XML a first-class data type that can be directly and natively accessed and manipulated.

For example, in ActionScript 2, you would often have to loop through child nodes to access data. With EX4, you can use dot notation to access data in a more specific and targeted way. To learn more about EX4, you can read the ECMAScript for XML (E4X) Specification on the Ecma web site:

http://www.ecma-international.org/publications/standards/Ecma-357.htm

By the way, the old XML class from ActionScript 2 is still around and has been renamed the XMLDocument class for updating legacy code to work in ActionScript 3 projects.

Tutorial: Create a Video Playlist with XML

In this tutorial, the XML file will be the playlist and its nodes will be unique videos with attributes for the Flash Video document's URL, label, and description. The code will: load the XML, bind the XML's data to a UI component, and have the UI component interact with video and a text field through event listeners.

Figure 9.14: *An XML-based video player.*

1. Navigate to the **Tutorials > Chapter 9** folder. Copy the **XML Playlist** folder to your computer. Open the folder and open **videos.xml** in the text editing application of your choice. Below are the contents of this file:

```
<?xml version="1.0" encoding="ISO-8859-1"?>
<videos>
    <video url="video/filmmakers.flv" title="Filmmakers Trailer" description="A trailer of interviews
with several filmmakers" />
    <video url="video/bonjour.flv" title="Jean-Paul Bonjour" description="Jean-Paul Bonjour discusses
what he's learned from working with 24p and how it has influenced how he produces his and friend's
films."/>
    <video url="video/escobar.flv" title="Eric Escobar" description="Eric Escobar, a 24p filmmaker who
has been accepted at Sundance twice, gives advice on becoming a filmmaker and what makes a good short
film." />
    <video url="video/lucero.flv" title="Anthony Lucero" description="Anthony Lucero is an effects edi-
tor in the Bay Area who has edited visual effects shots for filmmakers such as George Lucas, Tim Bur-
ton, and Robert Rodriguez. He also also written, directed, or edited short films using several profes-
sional HD formats." />
    <video url="video/24p_standard.flv" title="24p Standard" description="An animation showing how 24p
Standard mode works." />
    <video url="video/24p_advanced.flv" title="24p Advanced" description="An animation showing how 24p
Advanced mode works." />
</videos>
```

This XML file has a **\<videos>** tag that represents the entire playlist. Each child node, or **\<video>** tag, within it is a unique video. With the opening **\<video>** tag are three attributes: the **url** or location of the video file, a **title** to use for display and selection purposes, and a **description** to give the viewer more context.

2. Close the **videos.xml** file and open the file **xml_playlist.fla**, which is in the same tutorial folder.

3. This movie has three objects on the stage. A **FLVPlayback** component named **vidPlayback**, a static text field that is the label for a list component named **flvList**, and a dynamic text field, **descText**, that holds a description for each video. These three elements will be referenced in the ActionScript that we'll create next.

4. Press **Ctrl+N** (Windows) or **Command+N** (MacOS). In the New Document dialog, select the **General** tab, select **ActionScript File**, and click **OK**.

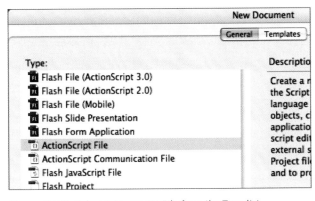

Figure 9.15: *Select ActionScript File from the Type list.*

5. Save this file as **FLVPlayList.as** in the same directory as the **xml_playlist.fla** document. This is going to be the class document file for this movie.

ABOUT DOCUMENT CLASSES

A document class is an external ActionScript class file that is paired with an FLA file. At compile time, the document class is included with the compiled SWF. At run time, the document class is constructed and run when the SWF's timeline is initialized.

Prior to ActionScript 3 and Flash CS3, the best practice was to place code in a layer named "actions" in the first frame. While this practice is better than having code sprinkled across movie clips, it still requires the code to reside in the FLA. When the code is inside the FLA file, quick reuse and version control is more difficult.

To set the document class, make sure nothing is selected (choose Edit > Deselect All) and in the Property panel for the Flash movie, enter the path and name of the class file in the Document class field, or in the Publish Settings dialog choose File > Publish Settings > Flash tab > Settings button.

To learn more about document classes, go to the Flash Developer Center on Adobe.com and read this article: http://www.adobe.com/devnet/flash/articles/flash9_as3_preview.html.

6. Return briefly to the **xml_playlist.fla** file and, with nothing selected, show the **Properties Inspector.** If the **Properties Inspector** is not open, press **F3** (Windows) or **Option+F3** (MacOS).

7. Enter **FLVPlaylist** in the **Document class** text field. This associates the **FLVPlaylist. as** with the timeline in this movie. Note that the ".as" extension is not needed.

Figure 9.16: *Entering the document class for the entire movie.*

8. Save the file and then click the **Pencil** icon, , to the right of the **Document class** text field. This will switch to the **FLVPlayback.as** file.

9. The document class needs to begin with the **package** statement. Enter:

```
package {

}
```

10. Inside the **package** statement, add the following six import statements:

Chapter 9: More Flash Video Applications

```
import flash.events.*;
import flash.net.*;
import fl.controls.SelectableList;
import fl.video.*;
import flash.text.TextField;
import flash.display.MovieClip;
```

We need to import these classes because we'll be writing code that uses methods and properties from them. Document class files (as opposed to code written internally in an Actions frame) requires that you import all the classes your code requires. Since we will code a few event listeners, the **flash.events** class is required. The **flash.net** class is needed to import the external XML file. The **fl.controls.SelectableList** class contains the methods and properties for working with the list UI component. Likewise, the **fl.video** class contains methods and properties for working with the **FLVPlayback** component. The **descText** text field requires that we import **TextField**. Lastly, any Flash movie file with a timeline requires the **MovieClip** class to be imported.

11. After the import statements, add the class declaration:

```
public class FLVPlayList extends MovieClip {
}
```

Note that the class name has to be the same name as the file name minus the file extension. A document class normally extends the MovieClip class. All of the methods and properties for this class have to reside within this declaration.

12. To load an external XML file, create a **URLLoader** object to load external data:

```
var flvListLoader:URLLoader = new URLLoader();
```

13. The class's constructor method now needs to be written. This is code that is automatically run when the document class is constructed by the Flash Player. Add the following:

```
public function FLVPlayList() {
    flvListLoader.dataFormat = URLLoaderDataFormat.TEXT;
    flvListLoader.addEventListener(Event.COMPLETE, loadComplete);
    flvListLoader.load(new URLRequest("videos.xml"));
    flvList.addEventListener(Event.CHANGE, playVideo);
    vidPlayback.addEventListener("complete", completePlayback);
}
```

The first line inside the constructor sets the data format for **flvListLoader** to plain text since XML files are plain text files. The next line adds an event listener to it and points the listener to the **loadComplete** method, which we will write

in a few steps. The third line uses the **load()** method to point to the playlist file, **videos.xml**, which we looked at in step 1.

An event listener is also added to **flvList**, the list UI component that displays the available videos from the list. It also is used for selecting which video to play. Anytime the current selection in the list changes, the **playvideo()** method is called.

The last event listener is for the **FLVPlayback** instance, **vidPlayback**. It listens for when a video plays completely and calls the **completePlayback()** method.

14. The first function to write is the **loadComplete()** method. Add it after the **FLV-Playlist()** constructor method.

```
function loadComplete(event:Event):void {
    var flvXML:XML = new XML(event.target.data);
    for each (var vid in flvXML..video) {
        flvList.addItem({label:vid.@title,
        data:vid.@url,
        info:vid.@description});
    }
    flvList.selectedIndex = 0;
    vidPlayback.source = (flvList.getItemAt(0).data);
    vidPlayback.play();
    descText.text = (flvList.getItemAt(0).info);
}
```

When the **flvListLoader** has completely loaded the **videos.xml** file, this method creates a new XML object, **flvXML**, from the external XML file. The **for each** statement creates a variable **vid** from each **<video>** element in the XML and binds its attributes (**title**, **url**, and **description**) to **flvList** as the label shown in the control, the data associated with each label, and as a longer description that will be used to set the text of the **descText** dynamic text field.

After the **for each** block, the first item in the **flvList** control is selected and is played inside **flvPlayback**.

15. When the selection changes in **flvList**, the **playVideo** method needs to be called. Enter the following:

```
function playVideo(event:Event) {
    vidPlayback.source = event.target.selectedItem.data;
    descText.text = event.target.selectedItem.info;
}
```

It responds to the change event by setting the source of **vidPlayback** to use the data property of the currently selected item in the list. It also sets the text property of **descText** to use the **info** property.

Chapter 9: More Flash Video Applications

16. The last event-handling method to write is the **playbackComplete()** method. It performs the task of playing the next video in **flvList** once a video completes and loops back to the first video once the last video finishes playing.

```
function completePlayback(eventObject:Object):void {
    var idx:uint = flvList.selectedIndex;
    if (flvList.selectedIndex == 5) {
        vidPlayback.source = (flvList.getItemAt(0).data);
        vidPlayback.play();
        flvList.selectedIndex = 0;
        idx = 0;
    } else {
        idx += 1;
        vidPlayback.source = (flvList.getItemAt(idx).data);
        flvList.selectedIndex = idx;
        vidPlayback.play();
    }
}
```

A variable, **idx**, is used to store the currently selected item in **flvList**. If **idx** is equal to 5, or the last item in the list, the video player loops back to the first video in the list. If **idx** is equal to something else, its value is increased by one and the video in **flvList** is selected and played back.

17. Save and preview the movie. A completed version is located in **Completed Tutorials > Chapter 9 > XML Playlist** on the DVD-ROM.

```
package {
    import flash.events.*;
    import flash.net.*;
    import fl.controls.SelectableList;
    import fl.video.*;
    import flash.text.TextField;
    import flash.display.MovieClip;
    public class FLVPlayList extends MovieClip {
        var flvListLoader:URLLoader = new URLLoader();
        public function FLVPlayList() {
            flvListLoader.dataFormat = URLLoaderDataFormat.TEXT;
            flvListLoader.addEventListener(Event.COMPLETE, loadComplete);
            flvListLoader.load(new URLRequest("videos.xml"));
            flvList.addEventListener(Event.CHANGE, playVideo);
            vidPlayback.addEventListener("complete", completePlayback);
        }
        function loadComplete(event:Event):void {
            var flvXML:XML = new XML(event.target.data);
            for each (var vid in flvXML..video) {
                flvList.addItem({label:vid.@title, data:vid.@url, info:vid.@description});
            }
            flvList.selectedIndex = 0;
            vidPlayback.source = (flvList.getItemAt(0).data);
            vidPlayback.play();
            descText.text = (flvList.getItemAt(0).info);
        }
        function playVideo(event:Event) {
            vidPlayback.source = event.target.selectedItem.data;
            descText.text = event.target.selectedItem.info;
        }
        function completePlayback(eventObject:Object):void {
            var idx:uint = flvList.selectedIndex;
            if (flvList.selectedIndex == 5) {
                vidPlayback.source = (flvList.getItemAt(0).data);
                vidPlayback.play();
                flvList.selectedIndex = 0;
                idx = 0;
            } else {
                idx += 1;
                vidPlayback.source = (flvList.getItemAt(idx).data);
                flvList.selectedIndex = idx;
                vidPlayback.play();
            }
        }
    }
}
```

Chapter 9: More Flash Video Applications

The External API

The Flash Player's External API facilitates communication between your Flash movie and its container, which in most cases is a web page. An API is an application programming interface, or a collection of exposed methods for how external code openly communicates with an existing technology, such as the Flash Player. The External API is of interest to Flash Video producers because it enables a whole new set of interaction possibilities between your Flash Video content and the web page that contains it. The External API is a good alternative when you want to:

- Put branded elements or controls in the HTML and not the Flash movie

- Have hyper-linked text referencing cue points or specific timed locations

- Display HTML content when certain events occur in the video

For many developers the External API has replaced the **fscommand()** and **getURL()** methods because it offers better compatibility across browsers and it requires less code to implement in both the Flash movie and web page.

Table 7.1: *Browser and platform support for the External API.*

Browser	Mac OS	Windows
Internet Explorer 5.0 and above	n/a	yes
Netscape 8.0 and above	yes	yes
Mozilla 1.7.5 and above	yes	yes
Safari 1.3 and above	yes	n/a

Flash Player and Browser Communication

From ActionScript to the containing web page you can: call any JavaScript function and pass arguments to it, pass data types, and receive a return value from the JavaScript function. From JavaScript to the Flash movie you can: call an Action-Script function, pass arguments using standard notation, and return a value to the JavaScript function.

Tutorial: Control Video with HTML and JavaScript

In this chapter's final tutorial, we'll cover the work required to enable communication between Flash Player and the browser. We'll create a web page with an embedded Flash Video. Ordinary HTML and JavaScript will be used to control playback, access cue points, and respond to movie events.

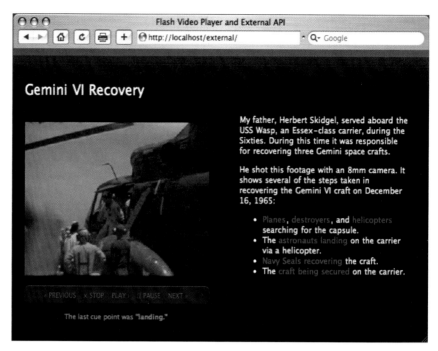

Figure 9.17: *The example web page with JavaScript-controlled Flash Video.*

This tutorial is a web page one might see for a show-and-tell session or a class project. The techniques employed, however, could also be used for a sales or training presentation. We will begin by creating a near-empty FLA file. It will appear to be empty because we won't add anything to the stage. We will, however, add the **FLVPlayBack** component to the **Library** and we will reference an external ActionScript file as the movie's document class.

1. Navigate to the **Tutorials > Chapter 9** folder. Copy the **External API** folder to your computer.

2. Launch Flash Professional.

3. Choose **File > New**. Select **Flash File (ActionScript 3.0)**.

Figure 9.18: *Select Flash File (ActionScript 3) from the Type list.*

 Chapter 9: More Flash Video Applications

3. Select **Modify > Document** and set the size to **320 × 240**.

Figure 9.19: *Set the width and height to same dimensions as the video file.*

4. Save this file in **External API > assets** folder and use **flvext.fla** as the file name.

5. Select **Window > Library**. Keep it open. Select **Window > Components**. Open the **Video** and drag the **FLVPlayback** component into the **Library** panel.

6. Choose File > Save to save the file.

 In order to create an FLVPlayback component through ActionScript, the component has to be added to the document's library.

Figure 9.20: *Drag the FLVPlayback component from the Components panel to the Library panel.*

7. To create the document class, choose **File > New**, select **ActionScript File**, and click **OK**. Save the file as **ExternalFlashVideo.as** in the **External API > assets** folder.

Figure 9.21: *Select ActionScript File from the Type list.*

8. The document class needs to begin with the **package** statement. Enter:

```
package {
}
```

9. Inside the **package** statement, add the following three import statements.

```
import flash.display.MovieClip;
import fl.video.*;
import flash.external.ExternalInterface;
```

A Flash movie file with a timeline requires the **MovieClip** class to be imported. The **fl.video** class contains the methods and properties for working with the **FLVPlayback** component. Likewise, the **ExternalInterface** class contains methods for enabling Flash Player to web browser communication.

10. After the import statements, add the **class** declaration:

```
public class ExternalFlashVideo extends MovieClip {
}
```

11. Create variables:

```
var vidPlayback = new FLVPlayback();
var vidCuePoint:String;
var vidContentPath:String = "gemini.flv";
```

The first variable creates an instance of the video component. The second creates a string variable for the current cue point. The third is the URL for the video.

12. The class's constructor method now needs to written. This is code that is automatically run when the document class is constructed by the Flash Player. Add the following:

Chapter 9: More Flash Video Applications

```
function ExternalFlashVideo() {
    vidPlayback.addEventListener("cuePoint", cp_listener);
    vidPlayback.x = 0;
    vidPlayback.y = 0;
    addChild(vidPlayback);
    vidPlayback.source = vidContentPath;
    ExternalInterface.addCallback("controlPlay", controlPlay);
    ExternalInterface.addCallback("gotoCuePoint", gotoCuePoint);
}
```

The constructor function starts with setting the source for the **vidPlayback** video component. It then sets the component's x and y position and adds its instance to the movie's display list, which places it on the stage. An event listener is added to the component to watch for cue points and to run the **gotoCuePoint** function when one occurs.

The last two lines of code in the method expose two functions to the **External API**: **controlPlay()** and **gotoCuePoint()**. The **addCallback()** method accepts two parameters: the name of the function to expose and the name to use externally. For simplicity's sake, I've used the same for both the internal function and the external name.

13. To pass the name of each cue point to an external JavaScript function, enter:

```
function cp_listener(eventObject:Object):void {
    vidCuePoint = eventObject.info.name;
    ExternalInterface.call("cuePointInfo", vidCuePoint);
}
```

The **cp_listener** method accepts a cue point event as a parameter and retrieves the cue point's name and assigns it to the variable **vidCuePoint**. The next line passes **vidCuePoint** to an external JavaScript function, **cuePointInfo()**, using the **call()** method of the **ExternalInterface** class.

14. To expose cue point navigation, enter:

```
function gotoCuePoint(vidCuePoint):void {
    vidPlayback.seekToNavCuePoint(vidCuePoint);
}
```

This method advances the current frame to the cue point passed to it.

> *If you've received an FLV with embedded cue points and you don't have the names handy for entering later in the HTML page, you can see the embedded cue points in the Component Inspector panel. Add the FLV to an FLVPlayback component and select the component, click the Parameters tab in the Properties Inspector, and double-click the Cue Points field.*

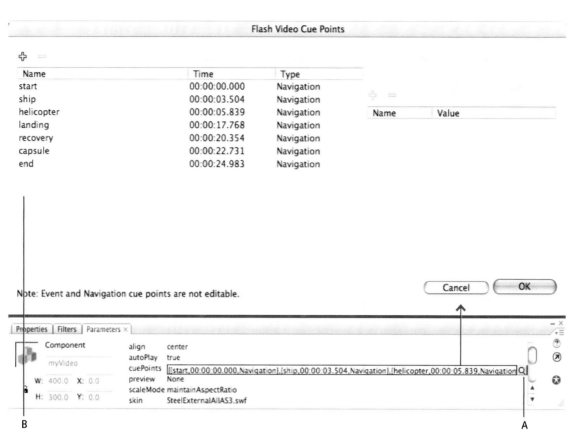

Figure 9.22: *Click the Magnify icon (A) to view the cue points (B).*

14. To expose the playback controls to JavaScript, write the following case statement:

```
function controlPlayback(controlFunction):void {
    switch(controlFunction) {
        case "play":
        vidPlayback.play();
        break;
        case "pause":
        vidPlayback.pause();
        break;
        case "stop":
        vidPlayback.stop();
        break;
        case "next":
        vidPlayback.seekToNextNavCuePoint();
        break;
        case "previous":
        vidPlayback.seekToPrevNavCuePoint();
        break;
    }
}
```

Chapter 9: More Flash Video Applications

This method will receive a variable from JavaScript using the **External API**. The JavaScript is going to pass the **id** element of the current link to this method as the variable **controlFunction**. In the HTML there will be a link with an **id** for each of the common playback methods. For example, the link around the word play will have an **id** of **play**, and when that's passed into the function, the function plays the video.

15. Test the movie by pression **Ctrl+Enter** (Windows) or **Command+Return** (Mac OS). You should see the video play.

16. In **Windows Explorer** or the **Mac OS Finder**, open **External API > assets**. You'll see a file named **flvext.swf**. This is the compiled version of the Flash document we'll reference in the HTML file, **index.html**.

17. Open the **External API** folder and open the **js** folder. Open the JavaScript file **flv_external.js** in the code editor of your choice.

18. In this tutorial, we'll use a popular open-source JavaScript library, **jQuery**. More information about it follows this step. Write the event listener that will work when the document becomes ready:

```
$(document).ready(function(){
    $('#cuepoint').hide();
    $("a.control").click( function() { controlPlay(this.id); });
    $("a.chapter").click( function() { gotoCuePoint(this.id); });
});
```

The code, **$(document)**, refers to the entire web page, or document. The **ready** event occurs when the document is ready for manipulation by the web browser and its JavaScript engine.

When the web page loads, the functions within the **$(document).ready** function run. The first line temporarily hides the div, **#cuepoint**. The next two lines act as event listeners. They listen for when an anchor tag (a web page link) with the **control** or **chapter** class is clicked. In the first case, it passes the anchor tag's **id** to the **controlPlay()** function. In the second case, it passes the **id** to the **gotoCuePoint()** function.

19. Write the **controlPlay()** function which will handle playback:

```
function controlPlay(controlFunction) {
    videoPlayer.controlPlay(controlFunction);
}
```

Back in step 14 we wrote **controlPlayback()**, an ActionScript function that has a set of case statements. The **controlPlay()** function listed above forwards

the **id** of the link to the **controlPlayback()** function, which then calls the corresponding video playback method.

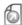 *JQuery is a JavaScript framework that includes methods for AJAX and dynamic HTML. What made it unique from the other Web 2.0 JavaScript frameworks is its XPATH and CSS-like approach to selecting DOM elements, its terseness, and its chainability. If you'd like to learn more about it, go to: http://www.jquery.org.*

20. Write the **gotoCuePoint()** function, which will handle cue point navigation:

```
function gotoCuePoint(vidCuePoint) {
    videoPlayer.gotoCuePoint(vidCuePoint);
}
```

In step 13 we wrote the ActionScript function, **gotoCuePoint()**. This JavaScript function, **gotoCuePoint()**, forwards the **id** of the link that calls it to the ActionScript function with the same name and advances to the corresponding cue point.

21. Write functions for showing cue points events broadcast from the Flash Player.

```
function cuePointInfo(vidCuePoint) {
    $('#cuepoint strong').html(vidCuePoint);
    $('#cuepoint').fadeIn('normal');
}
```

This function responds to the ActionScript function **cp_listener()**, which we wrote in Step 12. When the name of the cue point is passed to **cuePointInfo()**, it replaces the empty text node inside the **** tag with the name of the actual cue point. This tells the view what the current cue point is when it occurs.

22. Save and close the file.

23. Open the HTML file **index.html** in the **External API** folder.

24. Reference the external JavaScript file. Insert the following bit of code on line 7 below the **<script>** tag that references **jquery.js**.

```
<script type="text/javascript" src="js/flv_external.js"></script>
```

This has to come after jquery.js because its functions rely upon the jQuery library. If it were placed above it, the functionality wouldn't work.

25. Add the **id** attributes to the playback controls. Starting on line 43, add the **id** attributes marked in yellow to the following anchor tags:

```
<a id="previous" href="#" class="control">&laquo; Previous</a>
<a id="stop" href="#" class="control">&times; Stop</a>
<a id="play" href="#" class="control">Play &#8250;</a>
<a id="pause" href="#" class="control">|| Pause</a>
<a id="next" href="#" class="control">Next &raquo;</a>
```

26. Add the **id** attributes to the chapter links. Starting on line 58, add the **id** attributes marked in yellow to the following anchor tags:

```
    <li><a id="start" href="#" class="chapter">Planes</a>, <a id="ship"
href="#" class="chapter">destroyers</a>, and <a id="helicopter" href="#"
class="chapter">helicopters</a> searching for the capsule.</li>
    <li>The <a id="landing" href="#" class="chapter">astronauts landing</a>
on the carrier via a helicopter.</li>
    <li><a id="recovery" href="#" class="chapter">Navy Seals recovering</a>
the craft.</li>
    <li>The <a id="capsule" href="#" class="chapter">craft being secured</a>
on the carrier.</li>
```

27. Save the file.

28. Before this file can be previewed in the brower on your local machine, the Flash Player's security settings need to be adjusted. This is because we're testing a file locally that uses the External API. Open a web browser and go to: http://www. macromedia.com/support/documentation/en/flashplayer/help/settings_manager04.html. Note that if you upload this to a web server to preview, you won't have to do this.

Figure 9.23: *The Global Security Settings panel for Adobe Flash Player.*

29. Click the **Edit Locations** dropdown menu and choose **Add location**.

Figure 9.24: *The Edit locations dropdown menu.*

30. A pop-up window appears for selecting a file or folder to trust. Click **Browse for folder** and pick the **External API** folder for this tutorial and click **Confirm**.

Figure 9.25: *Trust this location pop-up window.*

31. You can now open the file, **index.html** in the browser and test the interaction.

If, for any reason, the movie doesn't play, check your code against the code listings on the following pages. Also, a completed version of this tutorial is on the DVD-ROM.

Chapter 9: More Flash Video Applications

Code: *Complete listing for ExternalFlashVideo.as*

```
package {
    import flash.display.MovieClip;
    import fl.video.*;
    import flash.external.ExternalInterface;
    var vidPlayback = new FLVPlayback();
    var vidCuePoint:String;
    var vidContentPath:String = "../flv/gemini.flv";
        public class ExternalFlashVideo extends MovieClip {
            function ExternalFlashVideo() {
            vidPlayback.addEventListener("cuePoint", cp_listener);
            vidPlayback.x = 0;
            vidPlayback.y = 0;
            addChild(vidPlayback);
            vidPlayback.source = vidContentPath;
            ExternalInterface.addCallback("controlPlay", controlPlay);
            ExternalInterface.addCallback("gotoCuePoint", gotoCuePoint);
        }
        function cp_listener(eventObject:Object):void {
            vidCuePoint = eventObject.info.name;
            ExternalInterface.call("cuePointInfo", vidCuePoint);
        }
        function gotoCuePoint(vidCuePoint):void {
            vidPlayback.seekToNavCuePoint(vidCuePoint);
        }
        function controlPlay(controlFunction):void {
            switch(controlFunction) {
                case "play":
                vidPlayback.play();
                break;
                case "pause":
                vidPlayback.pause();
                break;
                case "stop":
                vidPlayback.stop();
                break;
                case "next":
                vidPlayback.seekToNextNavCuePoint();
                break;
                case "previous":
                vidPlayback.seekToPrevNavCuePoint();
                break;
            }
        }
    }
}
```

The External API

```html
<!DOCTYPE HTML PUBLIC "-//W3C//DTD HTML 4.0 Transitional//EN">
<html lang="en">
<head>
<meta http-equiv="Content-Type" content="text/html; charset=utf-8">
<title>Flash Video Player and External API</title>
<script type="text/javascript" src="js/jquery.js"></script>
<script type="text/javascript" src="js/flv_external.js"></script>
<!--[if IE]><script type="text/javascript" src="js/fix_eolas.js" defer="defer"></script><![endif]-->
<link rel="stylesheet" href="css/screen.css" type="text/css" media="screen" title="no title">
<!--[if IE]><link rel="stylesheet" href="css/ie.css" type="text/css" media="all" title="no
title"><![endif]-->
</head>
<body>
    <noscript>
        <p><strong>If the links to the movie's chapters do not work for you, JavaScript is disabled
in your web browser.</strong><br/>Unfortunately, JavaScript is required to facilitate communication
between the Flash Player and HTML. Turn JavaScript on in your browser (which you can find in the pref-
erences or Internet Tools dialog).</p>
    </noscript>
    <div id="wrap">
        <div id="header">
            <h1>Gemini VI Recovery</h1>
        </div>
        <div id="sidebar">
            <p id="player">
            <!--[if !IE]> -->
            <object id="videoPlayer" type="application/x-shockwave-flash" data="assets/swf/flvext.swf"
width="320" height="240">
                <!-- <![endif]-->
                <!--[if IE]>
            <object classid="clsid:d27cdb6e-ae6d-11cf-96b8-444553540000" width="320" height="240"
                codebase="http://download.macromedia.com/pub/shockwave/cabs/flash/swflash.
cab#version=9,0,0,0" id="videoPlayer">
                    <param name="movie" value="assets/swf/flvext.swf" />
                <!-->
                <!--dgx-->
                <param name="play" value="true" />
                <param name="menu" value="true" />
                <param name="allowScriptAccess" value="sameDomain" />
                <param name="quality" value="high" />
                <param name="bgcolor" value="#000000" />
                <param name="allowScriptAccess" value="sameDomain" />
                <param pluginspage="http://www.macromedia.com/go/getflashplayer">
                <p>This movie requires Flash Player.</p>
            </object>
            <!-- <![endif]-->
            </p>
                <p id="controls">
                <a id="previous" href="#" class="control" title="Previous">&laquo; Previous</a>
```

Chapter 9: More Flash Video Applications

```
                <a id="stop" href="#" class="control">&times; Stop</a>
                <a id="play" href="#" class="control">Play &#8250;</a>
                <a id="pause" href="#" class="control">|| Pause</a>
                <a id="next" href="#" class="control">Next &raquo;</a>
            </p>
            <p id="cuepoint">
                The last cue point was <strong></strong>.
            </p>
        </div>
        <div id="main">
            <p>My father, Herbert Skidgel, served aboard the USS Wasp, an Essex-class carrier, during the
Sixties. During this time it was responsible for recovering three Gemini space crafts.</p>
            <p>He shot this footage with an 8mm camera. It shows several of the steps taken in recovering
the Gemini VI craft on December 16, 1965:</p>
            <p>
                <ul>
                    <li><a id="start" href="#" class="chapter">Planes</a>, <a id="ship" href="#"
class="chapter">destroyers</a>, and <a id="helicopter" href="#" class="chapter">helicopters</a>
searching for the capsule.</li>
                    <li>The <a id="landing" href="#" class="chapter">astronauts landing</a> on the carrier
via a helicopter.</li>
                    <li><a id="recovery" href="#" class="chapter">Navy Seals recovering</a> the craft.</li>
                    <li>The <a id="capsule" href="#" class="chapter">craft being secured</a> on the car-
rier.</li>
                </ul>
            </p>
<div class="clearall"> </div>
</div>
</div>
</body>
</html>
```

Wrapping Up

This chapter introduced you to several topics: working with cue points, closed
captions, XML and arrays, and the External API class. You can now take these
techniques and apply them in practical ways in future video projects.

CHAPTER 10

..

Flash Media Server and Flash Lite Video

The book's last chapter covers the basics of working with Flash Media Server and presents a tutorial on creating a Flash Lite application with device video.

Serving Flash Video with a Streaming Server

To stream files, you can set up a Flash Media Server from Adobe, or choose a third-party server such as the open source Red5 server or the new commercial Wowza Media Server Pro. If you cannot install a server, you can also have your video hosted by a Flash Video Streaming Service. These providers offer content delivery networks configured with Flash Media Server and can handle very high server loads.

Table 10.1: *Flash Video Streaming Options*

Option	Solution	Web Site for More Information
Adobe Flash Media Server	Server	http://www.adobe.com/products/flashmediaserver/
Red5	Server	http://osflash.org/red5
Wowza Media Server Pro	Server	http://www.wowzamedia.com
Akamai	FVSS Service	http://www.akamai.com/html/technology/products/streaming.html
Limelight Networks	FVSS Service	http://www.llnw.com/flash.html
VitalStream	FVSS Service	http://www.vitalstream.com/flash/
Mirror Image Internet	FVSS Service	http://www.mirror-image.com/

Despite the increased technical overheard, streaming video has several advantages over progressive video:

- It offers a persistent connection between the viewer's computer and the streaming server. This makes real-time video conferencing, video on demand, and multi-player games possible.

- When provisioned correctly, streaming servers can provide highly scalable distribution of content, which allows for hundreds and potentially thousands of simultaneous high-performance connections.

- You can serve video that is appropriate to the viewer's connection speed.

- Streaming video usually starts to play faster than progressive video.

- Users can seek to different locations in the video and that conserves both local and remote computing resources because only the requested frames are sent to the viewer's PC.

- Media files are more secure since streaming files are not stored in the local computer's cache.

- You can track viewing and usage statistics.

Specifying a Streaming URL

Setting the source location for a video located on a streaming server is as easy as setting one stored on an HTTP-based server for progressive download. The URL will follow the pattern of: **rtmp://www.yourservername.com/path_to/stream.flv**.

This can be used as the **source** parameter for an instance of the **FLVPlayback** component, or it can passed to the **play()** method of the **NetStream** object.

Using Bandwidth Detection

When using Flash Media Server (FMS), it's possible to use FMS's bandwidth detection features to serve files tailored to the bandwidth capabilities of each viewer. This provides a better viewing experience for all viewers, because viewers with slower connections receive video that is smaller, and viewers with faster connections receive video that is larger and not as compressed. In both cases, video loads quickly and the perception of speed is roughly the same for both viewers.

Not all streaming providers support native bandwidth detection. In the case your FMS installation does not come with this support, you'll need to upload an Action-Script Communication file (main.asc in this case) to the application folder residing on the streaming server.

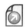 *You can download a sample main.asc file to use at: http://www.adobe.com/go/learn_fl_ samples. Download the Samples.zip file, unarchive the file, and look in \ComponentsAS2\ FLVPlayback.*

When providing multiple instances of the same video at different sizes and bit rates, you specify a SMIL (Synchronized Multimedia Integration Language, pronounced "smile") file. It is an XML-based file format listing a server location, unique files for target bandwidths, and the duration for each file:

```
<smil>
    <head>
        <meta base="rtmp://www.yourservername.com/videoapp/streams" />
        <layout>
            <root-layout width="320" height="240" />
        </layout>
    </head>
    <body>
        <switch>
            <video src="video_low.flv" system-bitrate="56000" dur="3:00.1">
            <video src="video_med.flv" system-bitrate="128000" dur="3:00.1">
            <ref src="video_hi.flv" dur="3:00.1"/>
        </switch>
    </body>
</smil>
```

Also, to configure the Flash movie to work with streaming servers that support bandwidth detection natively, you need to add the following two lines of Action-Script to your client-side code:

```
import fl.video.*;
VideoPlayer.iNCManagerClass = fl.video.NCManagerNative;
```

When using the FLVPlayback component with Adobe Flash Media Server, follow these steps on your local computer and on your installation of Flash Media Server.

On the Flash Media Server

1. Create a folder inside the Flash Media Server application folder. For example purposes, let's call it **videoapp**.

2. If needed, upload the **main.asc** file to the **videoapp** folder.

3. Create another folder, **streams**, inside the **videoapp** folder.

4. Upload all Flash Video files for this application to the **streams** folder.

On Your Local Computer

1. Select **File > Import > Import Video**.

2. Select **Stream from Flash Video Streaming Service (FVSS) or Stream from Flash Media Server (FMS)**. Enter the URL for the file on the server.

> ⦿ Already deployed to a web server, Flash Video Streaming Service, or Flash Media Server:
>
> URL: []
>
> Examples: http://mydomain.com/directory/video.flv
> rtmp://mydomain.com/directory/video.xml

Figure 10.1: *Using the Flash Video wizard.*

3. Go through the rest of the **Import Video** wizard. Save and compile the file. Upload the compiled SWF file to your web server and test.

Flash Lite 2 and Mobile Video

Native Flash Video using the Sorenson or On2 codecs will not be supported by Flash Lite until Flash Lite 3 is released. In the meantime, Flash Lite 2 supports device video, that is, video supported natively by the target device. For the best way to determine what video formats your target device supports, check the device specifications for the target device or use ActionScript to determine the supported formats. You can also use Device Central to view video formats supported by the target device.

Device Central may not list your target device, but device profiles are updated as new devices supporting Flash Lite are introduced. To check for new device profiles, launch Device Central and choose Devices > Check for Device Updates.

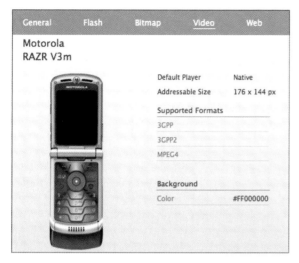

Figure 10.2: *Click the Video tab to see which formats are supported by a device.*

Preparing Video for Flash Lite

The mobile video types typically found on Flash Lite-enabled mobile devices are 3GP, 3GP2 (also known as 3GPP2), AVI, MOV, MPEG-4, and WMV. Again, the best way to find out what format to use is to look at the device's specifications or browse the device's information in Device Central. To export a video for a mobile device, you have several options for converting video to a device-supported format shown in the following table.

Table 10.2: *Mobile Video Compression Options*

Option	Web Site for More Information
Adobe Media Encoder	http://www.adobe.com/products/creativesuite/production/
Apple QuickTime Pro	http://www.apple.com/quicktime/pro/
Apple Compressor	http://www.apple.com/finalcutstudio/compressor/
IMTOO 3GP Video Converter	http://www.imtoo.com/3gp-video-converter.html
Total Video Converter	http://www.effectmatrix.com/total-video-converter/
Xilisoft 3GP Converter	http://www.xilisoft.com/3gp-video-converter.html
Sorenson Squeeze Compression Suite	http://www.sorensonmedia.com/pages/?pageID=2
Telestream Episode (Mac OS X) or FlipFactory (Windows)	http://www.telestream.net/products/ff_transworkflows.htm

How To: Exporting Mobile Video from the Adobe Media Encoder

The Adobe Media Encoder is available in all of Adobe's dynamic media applications: Premiere Pro, After Effects, Encore, and Sound Booth. To export device video such as 3GP using the Adobe Media Encoder, follow these steps:

1. Launch a project created in **Premiere Pro**.

2. Select a sequence or clip to export. Choose **File > Export > Adobe Media Encoder**.

3. Select **H.264** from the **Format** menu.

4. Select a device preset from the **Preset** menu. This will use the default encoding settings, but you are free to experiment and adjust the settings in the **Video** and **Audio** tabs.

5. If you'd like to preview the encoded video in Device Central, check **Open in Device Central**.

How To: Exporting Mobile Video from QuickTime Pro

Apple QuickTime Pro is a paid upgrade to the cross-platform media technology by Apple Inc. For about $30, you can export to any video and audio codec that is bundled with QuickTime. To export a mobile device video format from QuickTime, follow these steps:

1. Launch **QuickTime Player**. Open a movie you'd like to export.

2. Choose **File > Export**. Choose **Movie to 3G** from the **Export** drop down. Select a mobile video preset from the **Use** drop down. Consult with the device specifications on which presets are compatible with your phone. Click **Save** to export the video.

Figure 10.3: *Exporting a QuickTime movie as a mobile device video.*

Mobile Video Encoding Considerations

As powerful as handsets are becoming, it should be obvious that they still lack the processing power, high-speed Internet connections, storage, and memory capacity found on desktop and portable computers. Given all this, video for mobile devices cannot have the same duration, frame size, fps, and data rate as desktop video. That said, you may have to edit video down, crop, and encode at a lower frame rate and bit rate. Find out what is best for your device and test various encoding settings before deploying your project.

The ActionScript Video Object in Flash Lite 2

Controlling video playback with Flash Lite is a bit different than controlling video playback with Flash Player for PCs. The main difference is that you do not work with the NetStream object and attach it to the video object. With Flash Lite, you use the Video object's playback methods directly. The following five methods are for controlling video playback in Flash Lite 2:

- Video.play()
- Video.stop()
- Video.pause()
- Video.resume()
- Video.close()

The other difference between the two Flash implementations are methods and properties available to the desktop implementation that are not supported by Flash Lite 2. They are:

- Video.attachVideo()
- Video.clear()
- Video.deblocking
- Video.height
- Video.width
- Video.smoothing
- Video._visible

Previewing Video with Flash Lite Applications

Given the variety of possible video formats, previewing video is not currently supported while authoring content in Flash Professional CS3. To preview a Flash Lite SWF file with video, you need to load and view the SWF on the target device or you can use Adobe Device Central if the target device's profile is installed. I have to say that Device Central is an incredible application for previewing Flash Lite content and its integration with Flash Professional CS3 and the other Creative Suite applications is superb.

Deploying Flash Lite Applications with Video

You have two options for deployment: embedding the video in the SWF file's library (referred to as "bundled video") or loading it from an external location such as the phone's available memory or from a networked location (referred to as "external video").

Bundled Device Video

Embedding or bundling device video with the deployed SWF guarantees that handset users can view your video content because it resides on the phone and not on the network. It does, however, greatly increase the size of the SWF since it's embedded into the SWF file.

External Device Video

External device video is not embedded inside the deployed Flash Lite SWF. It resides outside the SWF file and can be stored on the phone in available memory or it can be streamed from a network address. To play external video, you pass the location of the video to the **Video.play()** method. The following are example use cases of referencing external video given a video object with an instance name of **myVideo** and a 3gp-formatted video file named **products.3gp**.

When the video is in the same directory as the SWF file, write:
```
myVideo.play("products.3gp");
```

When the video is in a directory relative to the SWF file, write:
```
myVideo.play("videos/products.3gp");
```

For devices that support the file:// protocol, you can also write:
```
myVideo.play("file://c:/videos/products.3gp");
```

For devices that support network access, you can place the file on an RTSP server (Real Time Streaming Protocol) and pass this to the **play()** method:
```
myVideo.play("rtsp://serverAddress/videos/products.3gp");
```

How To: Create a Template Using Device Central

Device Central integrates with Creative Suite to facilitate creating and previewing mobile content. You can create a blank Illustrator, Flash, or Photoshop file tailored to a specific mobile device supporting Flash Lite. This section will cover creating an Illustrator document for a Motorola Razr phone. After adding content, it can be imported into Flash Professional and made into a Flash Lite application.

1. Launch **Adobe Device Central**. The **Start** page for Device Central appears. From the **Create New Mobile** list, click **Illustrator File**. If the Start page is not present after launching Device Central, choose **File > New Document In > Flash**.

Figure 10.4: *The Start page for Device Central.*

2. In Device Central's main application window, click the **Group By** button, , and choose **Carrier**. This button is on the right side of the **Available Devices** header bar.

Figure 10.5: *You can sort the Available Devices profiles a number of ways.*

3. In the **Available Devices** list, Open the **Verizon** category (Fig 8.6 A), select **Motorola RAZR V3m** (Fig 8.6 B), and click **Create** (Fig 8.6 C). The new document will open in Illustrator.

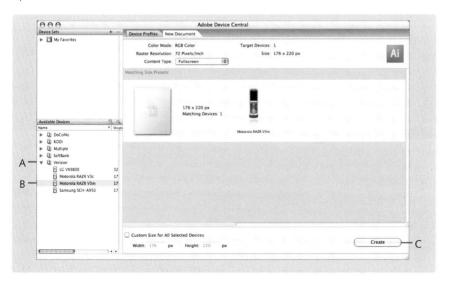

Figure 10.6: *Creating an Illustrator file in Device Central.*

Tutorial: Import an Illustrator File into Flash Professional

The next two tutorials will cover creating a Flash Lite application. We'll start by creating a Flash Lite application from Device Central and then import an Illustrator file that has symbols that we can use for buttons. In the second tutorial, we'll write the application's ActionScript and test the document using Device Central. The application will use footage from Chapter 5, but formatted for a mobile device.

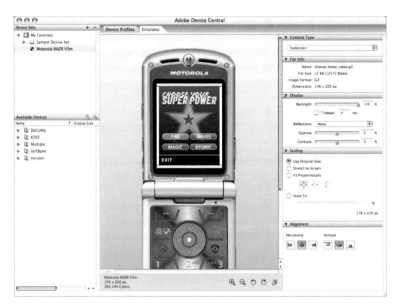

Figure 10.7: *The Flash Lite application running inside Device Central.*

Importing an Adobe Illustrator CS3 File

1. Navigate to the **Tutorials > Chapter 8** folder on the DVD-ROM. Copy the **Flash Lite Video** folder to your computer.

2. Launch **Adobe Device Central**. When the **Start** page appears, click **Flash File** under the **Create New Mobile** list. If the Start page is not present after launching Device Central, choose **File > New Document In > Flash**.

3. The **New Document** tab appears. At the top are the settings for the document. Choose **Flash Lite 2.1** from the **Player Version** menu, **ActionScript 2.0** from the **ActionScript Version** menu, and **Application** from the **Content Type** menu.

Figure 10.8: *The Flash Lite Document Settings panel.*

4. From the **Matching Size Presets** panel, double-click **Motorola RAZR V3m**.

5. Device Central opens **Flash Professional CS3** and creates a Flash document with document settings matching this targeted device.

6. Choose **File > Save**. Name the file **superpower.fla** in the **Flash Lite Video** folder.

7. Choose **File > Import > Import to Stage**. Navigate to the **Flash Video** folder on your computer. Select the Illustrator file **chsp_home.ai** and click **Import**.

ℹ️ *If you own a version of the Creative Suite 3 with Illustrator CS3, open chsp_home.ai and chsp_video.ai. Working with symbols in Illustrator CS3 feels a lot like Flash Professional.*

8. Collapse all the high-level layers. Afterwards, the layers panel should look like the screen portion on the right (A) of the following screenshot.

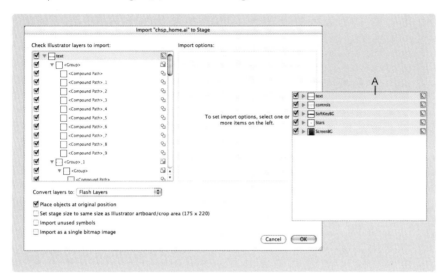

Figure 10.9: *The Illustrator import dialog.*

9. With the layers collapsed, we can now adjust how the high-level layers are imported. Select the **controls** layer and uncheck **Create movie clip** if it isn't already. Repeat this for the **SoftKeyBG** layer. This will preserve the layer but allow the elements on these layers to be independent of one another.

10. In the options below the layers list, check **Import unused symbols**. There are a few additional buttons we'll use for the individual video screens. They are included as symbols in the file, but are not currently used in the Illustrator file's art board. Check **Set stage to same size as Illustrator art board**.

11. Click **OK**. The file is imported directly to the stage and movie clips are automatically added to the **Library**.

💬 *This file uses the typeface Myriad. It's installed with most Adobe applications. If it isn't installed on your computer, replace it with a font such as Arial or Helvetica.*

12. Choose **File > Save**.

Structuring the Movie's Layers and Timeline

1. In the **Timeline** window add two layers at the top: **Labels** and **Actions**.

Figure 10.10: *The additional layers to create.*

2. Select the **Labels** layer, click **frame 1**, and in the **Properties** panel enter **Home**.

Figure 10.11: *Frame labels in the Timeline are modified in the Properties panel.*

3. Click **frame 10** in the **Timeline** window. Choose **Insert > Timeline > Blank Key-frame**. Select **frame 10** and enter **fire** for the **frame label** in the **Properties** panel. The remaining frame labels should also be created in the **Labels** layer.

4. Click **frame 20**. Choose **Insert > Timeline > Blank Keyframe**. Select **frame 20** and enter **waves** for the **frame label** in the **Properties** panel.

5. Click **frame 30**. Choose **Insert > Timeline > Blank Keyframe**. Select **frame 30** and enter **magic** for the **frame label** in the **Properties** panel.

6. Click **frame 40**. Choose **Insert > Timeline > Blank Keyframe**. Select **frame 40** and enter **atomic** for the **frame label** in the **Properties** panel. Select **frame 49** and choose **Insert > Timeline > Frame** to provide enough room to see the **atomic** frame label.

7. Select the **SoftKeyBG** layer. Click **frame 49** and choose **Insert > Timeline > Frame** to extend the contents of this layer throughout the movie. Select the **Screen BG** layer and repeat the same steps to extend the background gradient throughout the movie.

8. Select the **Actions** layer. In **frames 1**, **10**, **20**, **30**, and **40** insert a keyframe by choosing **Insert > Timeline > Blank Keyframe**.

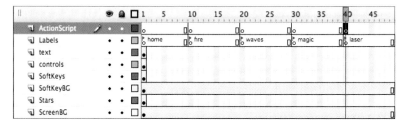

Figure 10.12: *Key frames set for the layers in this movie thus far.*

Chapter 10: Flash Media Server and Flash Lite Video

9. Now it's time to work on the controls for the **home** frame. Lock all the layers except the **controls** layer. Select the **fireButton**.

10. Choose **File > Save**.

Configuring Buttons

You'll notice that the button has a proper instance name in the **Properties** panel. In Illustrator, I was able to give instance names for each instance of the **BgButtonUpBg** symbol. I could not, however, set this symbol as a button clip in Illustrator. We'll use the **Library** panel to change it into a button, and we'll add a rollover state to it. Looking at the **Library** panel, notice that the imported Illustrator document is organized into folders based on the original file's layers and the settings chosen in the **Import** dialog.

Figure 10.13: *Library hierarchy.*

1. In the **Library** panel, open **chsp_home.ai > Illustrator Symbols**. Double-click the **BgButtonOverBg** movie clip. Choose **Edit > Select All** and then **Edit > Copy**. This graphic is the overstate for the movie's buttons.

2. Select the **BgButtonOverBg** movie clip and click the **Symbol Properties** button, 🔘, at the bottom of the **Library** panel. In the **Symbol Properties** dialog, check **Button** as the symbol's type. Click **OK**.

3. Double-click the **BgButtonOverBg** movie clip. In the **Timeline**, click the **Over** frame and choose **Insert > Timeline > Blank Keyframe**. Choose **Edit > Paste in Place**. The button now has an overstate.

Figure 10.14: *The overstate added to the button movie clip.*

> On a mobile phone, the user will press the five-way buttons on the phone, and as the selection moves to a new button, this graphic will indicate the currently selected button.

4. Convert the **PlayBtn**, **PauseBtn**, and **StopBtn** movie clips to button symbols by selecting each one, clicking the **Symbol Properties** button, 🔘, and checking **Button** in the **Symbol Properties** dialog.

5. Double click the **SmButtonOverBg** movie clip in the **Library** panel. Choose **Edit > Select All** and then **Edit > Copy**. This graphic is the overstate for the movie's play, stop, and pause buttons.

6. In the **PlayBtn**, **PauseBtn**, and **StopBtn** button symbols, create a blank keyframe in the **Over** frame (**Insert > Timeline > Blank Keyframe**) and paste the rollover graphic using **Edit > Paste in Place**.

> Note that this graphic is only the button background. You still need to copy and paste the play, stop, and pause shape icons. If you don't copy and paste them, the icon at the center of each button will disappear when the button is in the rollover state.

7. For each of these buttons, select and copy the shape icon in the **Up** frame and paste it into the **Over** frame using **Edit > Paste in Place**.

8. Using the **Time** bar, click **Scene 1** to return to it.

Figure 10.15: *Navigating back to Scene 1 via the Time bar.*

9. Select the **FIRE** button on the **stage**. Make sure you select the button shape and not the button text, which are separate elements. When you see a selection rectangle around the entire button shape, you have selected the button.

Figure 10.16: *The FIRE button selected.*

10. In the **Properties** panel, change the button's instance type to **Button** from Movie Clip. Also set the tracking option to **Track as button**. If you don't set this properly,

Chapter 10: Flash Media Server and Flash Lite Video

the buttons will flicker because the Flash Lite player will treat them like movie clips instead of buttons and play through the **Up** and **Over** frames continuously.

Figure 10.17: *Set the fireButton as a Button symbol.*

11. Follow the previous step to change the **WAVES**, **MAGIC**, and **ATOMIC** buttons. They should all be Button clips and tracking as a button. When you are finished, lock the **controls** layer in the **Timeline.**

12. Unlock the **SoftKeysBG** layer. Choose **Edit > Select All** and then choose **Edit > Copy**. Choose **Edit > Deselect All**. Delete the **HOME** text since this is the home screen and it's only needed on the other screens.

13. Select **frame 10** in the same layer and choose **Insert > Timeline > Blank Keyframe**. Choose **Edit > Paste In Place**. Then select **frame 49** and choose **Insert > Timeline > Frame**. This will extend **HOME** and **EXIT**, the two phone soft keys across the remaining frames in the movie. Soft keys are the buttons controlled by the two left and right select buttons below a phone's screen and above the phone's five-way navigation buttons.

Figure 5.18: *The left and right soft keys (A) and the five-way navigation buttons (B).*

14. Lock the **SoftKeys** layer and unlock and select the **controls** layer again. We will now place the play, pause, and stop buttons we modified in steps 2–5.

15. Select **frame 10** for the controls layer. Insert a blank keyframe. Drag the **StopBtn**, **PlayBtn**, and **PauseBtn** buttons from the **Library** panel to the stage. Use the following table and the **Properties** panel to name and position each instance.

Table 8.3: *Name and Position Information for the Play, Pause, and Stop Buttons*

Button Symbol	Name	X	Y
PlayBtn	playButton	68	160
StopBtn	stopButton	20	160
PauseBtn	pauseButton	116	160

16. Select **frame 49** and insert a frame (**Insert > Timeline > Frame**) to extend these buttons across the rest of the movie. Lock the **controls** layer.

17. Insert a new layer named **video** and place it above the **controls** layer but below the **text** layer. To insert a new layer, choose **Insert > Timeline > Layer**.

Importing and Bundling Device Video

1. With the user interface elements in place, let's add the video. In the **Library** panel click the **Panel Options** button, ⟨≡⟩, and choose **New Video**. In the **Video Properties dialog**, name the symbol, **fire**. For **Type**, select **Video (ActionScript-controlled)** and check **Bundle source in SWF for mobile and devices**. Check **Export for ActionScript** and keep the Identifier set as **fire**. Click **Import** and navigate to the **Flash Lite Video** folder on your computer. Open the **video** folder and import the file, **fire.3gp**.

Figure 10.19: *The Source property will reflect the location of the video on your computer.*

ℹ️ *Remember that device video can either be linked to externally or bundled inside the compiled SWF file. In order to control video playback with ActionScript, the video needs to have an indentifer exported for ActionScript.*

2. Import the other three video files in the **Flash Lite Video > Video** folder repeating the previous step. Use the file name (minus the file extension) as the **Symbol** and **Identifier** names for each of the videos.

3. Select **frame 10** in the **video** layer and insert a blank keyframe. Drag the **fire** video from the **Library** panel to the stage. In the **Properties** panel, name the instance **fireVideo** and set its position to **8, 8**.

Chapter 10: Flash Media Server and Flash Lite Video

4. Select **frame 20** in the **video** layer and insert a blank keyframe. Drag the **waves** video from the **Library** panel to the stage. Name the instance **wavesVideo** and set its position to **8, 8**.

5. Select **frame 30** in the **video** layer and insert a blank keyframe. Drag the **magic** video from the **Library** panel to the stage. Name the instance **magicVideo** and set its position to **8, 8**.

6. Select **frame 40** in the **video** layer and insert a blank keyframe. Drag the **atomic** video from the **Library** panel to the stage. Name the instance **atomicVideo** and set its position to **8, 8**.

7. Choose **File > Save**. The structure, layout, and visuals for the Flash movie are now complete. You've learned how to import Illustrator artwork, construct buttons from Library assets, and import and place video for Flash Lite applications. In the next tutorial, we'll write the ActionScript to control both navigation and playback.

Figure 20: *A screen from the application after completing the first part of the tutorial.*

Tutorial: Writing ActionScript and Testing in Device Central

The ActionScript used in Flash Lite 2.x is based on ActionScript 2.0. This means if you had never used ActionScript before reading this book, the code may look a little different than what you've seen in the previous chapters. Rest assured, however, the code we'll cover is a lot simpler than the code in the previous chapters.

1. In the **Timeline** select **frame 1** in the **ActionScript** layer. In this layer we'll write code that will set global settings for the movie and create navigation between this screen and the different frames containing video.

2. Choose **Window > Actions** to open the **Actions** panel. Enter the following:

```
fscommand2("FullScreen", true);
fscommand2("SetQuality", "high");
fscommand2 ("SetSoftKeys", "", "Exit");
_focusrect = false;
stop();
```

The first three lines of code use the **fscommand2** function. The **fscommand2** function facilitates communication between a Flash Lite SWF and the Flash Lite player or an application on the mobile device. The function is different than **fscommand** in that it accepts multiple arguments rather than one, it runs immediately rather than the end of frame, it can return a value, and it only works in Flash Lite—it does not work with the desktop Flash players.

The first line enables full-screen mode, the second turns on higher quality rendering, and the third line sets the right soft key label to "Exit" and sets the left soft key label to be blank.

Setting **_focusrect** to **false** turns off the yellow outline the Flash Lite player draws around selectable interface elements. Since we created overstates for all the buttons, setting this to true, the default, would be overkill and not improve the design.

The **stop()** method stops playback and keeps the player on this frame until the user triggers the navigation code we're about to write.

3. When the Flash Lite application initially runs, the first button, **fireButton**, should be selected by default. Enter:

```
if (selectedItem == null) {
    Selection.setFocus(fireButton);
} else {
    Selection.setFocus(selectedItem);
}
```

This if-else statement selects the first button, fireButton, when there is no selection. This occurs when the SWF begins to play. If there is a selection, it preserves the current selection.

Chapter 10: Flash Media Server and Flash Lite Video

4. Let's write the navigation code:

```
fireButton.onPress = function() {
    selectedItem = this;
    gotoAndStop("fire");
};
wavesButton.onPress = function() {
    selectedItem = this;
    gotoAndStop("waves");
};
magicButton.onPress = function() {
    selectedItem = this;
    gotoAndStop("magic");
};
atomicButton.onPress = function() {
    selectedItem = this;
    gotoAndStop("atomic");
};
```

There are event listeners for each of the four buttons on the stage. In each of these **onPress** event listeners, a function is assigned to move the playhead to a frame with one of the labels we created in the last tutorial.

5. Choose **File > Save**.

6. The last code that needs to be written for this frame is an event listener that will respond when the user clicks the right soft key and wants to exit the application. Enter:

```
Key.removeListener(softKeyListener);
var softKeyListener:Object = new Object ();
softKeyListener.onKeyDown = function () {
    var keyCode = Key.getCode ();
    if (keyCode == ExtendedKey.SOFT2) {
        fscommand2 ("Quit");
    }
};
Key.addListener(softKeyListener);
```

This application will use soft keys in several frames and all frames will use an event listener with the same name to simplify removing and reattaching it across frames. The first line removes the event listener from the **Key** object so one with the same name but different navigational instructions can be attached to it.

The next seven lines create an object, **softKeyListener**, that will listen for keys that are pressed and will quit the application if the SOFT2 key or right button is pressed. The last line reattaches the listener to the **Key** object.

7. This frame contains the fire video. The code in this frame can also be used in the remaining video frames with slight modifications. Select **frame 10** in the **Action-Script** layer. In the **Actions** window enter the following code:

```
stop();
fscommand2("SetSoftKeys", "Exit", "Home");
fireVideo.play();
Selection.setFocus(pauseButton);
```

The **stop()** method parks the playhead on this frame. It will stay here until the navigational code that is part of the soft key event listener runs. The next line of code sets the soft keys for the current frame. The third line of code plays the video instance, **fireVideo**. Since the video begins playing, the focus is moved to the pause button for convenience.

8. The three button symbols on the stage, **stopButton**, **playButton**, and **pauseButton**, need to be connected to the video object. Enter:

```
stopButton.onPress = function() {
    fireVideo.stop();
    Selection.setFocus(playButton);
};
playButton.onPress = function() {
    fireVideo.resume();
    Selection.setFocus(pauseButton);
};
pauseButton.onPress = function() {
    fireVideo.pause();
    Selection.setFocus(playButton);
};
```

These three event listeners listen for the **onPress** event. This occurs when the center button on the phone's five-way control is pressed.

The **stopButton** code stops playback by calling the **stop()** method. It conveniently sets the focus to the **playButton** so the user can play the video again. The remaining three buttons work in similar ways. The **playButton** button resumes playback and sets the focus to the pause button, and the **pauseButton** button pauses the video and sets the focus to the play button.

9. The last several lines of code address the phone's soft keys. The code works a lot like the event listener written earlier with the exception that it listens for an additional soft key, **SOFT2**.

```
Key.removeListener(softKeyListener);

var softKeyListener:Object = new Object();

softKeyListener.onKeyDown = function() {
    var keyCode = Key.getCode();
    if (keyCode == ExtendedKey.SOFT1) {
        fscommand2("Quit");
    } else if (keyCode == ExtendedKey.SOFT2) {
        gotoAndStop ("home");
    }
};
Key.addListener(softKeyListener);
```

It begins by removing the listener, recreating the listener object, and creating a function for the listener. The function listens for either soft key to be pressed. The left soft key still exits the application. The right soft key returns the user to the home screen.

10. Now you can copy and paste this code in frames 20, 30, and 40 in the ActionScript layer. In each frame you'll have to change all instances of fireVideo to the instance name of the video placed in the frame. In **frame 20**, use **wavesVideo**, in **frame 30** use **magicVideo**, and in **frame 40** use **atomicVideo**.

11. Choose **File > Save**.

Testing the Movie in Device Central

1. Choose **Control > Test Movie**. Adobe Device Central should launch. If you see the following warning in the **Message** panel, change the **Content Type** to **Application** and make sure the target device supports Flash Lite 2.

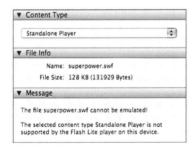

Figure 10.21: *Change the content type to Application.*

You should now be able to navigate to the different video frames; play, pause, and stop the video; and return to the home frames. Use the buttons on the device that appears in the center panel. They are live. Device Central offers many ways to preview Flash Lite content. For example, you can preview the content on any number of devices that support the Flash Lite and ActionScript versions you are targeting. It

also includes preview controls to see how backlighting, environmental reflections, and gamma can affect the appearance of your content.

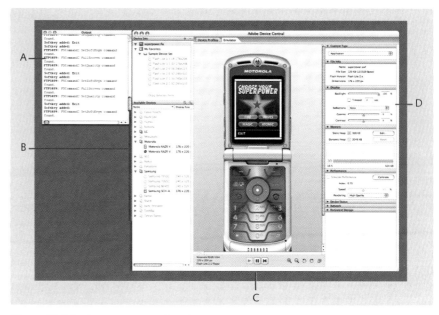

Figure 10.22: *The Device Central application user interface.*

The **Output** window, (Fig 8.22 A) (**View > Flash Output > View**), shows trace statements and device messages. You can preview content as it would appear on similar devices by double-clicking a device in the **Available Devices** list (Fig 8.22 B). You can stop the movie, pause it, and restart it as well as zoom and rotate the device (Fig 8.22 C). Change the appearance and simulate various display conditions using the options in the **Display** panel (Fig 8.22 D).

Wrapping Up

This chapter introduced you to streaming video basics and to device video with Flash Lite. If you've completed all the tutorials in the book, you should have a solid foundation to work with Flash Video in Flash applications on web pages and now on alternative devices.

Index

U

UFO.js, dynamic insertion of Flash, 164
URLLoader class, 187, 191
Usability, testing, 114

V

VideoController class, 106–108
VideoEvent class, 124
videoHandler(), 135
Video playlist, see Playlist
Video tag, XML, 189
VP6, compression considerations, 46–47

W

Web 2.0, Flash popularity, 2
Web server, Flash compatibility, 167–168

X

XML, see Extensible Markup language

Z

Zoom, guidelines, 13

Producing Flash CS3 Video

Techniques for Video Pros and Web Designers

Producing Flash CS3 Video

Techniques for Video Pros and Web Designers

John Skidgel

AMSTERDAM • BOSTON • HEIDELBERG • LONDON
NEW YORK • OXFORD • PARIS • SAN DIEGO
SAN FRANCISCO • SINGAPORE • SYDNEY • TOKYO

Focal Press is an imprint of Elsevier

Senior Acquisitions Editor:	Paul Temme
Publishing Services Manager:	George Morrison
Senior Project Manager:	Brandy Lilly
Associate Editor:	Dennis McGonagle
Assistant Editor:	Chris Simpson
Marketing Manager:	Becky Pease

Focal Press is an imprint of Elsevier
30 Corporate Drive, Suite 400, Burlington, MA 01803, USA
Linacre House, Jordan Hill, Oxford OX2 8DP, UK

Library of Congress Cataloging-in-Publication Data
Application submitted

British Library Cataloguing-in-Publication Data
A catalogue record for this book is available from the British Library.

ISBN: 978-0-240-80910-6

For information on all Focal Press publications
visit our website at www.books.elsevier.com

07 08 09 10 11 5 4 3 2 1

Printed in Canada

Dedication

This book is dedicated to Blanca Josephine Skidgel and Ava Josephine Skidgel.

Acknowledgements

The idea for this book came to me in July of 2004. Paul Temme of Focal Press was instrumental in helping me hone in on this vision and patient enough to let me pick the time to write it. I was lucky to have Scott Fegette as a technical editor. I have valued his feedback, insight, and assistance. Whenever I'm in a pinch I know Dan Cowles will be there to help with a shoot. I'm ever grateful for his assistance. Lastly, I would not be able to write without support from my wonderful family. Thank you, Allison, Beatriz, and Ava!

Contents